JEAN METZINGER IN RETROSPECT

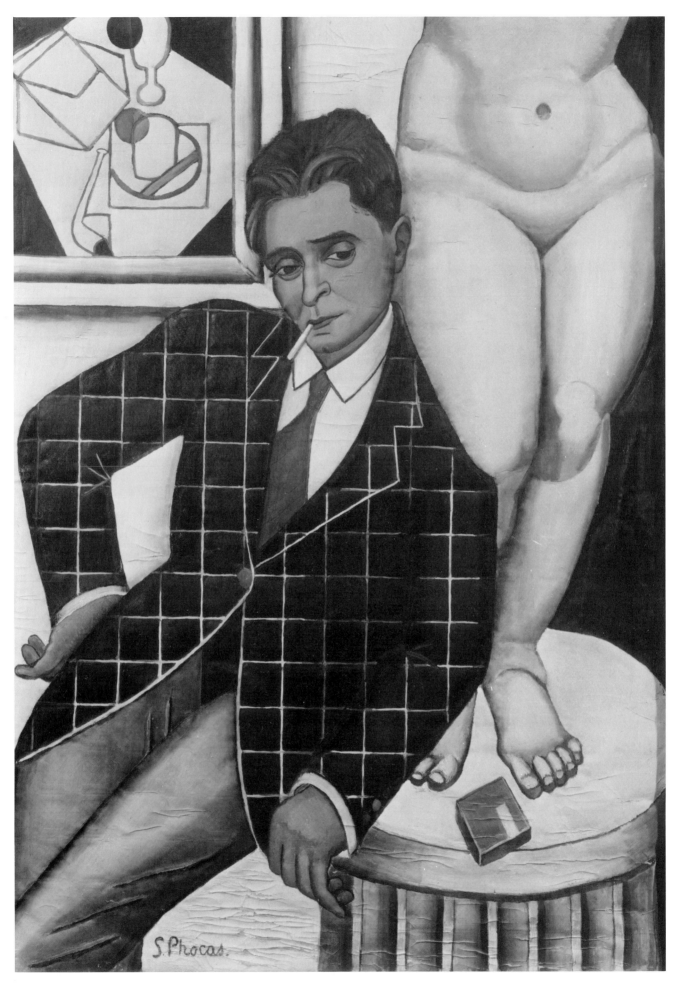

Suzanne Phocas, *Portrait of Metzinger*, c. 1926

JEAN METZINGER IN RETROSPECT

JOANN MOSER · WITH AN ESSAY BY **DANIEL ROBBINS**

THE UNIVERSITY OF IOWA MUSEUM OF ART · IOWA CITY

Published on the occasion of the exhibition **Jean Metzinger in Retrospect**, organized by The University of Iowa Museum of Art, Iowa City.

The University of Iowa Museum of Art
Iowa City
31 August–13 October 1985

Archer M. Huntington Art Gallery
University of Texas at Austin
10 November–22 December 1985

The David and Alfred Smart Gallery
The University of Chicago
23 January–9 March 1986

Museum of Art, Carnegie Institute
Pittsburgh, Pennsylvania
29 March–25 May 1986

The exhibition *Jean Metzinger in Retrospect* is supported by a grant from the National Endowment for the Arts, Washington, D.C., a federal agency.

The catalog *Jean Metzinger in Retrospect* is published with the assistance of the J. Paul Getty Trust.

Distribution by the University of Washington Press

Library of Congress Catalog Card Number: 85–51290
ISBN 0-87414-038-2
First edition

Front cover:
Jean Metzinger
La Plume jaune, 1912 (catalog no. 36)
Oil on canvas
28¾ x 21¼ (73.0 x 54.0)
Lent by Mr. and Mrs. R. Stanley Johnson

Frontispiece:
Suzanne Phocas, French, born 1897
Portrait de Metzinger, c. 1926
Oil on canvas
45¼ x 31½ (115.0 x 80.0)
Musée d'Art Moderne de la Ville de Paris

Back Cover:
Jean Metzinger
Dancer in a Café, 1912 (catalog no. 53)
Oil on canvas
57½ x 45 (146.1 x 114.3)
Collection of Albright-Knox Art Gallery, Buffalo, New York

CONTENTS

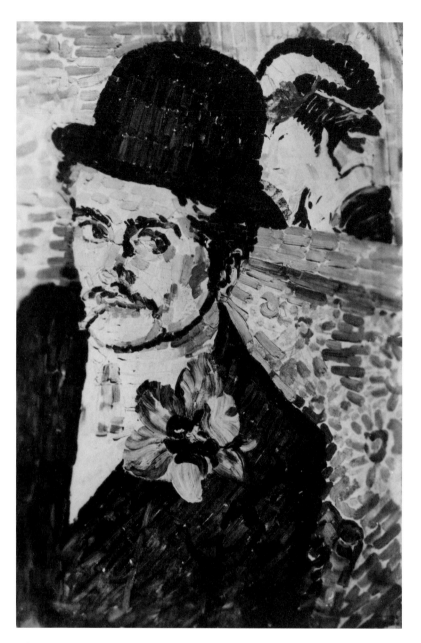

Robert Delaunay, *Portrait of Jean Metzinger* (The Man with the Tulip), 1906

What's Metzinger? A scrupulously polite, well-dressed gentleman as ever was, in a scrupulously neat chamber, with a scrupulously well-ordered mind. He is as complete as a wax figure, with long brown eyelashes and a clean-cut face. He affects no idiosyncrasies of manners or dress. One cannot question his earnestness and seriousness or sincerity. He is, perhaps, the most articulate of them all.

Gelett Burgess, an American writer, after a visit to Metzinger's studio in 1909.

INTRODUCTION

JOANN MOSER

Senior Curator of Collections · The University of Iowa Museum of Art

The idea for a retrospective view of Jean Metzinger's paintings originated in 1979 when I attempted to do some research on four paintings by the artist in the collection of The University of Iowa Museum of Art. Each was undated, and each represented a distinctly different style of expression. Only the least interesting of the four paintings related to the Cubist style with which Metzinger is typically associated.

My attempts at research met with little success. Although Metzinger is always mentioned prominently in publications on Cubism, it is usually as coauthor with Albert Gleizes of the first treatise on Cubism, Du «Cubisme», that he has received the most attention. He is also often mentioned as an organizer of the famous "Salle 41" at the 1911 Salon des Indépendants, as a participant in the 1912 exhibition of the Section d'Or, and as an active member of the Puteaux group of Cubists. Only in that context do some publications touch upon his art, usually with reference to the same few paintings of 1912–13 for which he is best known. The one publication that even begins to deal with his development as an artist is a catalog published in 1964 by International Galleries, Chicago, which is valuable primarily for its reproductions of paintings. A research trip to Paris convinced me that I had not overlooked any publications on Metzinger, that indeed even in his native country, where he had spent his entire life, little was known about the career and paintings of Jean Metzinger.

As I searched for information and publications on Metzinger, I began to see more paintings by him and came to appreciate the quality of his work, especially during the period from 1904 through 1930. It became apparent that an assessment of Metzinger as an artist was long overdue. The first step was to locate a substantial number of paintings so that his stylistic development could be studied and analyzed. I have spent more than four years looking for paintings by Metzinger, both in the United States and Europe, in public and private collections. In many instances I have found photographs of paintings I have not been able to locate. A rich source of reproductions was the Léonce Rosenberg Archive at the Caisse Nationale des Monuments Historiques et des Sites in Paris, where black-and-white prints were made from negatives owned by the dealer who handled Metzinger's paintings after 1915. Other photographs of works that have not been located were found in art dealers' files and auction catalogs. Of course the primary sources of photographs were museums and collectors in possession of works by Metzinger.

As I saw more paintings by Metzinger and collected reproductions of other works that could not be located, it became apparent that no serious analysis of Metzinger's development could begin before a large body of work had been assembled and an attempt made to establish a chronology of his life and work. From this realization evolved the present exhibition. More than 150 paintings were located before a selection of works was made for this exhibition. Although several important paintings were not available for loan, many generous lenders recognized the importance of this project and assisted me in any way they could. Gathering so many works together in one location will permit a careful study of them in relation to one another. Brushwork, painting technique, materials, and color choices will provide important clues to dating the works when several paintings are seen side by side. It will also help

in identifying later paintings by Metzinger from the 1930s, 1940s, and early 1950s, when he reworked ideas and compositions from his earlier Cubist period in a decorative but awkward manner.

The problem of dating Metzinger's paintings loomed large from the start of my research. No journals or diaries of Metzinger have been discovered, although it is quite possible, and even probable in view of Metzinger's skill as a writer, that some exist. A small selection of his writings was published under the title of Le Cubisme était né: Souvenirs par Jean Metzinger (Paris: Editions Présence, 1972), but because they are not dated, they give little information about his artistic development. Only very recently has some correspondence between Albert Gleizes and Jean Metzinger come to light, which suggests that more correspondence may yet be discovered. The details of Metzinger's personal life, especially during his formative years as an artist, are vague. His first wife died around 1918, his only daughter died shortly thereafter, and his second wife, Suzanne Phocas, whom he married around 1925, has little information about his early career. Few of the works before 1917 are dated. Several works can be dated by matching them with Salon entries for a particular year or by identifying them as paintings in other exhibitions, such as the Section d'Or exhibition of 1912 or a show of Cubist and Futurist pictures in Pittsburgh in 1913. Several key paintings dated in this way have served as touchstones for dating other works by means of stylistic analogies. During the late teens and early 1920s Metzinger put dates on more of his paintings, perhaps at the urging of Léonce Rosenberg, and many works from these years were reproduced and dated in Rosenberg's publication, the Bulletin de l'Effort moderne.

A somewhat less reliable, although still useful, method of dating Metzinger's work is that of comparing individual paintings with works by some of his artist friends, such as Robert Delaunay, Juan Gris, and Fernand Léger, with whom he shared stylistic affinities at different stages in his development. It is tempting to rely more heavily on comparisons with other artists than judiciousness warrants, since Metzinger's involvement with a large group of artists resulted in an active exchange of ideas, motifs, and stylistic mannerisms. However, this method assumes that similarities in paintings by two different artists indicate that both works were done at approximately the same time; it often implies that the work of the lesser known artist was influenced by the work of the better known one. This may be true in many instances, but the exceptions can be misleading. Thus, comparisons with other artists as a method of dating Metzinger's work have been used only when no other evidence was available. The relationship of Metzinger's work to that of his fellow artists, especially Juan Gris and Fernand Léger, is a fertile area for future research once the dates of Metzinger's paintings have been established independently.

To confuse further the issue of dating Metzinger's paintings, some works have been reproduced in various publications such as auction catalogs or magazine advertisements with dates that appear to be incorrect upon closer examination. Also, it seems that some works may have been backdated by Metzinger himself much later in his career. In some cases, certificates of authenticity were issued by the artist in the early 1950s, assigning inaccurate dates to works produced much

earlier. An attempt has been made to correct the more obvious errors in dating, but additional work remains to be done in such areas as assigning some "Cubist" works to the post-1930 period when Metzinger seems to have produced awkward pastiches of his earlier Cubist style. It is hoped that this initial study of Metzinger's work will bring forth new information and additional paintings that will augment and refine the chronology presented here.

Although a chronological arrangement could be worked out adequately for the pre-Cubist and post-Cubist paintings, primarily because fewer works were involved, strict adherence to this method became unwieldy in dealing with the Cubist paintings. The sheer number of works, most of which were undated, often made assignment to a specific year difficult. By dividing the Cubist paintings into figure subjects, still lifes, and landscapes—and then organizing them chronologically within each group—the numbers became more manageable. Such an arrangement also reveals more accurately Metzinger's own practice of painting variations on a theme over a long time span and of working in several different styles in a single year.

In providing a significant reassessment of Metzinger's role in the Cubist movement, both as a writer/theoretician and as a painter, Daniel Robbin's essay in this catalog also enlarges our understanding of Cubism itself. As the only artist involved with the Puteaux group of Cubists who had ties as well with the Picasso-Braque axis, Metzinger was a leading spokesman for the movement in its early years. If the paintings in this exhibition do not show a radical innovator, they do reveal a highly skilled artist whose works deserve greater recognition and study than they have received until now.

Both the selection of paintings and drawings included in this catalog and the information about them are by no means complete. The decision to limit this exhibition to Metzinger's work from 1904 through 1930 was determined by practical considerations as well as by the recognition that the quality of Metzinger's work diminishes significantly after this time. There are many works for which I was unable to obtain satisfactory photographs. For some works, I was unable to determine the medium or size because the location of the work was not known. I am certain there are numerous works, especially in private collections, of which I am not yet aware. As the date of the exhibition approached and the catalog was being prepared for the printer, I discovered additional works, but it was too late to include them. Hence, as comprehensive as this catalog may seem to be, it is not intended to be definitive. It is hoped that the present exhibition and the the catalog accompanying it will renew interest in this important artist, and that as a result additional information on Metzinger's life and work will be brought to public attention.

JEAN METZINGER: AT THE CENTER OF CUBISM

DANIEL ROBBINS

May I. C. Baker Professor of the Arts • Union College, Schenectady, New York

The circumstances that led to the identification of five French painters as the Cubists at the 1911 Salon des Indépendants are easily reconstructed. John Golding retrieved and published many of the facts in his 1959 *Cubism: A History and an Analysis, 1907–1914*, drawing heavily on the *Souvenirs* of Gleizes, a portion of which had been published in 1957. It is not difficult to understand the reasons why recognition of the roles of four of these five original Cubists—Delaunay, Le Fauconnier, Gleizes, and Metzinger; that is, all but Léger—dropped out of historical consideration as important factors during those years, beginning in the late 1920s and 1930s, when the standard history and still prevailing interpretation of Cubism was developed. This was in large part the work of Alfred Barr, who based many of his facts and interpretations on the writing and opinions of Daniel-Henri Kahnweiler, the art dealer whose intellectual and commercial identification with Derain, Picasso, Braque, Gris, and Léger was initially more crucial than his desire to demonstrate that the artists whom he represented exclusively were, in fact, true Cubists. This process of wresting the paternity of Cubism from the publicly identified group and locating it among the Kahnweiler group began during the First World War when Kahnweiler, deprived of his gallery as an enemy alien, was living in exile in Switzerland, a refugee welcomed and comforted by one of his best and most sympathetic clients, Hermann Rupf of Berne.

The most difficult question, however, remains unsolved: what was the relationship between the Salon des Indépendants group (Delaunay, Le Fauconnier, Gleizes, Léger, Metzinger) and Picasso and Braque prior to 1911?

For the solution to this question, the recovery of solid facts has been very difficult, and the answers necessarily must involve interpretation, especially across the years subsequent to the events whereby the pictorial attitudes of the Cubists were formed. At each point along the historical trajectory that marks our understanding of Cubism, contemporary concerns, not only aesthetic, but also financial and political, intervene.

When Barr wrote in 1936, seeing Cubism linked to abstract art in a specific way, he fixed a developmental pattern as essential in the stages of Cubism: analytical Cubism and synthetic Cubism—the concepts themselves borrowed from Kahnweiler and Juan Gris—were the dominant phases, and these were traced in the work of Picasso and Braque. In 1939, when the Museum of Modern Art acquired Picasso's *Demoiselles d'Avignon*, these twin concepts were firmly joined by another powerful factor, the so-called first Cubist painting, a position it has retained until recently.[1] To these building blocks was added another factor evident in the *Demoiselles*: the influence of African sculpture.

All of Cubism was thus judged against a paradigm created by the examination of only a fraction of the evidence. But as one may note in a review of the historiography of Cubism, the paradigm has been so strong that it survived till recently, crumbling only when Robert Rosenblum was able to demonstrate that concerns of content were among the primary considerations of Picasso and Braque.[2] The other Cubists never took an important place in the standard history of Cubism because their work did not evolve from an analytical to a synthetic phase across the continental divide of collage. They never manifested an interest in African art in their work. They did display, however, an interest in certain subjects, and such concern relegated them to the realm of the anecdotal, to which—it was thought—Cubism was rigorously opposed.

Trying to fit the minor Cubists into the same developmental pattern established for Picasso and Braque was like attempting to force the big feet of Cinderella's stepsisters into glass slippers fashioned by the fairy godmother only for Cinderella. Kahnweiler had made the shoes. The Cubists of the 1911 Salon des Indépendants did not fit into them, and for that reason it was easy to dismiss them as having never understood Cubism at all! Douglas Cooper, for example, writing about Henri Le Fauconnier's work in 1910–11, acknowledges that of the group publicly identified with Cubism he was

> . . . at first the leading personality and his enormous painting *Abundance*, shown at the Indépendants in 1911, greatly impressed the group. This in itself reveals how little most of these painters were concerned with true Cubism in its essential aspects. There is really nothing Cubist about *Abundance*: the use of light is consistent, the perspective is traditional, the cubes and facets are not arrived at by formal analysis, nor do they serve to recreate space and volume. Le Fauconnier has simply disguised a conventional allegorical subject by giving it a superficially Cubist look.[3]

Apart from specific observations about light, perspective and cubes, which are incorrect, the principal difficulty with Cooper's argument, which is merely a sharp restatement of numerous similar remarks current about minor or satellite Cubists since the mid-thirties, is that in 1911, when it first came into wide usage, into public consciousness, Cubism was defined in terms of the appearances and intentions of Le Fauconnier, Metzinger, Gleizes, Delaunay, and Léger, and not in terms of Picasso's and Braque's work. To suggest that the planar and volumetric treatment visible in the second version of *Abundance* does not proceed from "formal analysis," an idea subsequently invented to characterize a method of Picasso and Braque, is to reason in a circular fashion.

Le Fauconnier had his own evolution as a painter, had never met Picasso before 1911, and—like Gleizes, Metzinger, Delaunay, and Léger—was apparently surprised to discover a year earlier—between the spring and the fall of 1910—that there were other artists whose work and aims were akin to his own. He was still more surprised that, as a result of the grouping together of the paintings of his friends in the spring of 1911, the five artists became known as the Cubists. He had already published a clear statement of his aesthetic intentions in "Das Kunstwerk" in September of 1910, having been invited by Kandinsky not only to exhibit with the Munich *Neue Künstlervereinigung*, but also to contribute a preface.[4] This preface, which antedates by some months Metzinger's "Note sur la peinture" in *Pan* of October-November 1910, is an accurate account of the artist's aims and method. It has nothing to do with "formal analysis" or "analytic" as these terms have evolved over fifty years from Kahnweiler, through Gris, through Barr, to the most recent revisionist attempts to rescue some validity for the notion in connection with the stylistic unfolding of Cubism.[5] It does, however, have something to do with Metzinger's understanding of the birth of a new kind of painting, one that was anti-Hellenic and employed a mobile perspective. It was Metzinger, we must remember, who who first per-

ceived a similarity between Le Fauconnier and Delaunay, on the one hand, and Picasso and Braque, on the other. Moreover, it is Metzinger alone among the group of five (Gleizes and Léger were not mentioned in the *Pan* article) who can be documented to have known and been affected by the work of Picasso at this time.

As with Le Fauconnier, the history of Cubism has been particularly unkind and unjust to Metzinger. The historical role he played has necessarily been misunderstood because Cubism's evolution was formulated without regard for this painter's work. It seems reasonable to suggest that there has been a certain want of logic in history's treatment of Metzinger. On the one hand, critics have hailed the extraordinary perception of this sensitive and intelligent man who, it is universally believed, was the first to recognize explicitly the significance of the use of "a free, mobile perspective" in the new painting, and who understood that "the clever mixing, again and again, of the successive and the simultaneous" by Braque constituted the decisive break with the Hellenic tradition.[6] In short, they have admitted, as did Cooper, that Metzinger "had written an informed article on the Cubism of Braque and Picasso." On the other hand, Cooper also wrote that Metzinger's "own painting showed no evidence of a desire or ability seriously to follow them in their pictorial quest. Metzinger was a painter of little imagination and no originality, who seized on the planes and faceting in the analytical painting of Braque and Picasso and tried to use the same technique himself. . . . Here was a real case of a 'jackdaw in borrowed plumage,' for Metzinger did not properly comprehend the pictorial logic or structural significance of Picasso's methods."[7]

It would be more accurate to observe that Metzinger was indeed, as Golding noted, "the first to write of the fact that Picasso and Braque had dismissed traditional perspective and felt free to move around their subjects, studying them from various points,"[8] but that he did not have any notion of the concept of "analytical painting" at all, because this was a later construction formulated explicitly to describe what once seemed to be the method of Picasso and Braque. This concept, moreover, has been gradually drained of its interpretive validity as the realist intentions of the orthodox Cubists have at last moved to the fore.

It would be useful to examine Metzinger's paintings not in terms of a later and largely erroneous concept developed in connection with Picasso and Braque, but rather in light of his own writing and his own techniques—in short, to try to understand his work by removing from in front of it the filter of Picasso-Braque Cubism.

This exhibition and its catalog constitute the first steps in the effort to study Metzinger. The task is not easy because historical neglect has contributed to the scatter of the pictorial evidence. Biographical data is scanty and documentation is scarce. Metzinger was a private person who endured many losses in his life: before 1920, his first wife, and his daughter. And his second wife, Suzanne Phocas, although devoted to his memory, was very careless with what remained of his papers. Nevertheless, some conclusions can be made through study of his pictures, the fragments of published *Souvenirs*, and some hitherto unknown letters.

Let us begin with a different approach, with the simple acknowledgment of the fact that Jean Metzinger was the first to perceive an identity, or at least an overlap, among the intentions of the four artists—Picasso, Braque, Delaunay, and Le Fauconnier—about whom he was writing in the *Pan* article, thus becoming the discoverer of what later came to be known as Cubism. Instead of focusing solely on the most immediate

and obvious of the characteristics that the work of this group had in common—the mobile perspective, or literal moving about an object, which Metzinger had ascribed specifically to Picasso—one should also take into consideration what Metzinger wrote about Delaunay and Le Fauconnier to see what else he discerned as congruent among the concerns of these painters.

The last part of Metzinger's article in the October-November 1910 number of *Pan* was not included in Edward Fry's immensely useful book of 1966 recapitulating so many of the first texts written on Cubism. Probably it did not seem very important, and surely it must have appeared wrong that Metzinger, in his discussion of Delaunay, began by writing about an earlier work, *Manège*, the first version of *Carrousel with Pigs* or *Electric Carrousel*, an important large-scale work of 1906. (It was to be destroyed by the artist in 1912 and taken up two more times, once in 1913 and again in 1922.)[9] The theme of this picture was the circular motion of the merry-go-round and reflections of it in electric globes shaped like discs. The overall effort was to identify or fuse these plastic movements into a unity with the crowd. Metzinger saw in this painting a résumé of the paroxysms of the epoch (showing his familiarity with Jules Romains), and he also saw in it the specific source of the artist's current style—that is, the *Tower* pictures of 1910, resulting from what was until then an unknown logic.[10]

What is this logic? "The tower vertiginously comes to life from a thousand notions which it has, and on the canvas rises up another tower of unexpected and variable proportions, beautiful. Intuitive, Delaunay has defined intuition as the brusque deflagration of all the reasonings accumulated each day. He paints as the people build." This summation of Delaunay's intentions goes further than what Metzinger wrote about Picasso; it directly relates the artist's pictorial concerns not only to a method involving different views of a thing, but also to the whole process of picture-making as a simulacrum for the quality of contemporary social thought, the fusion of a day's conceptions.

In fact, one may note overall in Metzinger's *Pan* article a distinct progression from Picasso to Braque, from Braque to Delaunay, and from Delaunay to Le Fauconnier. Each time Metzinger states and then restates the fundamental quality he discerns as held in common by the four artists—that is, simultaneity—he complicates and enriches it with the specific and individual contribution of each. Thus the discussion of Picasso properly belongs at the beginning because it is the simplest and clearest expression of the new painting: ". . . the picture is not to be a transposition or a diagram, in it we are to contemplate the sensible and living equivalent of an idea, the total image"— in short, the total image of a thing perceived from many points of view. With Braque the idea is complicated by the "learned confounding of the successive and the simultaneous," increasing the conceptual burden by distinguishing between sequential order and two or more things occurring at the same time. With Delaunay, the process is enlarged further to become the equivalent of the current epoch's approach to apprehension, to comprehension.

But Delaunay's art, although astonishing, is not alarming. That dubious distinction is left for Le Fauconnier, the last of the four artists discussed. Metzinger makes his largest generalizations with regard to Le Fauconnier, returning, in the structure of his short article, to the sweeping and shocking remarks with which he began—a final break with the tradition of the past and the creation of a genuinely modern art. Le Fauconnier is both "astonishing" and "alarming": "the astonishing indicates the accomplishment of an effort never yet accomplished, it

contains the idea of revelation; the alarming implies a distorted, vitiated comprehension of the past." This means that Le Fauconnier has a different understanding of the past:

Le Fauconnier situates his idea, inaccessible to those others, especially those who speak at length about order and style, in a vast equilibrium of numbers. Taking up again with impartiality the gifts of intelligence and the senses, he tolerates "a certain coefficient of naturalism," that which is necessary to satisfy the exigencies of a normal sensuality without shadowing the mind . . . he does not allow charm to usurp the space reserved for force, that any one of the terms of his ample formula exalts itself to the detriment of the others. An exact bond is forged in irreducible blocks of the constituent parts of the painting. Le Fauconnier attains the summation of evocatory power, the mode of beauty that he espouses is grandeur.

Only when one reads the whole article does it become clear that in the treatment of these four artists there is a progression from the specific to the universal, from the physical, the temporary, and the contemporary through an image of sequential time to an image of an entire period, to a final synthesis of the whole, including history, reduced to an elemental common denominator—"in a vast equilibrium of numbers." There is approximate symmetry in the conclusion of Metzinger's *Pan* article, almost the opposite of the way it began: "I do not doubt that tomorrow one will say . . . exuberant as a Delaunay, noble as a Le Fauconnier, beautiful as a Braque or as a Picasso." It is the greatest challenge to the modern painter not to "cancel" tradition, but to realize that it has been part of his formation, that "it is in us," acquired by living. This is why Metzinger and his colleagues are free "to leave the antique world to the archaeologists, the old coins to the numismatists." To the spatial displacements about which he began writing in connection with Picasso, the moving around an object, he adds now the cultural displacements of "Egypt, of the Greeks, of the Chinese," an enlargement of the concept of simultaneity in both a physical, geographical sense and a mental, cultural, and historical sense. It is the accumulation of the past in the present, the swelling of the present into the future that haunts him, and this is the gigantic task that Le Fauconnier has taken up. Metzinger reserved for last that aspect of modern painting which seemed to him most serious, most difficult, grandest.

Metzinger projects another notable quality in this earliest article to suggest the existence of a new kind of painting: a resolutely matter-of-fact attitude toward final answers. Anticipating the text of *Du «Cubisme»*, still two years from publication, Metzinger stakes out a commonsense position for Picasso, Braque, Delaunay, and Le Fauconnier:

They are too enlightened to believe in the stability of any system, even one called classical art, and at the same time they recognize in the most novel of their own creations the triumph of desires that are secular. Their reason holds the balance between the pursuit of the transient and the mania for the eternal . . . when, in order to defeat the deceptiveness of vision, they momentarily impose their domination on the external world. No Hegelian superstition invades their understanding.

Metzinger is comfortable with the Bergsonian notion of duration and sees it growing out of logical positivism: he is in no sense an idealist. There are no absolutes in his system: "Aphrodite, the Venus of museums, the archetype of formal perfection, no more than the figurines of Oceania, Christian demons, or the landscapes of Hiroshige crystallizes the absolute. Only the idleness of eroticisms makes its own eternity, a sign coming out of a dead language, the *Goddess* of marble is transformed into an abstract *Goddess*. I expect that she will go very far away from us to take her place in some sort of platonic hierarchy."

Before examining the paintings of Metzinger and those of his friends who have so long taken a back seat in the history of Cubism, a brief review of the Paris art world of 1909–10 seems in order, emphasizing the activities of the lesser-known masters and retrieving, when possible, the attitudes displayed toward them by other artists, by dealers, collectors, by writers and art critics. Each of the painters had an independent development, and when their paths crossed, they did not necessarily become friendly, still less fall under one another's influence. The relationships that existed among them ranged from close friendship to casual acquaintance, from early perception of shared artistic affinities to indifference, sometimes even hostility. We must be wary of assuming that because two men were friendly with a third that all three shared immediately an identity of outlook. Yet even in the sequence in which the web of friendships unfolded, there is evidence of the gradual dawning of an awareness, even an acceptance, a welcoming of group unity, a unity that reaches its apogee in 1912 and then begins to disintegrate.

We learn from the fragmentary memoirs of Metzinger, for example, that he became friendly with Apollinaire in 1907, having met him through Max Jacob.[11] During the previous two years, Metzinger had been very close to Robert Delaunay, the two having painted each other's portraits in 1906. They had even been linked together in their special variety of Divisionism by the critic Louis Chassevent, who set them apart from other Fauves and Neo-Impressionists at the 1906 Salon des Indépendants, remarking that "M. Robert Delaunay pushes his love of relief up to the point of fluctuation," and that "M. Metzinger is a mosaicist like Signac, but puts more precision in the cut of his cubes of color, which appear to have been fabricated by machine."[12]

For Chassevent in 1906 the word "cube" did not signify a movement in regard to the large, thickly painted, vibrating, and highly structured canvases of Delaunay and Metzinger; nor did the word "cubes" hold for Louis Vauxcelles any special meaning when he wrote two and a half years later, in November of 1908, a brief note about Braque, who was exhibiting landscapes at Kahnweiler's gallery: "He scorns forms, reduces all, sites and figures and houses, to geometric schemas, to cubes."[13] In neither case did the use of the word "cube" lead to the immediate identification of the artists with a new pictorial attitude, with a movement. The word was no more than an isolated descriptive epithet that, in both cases, was prompted by a visible passion for structure so assertive that the critics were wrenched, momentarily, from their habitual concentration on motifs and subjects, in which context their comments on drawing, color, tonality, and, only occasionally, conception, resided.

In his 1968 exhibition catalog *Neo-Impressionism* for the Guggenheim Museum, Robert Herbert published a passage by Metzinger reprinted by Georges Desvallières in *La Grande Revue*: "I ask of divided brushwork not the objective rendering of light, but irridescences and certain aspects of color still foreign to painting. I make a kind of chromatic versification and for syllables, I use strokes which, variable in quality, cannot differ in discussion without modifying the rhythm of a pictorial phraseology destined to translate the diverse emotions aroused by nature." In the same catalog entry, Herbert traced "the interesting history of the word 'cube'" back at least to May 1901 when Jean Beral, reviewing Cross's work at the Indépendants in *Art et littérature*, commented that "he uses a large and square pointillism, giving the impression of mosaic. One even wonders why the artist has not used cubes of solid

matter diversely colored: they would make pretty revetments."[14]

The passage by Metzinger as well as the early use of the word "cube" by different observers points to origins in Neo-Impressionist art and theory of some of the cardinal qualities of Cubism when it became recognized as a movement: the "fluctuant" aspects of color and form (to use Judkins's term)[15] and the connection with symbolist literary theory. It suggests a direct or perhaps indirect (through Gleizes) acquaintance with the theories of René Ghil, clearly and demonstrably shared by all those who had contact with the Abbaye de Créteil.[16]

When Delaunay was released from military service—where as a librarian he had developed a fondness for the poems of Jules Laforgue, Marcel Duchamp's favorite poet—his admiration for the character and art of Henri Rousseau, already begun in 1906 before he went into the army, led him into greater contact with the German collector-dealer Wilhelm Uhde. It was Uhde who had opened a small gallery on the rue Notre-Dame-des-Champs.[17] Uhde owned thirteen paintings by Braque, but there is no reason to believe that these paintings influenced Delaunay's style during 1907–08 any more than his admiration for Rousseau is manifest in his manner of painting.[18] Sonia Terk's marriage to Uhde in 1908, followed very soon by the love affair between Sonia and Robert Delaunay, permitted Delaunay to have a greater opportunity to know the paintings of Braque and Picasso and yet was almost immediately responsible for removing the lovers from the Uhde circle. By at least the summer of 1909, over a year before the Delaunay-Terk marriage, the two were chiefly occupied with each other.

Gleizes tells us in his *Souvenirs* that in 1910 "toward the end of the year," at Le Fauconnier's rue Visconti studio, when the painter was "step by step" elaborating "the famous *Abundance* which would figure in the Salon des Indépendants of 1911," he received "Metzinger, Delaunay and his wife Sonia [they were not married until November], Léger, Jean Marchand; the poets Paul Fort, Jules Romains [Sonia Delaunay's recollections date the meeting with Romains only to January 1912, when the Delaunays spent a month at Laon, where Romains (as Louis Farigole) was professor of philosophy at the lycée], Castiaux, Jouve, Arcos, Mercereau, Apollinaire, Allard, Salmon; the Douanier Rousseau came there each time and his candor was equalled only by his politeness."[19] Gleizes actually quotes an amusing exchange between Rousseau and Romains in which the naiveté and ignorance of Rousseau surfaced in an extraordinary way when he confused Rodin with the author of *Les Mystères de Paris*.[20] This could not have taken place in the fall of 1910 because Rousseau died on 4 September of that year. To complicate matters still further, Le Fauconnier's brother-in-law H. Sevin wrote in his unpublished biography that immediately after Le Fauconnier's return from the longest of his Ploumanach stays (1908–09), the artist left the rue Visconti for another atelier on the rue Notre-Dame-des-Champs "larger, less high up, more agreeable for living purposes."[21] If this was true, then Gleizes had a poor sense of the geography of Paris. Yet his description of the climb to the top floor of rue Visconti is sharp and detailed, and carries the ring of authenticity.

What these contradictions and ambiguities indicate is the virtual impossibility of relying exclusively on the certainty of external documentary evidence, especially based on recollections written long after events had occurred. This is especially true when we factor in details presented in Metzinger's memoirs, until now not part of the record.

In trying to reconstruct the precise sequence of meetings, of acquaintanceship, of friendship, of shared ideals, and finally of that most complex of questions, influence, one must be guided by judgment based on weighing all the factors, and the most certain is the evidence of the pictures themselves. When one compares, for example, Le Fauconnier's portrait of Paul Castiaux with Gleizes's portrait of his Uncle Robert (1910),[22] the influence is clear; moreover, the pictorial similarities fit into a general and acknowledged personal relationship. When one compares the 1908–09 work of Delaunay to that of Braque or Picasso, there is no self-evident specific relationship, not in handling of form, color, or choice of subject. On the other hand, there does appear to be a relationship, even a partial dependence, on 1910 Picasso in those few unlocated Metzinger works that are known from that year through photographs.

There is, however, and there had been since 1905 in the work of these young unestablished painters, a continual and restless search for new subjects and new methods. The methods grew out of the newly accepted attitude toward the function of painting and the recognition that its purpose was not to imitate nature but to express something appropriate to itself.

In the ateliers where, after the turn of the century, so many young artists learned their métier, the teaching was dominated by the Nabi painters. At the Académie Julian where, for example, Le Fauconnier had for studio comrades in 1905 Segonzac, Luc Albert Moreau, Boussingault, and Roger de la Fresnaye, Redon told the students that they were obliged to reinvent painting if it were to survive. The sense of anxiety—or lack of certitude, as Juliette Roche puts it[23]—proceeded from the common recognition that reproductive painting was dead; that painting had no longer a documentary function; that Impressionist painting was trivial; that lyrical or poetic painting was too slight to sustain itself; and that symbolism was arcane and inevitably limited, at least till the symbols invented by the artists might sufficiently impress themselves on the minds of observers to gain a degree of acceptance. The only truth left to these painters had been formulated years before by the Nabis, that painting had to do with what proceeded from the process of covering and dividing a plane surface.

In his memoirs, Metzinger writes sharply of the extent to which by 1907 even the subject of the demimonde, the world of cabaret, of Toulouse-Lautrec, was exhausted. No one, he writes, who lived on the Butte could any more enter the Moulin Rouge than they could look seriously at Puvis de Chavannes or read Balzac.[24] The last artist to wring urgent meaning from turn of the century fringe-life was Picasso in the *Demoiselles d'Avignon*. The lure of *l'art social* manifested in Steinlen, Valloton, or Lautrec, pursued during the first years of the century by Gleizes and Villon was, according to Metzinger, clearly and widely recognized as a dead end by 1907–08. Only the problem of structure remained as a palpable certainty for painting. If there was a way out of the impasse, it had to lie in this direction.

Yet, despite his close relations with Metzinger, Delaunay did not meet and become friendly with Apollinaire till 1911![25] This is perhaps because Delaunay began his military service in the fall of 1907.

We also learn from the memoirs of Metzinger that he and Gleizes had met as early as the spring of 1906, when Gleizes admired his paintings at the Salon des Indépendants. This conflicts with Gleizes's recollections. Gleizes tells us in his *Souvenirs* that it was not until 1910 that he met Jean Metzinger and Robert Delaunay, the intermediary being Alexandre Mercereau, whom Gleizes had known intimately since 1905, and whom Le Fauconnier had known at least well enough to invite to dinner at his studio by 1906.[26] Yet Gleizes, although noting an evening "of haschisch" at rue du Delta in 1908, at which Le

Fauconnier was present, also wrote that it was not until the spring of 1909 that he realized that Le Fauconnier was an artist struggling with problems similar to his own and, indeed, further along toward their solution, prompting him to seek out his conversation and friendship.

Metzinger noted: "I had exhibited in the Serres du Cours-la-Reine several paintings where the care not to alter the picture surface was strongly professed." He continued by pointing out that this concern was not so far removed from what interested most other painters that he didn't expect his efforts to be understood, or even noticed. Thus, he wrote, he was "joyously surprised" by Gleizes's "spontaneous sympathy."

"Albert Gleizes did not know Montmartre, had never seen a Picasso or Juan Gris, never heard Maurice Princet construct an infinity of different spaces for the use of painters . . ." After quoting a Gleizes comment likening to counterfeiting the trompe l'oeil effect of painting a ball on a vertical and rigorously flat surface, Metzinger wrote that "in 1906 Gleizes foretold Cubism, and condemned in anticipation those who would see in it only the application of a word of order."

We know that as early as 1905 Delaunay had established an enduring friendship with the American painter Samuel Halpert and had even gone to Brittany with him.[27] Halpert is known to have been a visitor to the Abbaye de Créteil in the summer of 1907 and even to have participated in Abbaye exhibitions along with Gleizes, Brancusi, Henri Doucet, Umberto Brunelleschi, and others, yet there is no reason to believe that, as yet, these intertwining acquaintances led to any definite or urgent sense of common purpose. While living in Montmartre, Metzinger knew and admired the work of Picasso and was friendly with the insurance actuary and amateur mathematician Maurice Princet. His own passion at the lycée in Nantes had been mathematics, and he was prepared to understand the imaginative possibilities of non-Euclidian geometry as developed by Princet, who, he wrote, "loved to interest the painters in the new views on space opened up by Victor Schlegel and several others."[28] Metzinger reports that Princet marveled at how rapidly Picasso understood him, when by contrast Matisse could barely get through "a work of vulgarization" on hyperspace. But Metzinger was not astonished, remarking that it was Picasso's tradition that prepared him so well to understand a problem of structure. Princet, however, did not meet Delaunay until 1911, when he became so enamored of his work that he wrote the introduction to the catalog for Delaunay's exhibition in late February 1912 at the Galerie Barbazanges, an exhibition shared with Marie Laurencin. In the introduction, he did not write about multi-dimensions or hyperspace, but only about Delaunay's temperament, energy, ideas, and technique. Gleizes knew nothing of Picasso, Princet, or, as Metzinger wrote, "anyone in Montmartre." Yet, when Gleizes led Metzinger back to his studio in Courbevoie (probably in the spring of 1909),[29] he is said to have expressed such a respect for the "vertical and rigorously plane surface" of the canvas that he allegedly invoked Pascal to protest those painters who violated it by producing a sense of relief.[30]

If every talented young painter in Paris had more or less reached the same conclusions about the bankruptcy of motifs by 1907–08, and if the review of their biographies and memoirs produces repetition of similar anxieties and dozens of conflicting tales about specific points of juncture, where are we to look for an understanding of how Cubism began, and what it meant to contemporary artists and society?

It seems reasonable to look at that evidence which points to a period of time when a group of painters and a number of writers on art realized that a new track had opened. One might

try to clarify what method and intention united a large group of painters known to be in regular contact with one another. Thus the problem is not who invented Cubism, whether this one or that one understood a technique that after all took some years to develop, but rather why it was that a particular pictorial attitude, which subsequently became known as Cubism to the contemporary public and hence to history, apparently solved—at least for a time—that sense of unease about the function of painting that haunted so many young artists during the first decade of the century.

With some precision it can be said that this span of time began about mid-March of 1910. Here, for the first time at the Salon des Indépendants, five independent artists whose paintings were not hung together made an impression not only on each other but on the critics as well. The artists were Le Fauconnier, who showed four works; Metzinger, who showed three landscapes, one still life, one nude, and a portrait of Guillaume Apollinaire; Delaunay, who showed three works; Gleizes, who exhibited five works; and Léger, who was represented by five works.[31]

We have an accumulation of evidence that suggests that all of these painters knew each other by the late winter of 1910, but that only one of them—Metzinger—had familiarity with the work of Picasso and Braque. From what we know of the work (the Le Fauconniers, the Gleizes, and the Delaunays can all be identified; the Metzingers and the Légers cannot, except for Metzinger's nude and the portrait of Apollinaire), one can state with some assurance that each artist was different, and that the only one whose work bore a resemblance to Braque's or Picasso's was Metzinger.[32]

When Vauxcelles wrote his initial review of this twenty-sixth Salon des Indépendants, he made a passing and imprecise reference to these painters as "ignorant geometers, reducing the human body, the site, to pallid cubes."[33] In his opening account of the same salon, Apollinaire initially remarks "with joy" that the general sense of the salon—which contained 6,000 works—signifies "déroute de l'impressionnisme."[34] In the habitual fashion of salon critics, he had promenaded through the exhibition, stopping in front of paintings that offered particular interest. He merely mentions his own portrait by Metzinger, "the portrait of your servant," but of the *Nude* he comments, "a nude woman solidly constructed—others would say built like a wall." He uses the word "maçonnée," which has two related meanings, that of blocks or cubes of masonry, stonework, and also, in slang, the connotation of messing-up or bungling, thus cleverly showing an awareness of the pejorative tone with which similar isolated uses of words referring to geometric constructions had been used. But Apollinaire was not yet ready to make a general observation linking the five artists in whose work this tendency to construct dominates. Indeed, except for the double entendre of "maçonnée," implying that others will not like the work for precisely the reasons that he, Apollinaire, finds it interesting, the terms in which he discusses Metzinger are not very different from the constructive cubes noted by Chassevent in 1906 or those noted by Vauxcelles in 1908 in connection with Braque—description that emphasizes a structural, geometric, even mechanical method. Yet, "Metzinger aims high. He undertakes—a little coldly perhaps—tasks from which not many masters would be able to extricate themselves. His art is never petty." Apollinaire (again, like Chassevent) immediately compares Metzinger to Delaunay, whom he feels has not gone so far. Yet he writes—not specifying the paintings—that they are "solidly painted" even if they have "the unfortunate air of commemorating an earthquake." Two paragraphs further he signals "the large fig-

ures of Le Fauconnier who orients his studies on the side of nobility and majesty, even going so far as to sacrifice beauty."[35]

Continuing, Apollinaire mentions in passing Jean Crotti, who does not use pointillist theory to obtain pure tones, but only to lend a chic appearance to his work; Maurice Marinot, who seeks decorative effects; and Duchamp, whose nude he found "very unpleasant." Like Vauxcelles, but with an open mind and vivid imagination, Apollinaire searches the salon for mood and conception. He notes in Room 19 Henri Doucet, "whose dancers at a Montmartre Bal and miserable portraits will separate him forever, I hope, from his old friends of Abbaye." In Room 26, he takes note of Albert Gleizes's portrait of the poet Arcos. He merely says that he prefers the landscape of Gleizes (he means *The Tree*) to this portrait. Finally he links Segonzac and Mlle. Maroussia as opposites in their use of color and size: Segonzac "uselessly" employs a great deal of both, while Maroussia "paints with sobriety, searches for expression and force, but a little to the detriment of beauty." Then he notes that probably Maroussia will not appreciate that remark, for another "proud artist" (that is, Le Fauconnier), about whom he had written something analogous, took it as a criticism. He does not discuss Léger.

In summing up the ensemble in his article of 22 March, Apollinaire states that the principal tendency of the young artists is for composition. While observing that many different means were used, he concludes: "One has never seen so systematic an art, or so many different artistic systems."

This search for system, for structure, is exactly what Gleizes stresses in his *Souvenirs*. He had been trying for several years to treat the elements of his art—drawing, lines, volume—as "independent of that which they could represent."[36] Lines, volumes, densities and weight, symmetrical equilibrium of the parts—these were his preoccupations and, he says, those of Le Fauconnier, with whom he had become friendly in early 1909. The geometric, skinned look of their work was a consequence of this stress on structure:

I understood that up until then I had taken for an end what was only an invitation to manifest on the [picture] plane another order, that of painting, an action provoked by its own laws and provoking a delectation by itself. I drew schemas of landscapes and figures, recognizing a quid pro quo between two attitudes, one where the "subject" served as a base of departure for the painted work, the other where the pictural "object" transmitted as soon as its component parts [developed] and determined the modifications of a subject.

Gleizes was looking for others who had developed the same degree of consciousness with regard to the necessity of radical reversal of the positions of subject and object. He singled out Metzinger and Delaunay whom, he wrote, he met at Mercereau's only in 1910. (As we have seen, Metzinger puts the date earlier—1906—probably meaning 1909.) Gleizes says that he knew the work of Delaunay and Metzinger only vaguely: "I had scarcely seen their exhibition together at the Indépendants where I too had exhibited." This is an interesting slip in memory, for Metzinger and Delaunay were hung together in Room 18, but not as an "exposition ensemble." The same arrangement had occurred in 1906. Had they some influence with the hanging committee? Gleizes continues: "I had read especially a *compte rendu* that had struck me, written by Jean Metzinger for a young literary review, *Pan*." But this article, in fact, was *not*, as Gleizes implies, a *compte rendu* of the Indépendants of 1910, but the "Note on Painting" written in September that appeared in the October-November issue. It was, if anything, prompted by the Salon d'Automne where the affinities among Le Fauconnier and Delaunay, who exhibited, and Picasso and Braque, who did not, were discussed. It was

only at the Salon d'Automne of 1910 that a review linked to a specific group of artists the geometric or systemic tendency so often noted either as a general salon phenomenon or, alternatively, in connection with passing observations about individual artists. As Gleizes puts it in his *Souvenirs*:

With no intention to manifest in favor of whatever, the placement committee hung Metzinger in a corner of a peripheral corridor, and in the neighboring room, Le Fauconnier and me. Near us was Jean Marchand. Jean Metzinger had sent a canvas entitled *Nu à la cheminée* [lost],[37] Le Fauconnier, two landscapes of Ploumanach,[38] me, a landscape of the environs of Paris[39] and a very geometricized drawing. In fact, among our canvases there were only rather distant rapports. The most audacious was certainly that of Metzinger. Nevertheless, their kinship escaped neither the placers nor certain journalists . . .

Gleizes quotes from *La Presse*, wherein a hostile journalist acknowledges the impact made by "the geometric follies of Messieurs Le Fauconnier, Metzinger and Gleizes."[40]

Apollinaire's initial treatment of the salon that for Gleizes finally awakened a sense of group recognition still failed—by comparison with the review in *La Presse*—to unite the artists. His articles in *L'Intransigeant* begin with the observation that the Salon d'Automne of 1910 (at which Matisse showed *La Danse* and *La Musique*) furnished few surprises. He links Metzinger and Le Fauconnier only by treating them in successive paragraphs and administers to each a slap on the wrist.

In a corner, one could almost say in penitence, they have hung the two canvases of Jean Metzinger, who has set himself the task of experimenting with all the procedures of contemporary painting. This is perhaps to lose precious time and to dissipate his energy without profit. One sees this in these examples which appear to me to be a retreat for the artist. When one has chosen a way, it should be held. It is sad to see a cultivated painter waste himself in sterile efforts.
Le Fauconnier has painted in gray tones, very difficult, a landscape very well conceived, if not very well constructed.

The articles in *L'Intransigeant* do not mention Gleizes and Léger.

However, in a later and much shorter account of the Salon d'Automne that appeared in the fall number of *Poésie*, a Parisian quarterly, Apollinaire changed his attitude about the salon. First, he praised Matisse highly, claiming that he alone had consistently defended him. Then, he singled out the eight paintings of Maurice Denis's Decameron series—which he had utterly dismissed in *L'Intransigeant*: "In obstinately wishing purity . . . Denis has only wound up queer." Apollinaire now qualified these works as the most important of the entire salon.[41]

Finally he noted that some important artists "like M. André Derain, Marie Laurencin, Puy, etc., have not shown. Some have spoken of a bizarre manifestation of Cubism. Badly informed journalists have finished up by seeing there a metaphysics of the plastic arts. But, it is not that, it is only a flat imitation, without vigor, of works not shown and painted by an artist gifted with a strong personality, and who, moreover, has delivered his secrets to nobody. This great artist is named Pablo Picasso. But the Cubism at the Salon d'Automne is only the jackdaw in borrowed feathers." (Here is the source of the metaphor Douglas Cooper used for Metzinger in his 1970 account.)

This spirited reaction in a quarterly was probably the first time that the word *Cubism* was used not only in relation to the group movement at the salon, but also in relation to Picasso. Previously, as we have seen, the word "cube" had been employed always in the context of particular motifs being reduced to cubes, that is, as a code for geometric structure dominating

motif, and in connection with Metzinger, Delaunay, and Braque in 1906 and 1908, and then in 1910, at the Indépendants, in connection with Gleizes, Le Fauconnier, Metzinger, and Delaunay. As far as we can discover, however, no other journalist wrote about "Cubism"—only about the geometric follies of Metzinger, Le Fauconnier, and Gleizes. As far as approaching a "metaphysics" for this movement, the only author who seriously attempted to define the significance of this new tendency, other than Metzinger, was Roger Allard in an important article, "Au Salon d'Automne du Paris," in the November issue of *L'Art libre*.[42]

This is not to suggest that other journalists, critics, poets, painters, and even the public might not have been talking about Cubism. Nevertheless, if the word as a descriptive term for a movement had any currency before the spring of 1911, it could only have been in conversation in the wake of the 1910 Salon d'Automne. Allard, like Metzinger, does not refer to Cubism. His article, appearing at approximately the same time as Metzinger's in *Pan*, is very important because it attempts to define the conditions that govern a new direction, a fresh departure, while it also describes the commentary provoked by the exhibited works.

Plunging right into the salon, Allard poses the crucial issue: what is new? Every work at the exhibition, the Girieud *Bathers* he somewhat admires, the Bourdelle *Carpeaux* that he dislikes, pales before the principal question.

Metzinger, H. Le Fauconnier, and Albert Gleizes, the first especially, have been for the public whose notion of greatness is so distorted . . . a generous mine for [mirthmaking] amusing commentary. However, it seemed to me that the rose-colored trees and orange meadows of yesterday brought out even more bile, or even better stimulated the laughter of those rubber necks, depending on their temperaments. The deformation of lines, except those of the human face, seems to provoke on the nervous cells of people of all sorts somewhat less of a reaction. The prejudices of form are therefore less assured; this augurs well for the innovators—as follows: Metzinger's nude and his landscape are ruled by an equal striving for fragmentary synthesis. No usual cliché from the aesthetic vocabulary fits the art of this disconcerting painter. Consider the elements of his nude: a woman, a clock, an armchair, a table, a vase with flowers . . . such, at least, is an account of my personal inventory. The head whose expression is very noble is rendered formally, and the artist seems to have drawn back from the integral application of his law.

That is, in the treatment of the head Metzinger retreats (*recule*) from the bold ideas set forth in the rest of the painting.

In reality, a painting by Metzinger has the ambition to sum up all the plastic matter of an aspect, *and nothing else*. Thus is born, at the antipodes from Impressionism, an art that, caring little to copy on occasional cosmic episode, offers to the intelligence of the spectator, in their pictorial fullness, the essential elements of a synthesis situated in time. The analytical kinships among objects and their mutual subordinations will be henceforth of little importance, since they will be suppressed in the painted realization. These come into play later, subjectively, in each individual's mental realization.[43]

The importance of Allard's understanding of the genuine innovation visible at the salon is hard to overestimate. He goes well beyond Metzinger's emphasis in the *Pan* article on multiple points of view, that is, beyond the technical innovations of the new painting. He penetrates to its intellectual core: an art capable of synthesizing a reality in the mind of the observer, one based on the modern concept of the process of thought. Synthesis is both the method of the new painting and its aim. The process is analogous to Creative Evolution, that is, not only to Bergson's notion of the assimilation of experience in duration, but to the equally important idea that such a process is creative. The first exposition of the true significance of the new art is achieved in connection with the art of Jean Metzinger.

Allard's article went even further. He wrote that the art of Le Fauconnier "proceeded from analogous formulas." But their application in the particular case of landscape is somewhat accommodated to a deference to our visual servitudes. From this gray decor of rocks at Ploumanach emanates a wise invitation: enough of displays, of "visions that impose themselves violently," of "pulsating slices of life"—enough of notations and of anecdote.

"A beautiful painting is only an exact equilibrium, that is to say, an accord of weights and a relationship of numbers." This statement indicates that Allard was familiar with Le Fauconnier's text "Das Kunstwerk" published in September 1910 as a foreword to the Munich NKV exhibition; not only the sense, but the wording is similar. We found in Metzinger's article in *Pan* the same encounter with numbers.

Here then is the likely candidate for the article on plastic "metaphysics" that drew fire from Apollinaire because no awareness was shown of Picasso, no acknowledgment, in an exegesis of the new painting so complete as to be almost a manifesto. But, as Fry observed, in 1910 Allard did not know Picasso or Braque, nor for that matter did Le Fauconnier or Gleizes.

According to Gleizes it was only from the beginning of the Salon d'Automne "that we seriously discovered one another."[44] The group consisted of Gleizes, Le Fauconnier, Metzinger, Delaunay, and Léger, "whose acquaintance we made in that period." The order of mutual acquaintance is as follows: Gleizes and Le Fauconnier met as early as 1908, but became close friends only in the spring of 1909; Gleizes and Metzinger met as early as the Indépendants of 1909 (according to Metzinger's memoirs); Metzinger and Delaunay were friendly and already linked before 1906; and Léger was already familiar with Le Fauconnier and Delaunay by 1907,[45] but had not met or become interested in Gleizes till 1910.

Gleizes describes what happened next: "And we understood what affinities brought us together. The interest to visit each other, to exchange ideas, to make a block appeared imperious. Going to each other's studios we perceived the degree to which our aspirations were close."

In *Souvenirs*, Gleizes briefly but systematically reviews the positions of each of his new friends as of the fall of 1910. Each, he says, had sought a means of finding a way beyond Impressionism. As a consequence, Metzinger and Delaunay had worked "in the spirit of Divisionism. Le Fauconnier had been impressed by Matisse. Léger, after studying at the Ecole des Beaux-Arts . . . in his turn had begun painting in an Impressionist manner."[46] One of the major topics of conversation among these friends, according to Gleizes, was the discussion of those masters from the past whose work held the most meaning for them. Their discussion of older masters was always qualified by a twofold assumption: that the specific techniques, "secrets de métier," of past artists corresponded to mental attitudes that also were past and irrecoverable, and that nevertheless there were certain values pertaining alone to the process of painting that might be rediscovered. "With passion and disinterest," that is, in an atmosphere of scientific investigation, the young painters "consecrated themselves to discover these lost values." Continuing his account of late 1910, Gleizes comments: "The masters who appeared most likely to furnish the link between us and the masters of the Renaissance were David and Ingres. . . . How many conversations took place among us apropos of these great ancestors, how many

times we endeavored to guess at the genesis of their works! What diagrams we would develop in order to penetrate them! Our schemas are visible in the canvases that we were painting at that time."

Summing up, he says: "1910 was the year when, in the last months, there joined together a kind of coherent group that represented certain precise tendencies for our generation, until then scattered. From the painters who met one another, joined by poets, sympathies were created, an ambience was formed that was soon going to determine an action the effects of which would not be long in being felt outside [the circle]. Painters and writers went forward shoulder to shoulder, animated by a sense of sharing the same faith."

John Golding's account of the first Cubist manifestation, that is, the first exhibition during which other painters, writers, and the large art public encountered and spoke about Cubism, is based largely on the *Souvenirs* of Gleizes.[47] It remains an excellent summary of the events leading up to the opening of the 1911 Indépendants, and captures much of the excitement provoked by the effect of the paintings of the group hanging together. However, by ascribing motivations to the poets, and in particular by suggesting what Apollinaire and Salmon had in mind because they "realized that Picasso's latest style contained the elements of a new art,"[48] Golding's recapitulation of Gleizes's account of the 1911 Salon des Indépendants is somewhat distorted.

Subsequent understanding of the events is similarly distorted. Gleizes specifically cites Apollinaire, Salmon, and Allard as participants in the discussions at the Closerie des Lilas that led to the idea that the five painters who discovered their affinities in the fall of 1910 ought to make an effort to reconstitute the hanging committee of the 1911 salon. There is, however, every indication that the painters reached this conclusion only because they feared that "in all probability we would be dispersed to the four corners of the salon and the effect produced on the public by a group movement would be lost. It was necessary that it be produced. We had to be grouped; this was the opinion of all."

There is not the least hint that Gleizes or his friends (except for Metzinger, whose article in *Pan* had been the first to link the two groups of painters) suspected that the affinities they had only recently discovered among themselves extended even further. The implication that Salmon and Apollinaire saw an art derived from Picasso in the work of Metzinger, Le Fauconnier, Gleizes, Delaunay, and Léger has been based on the note written by Apollinaire in the autumn 1910 issue of *Poésie*, already noted above.[49] Countering "some badly informed journalists" who were seeing a metaphysics of plasticity and beginning to "speak of a bizarre manifestation of Cubism," Apollinaire wrote—in this, his first use of the term "Cubism"—that the Cubism of the Salon d'Automne of 1910 was but "a pale imitation, without vigor, of works not exhibited" and painted by Picasso. In April 1911, in his passionate defense of the artists exhibiting in Room 41, he seems at pains to shun the word, using it but once in connection with Metzinger who "is here the only one adept at Cubism proper." It is important to note that the definition he provided at this point in connection with Metzinger is extremely close to that already published by Metzinger himself in *Pan* and by Allard in *L'Art libre*. Apollinaire wrote, "This cinematic art in some ways has for its goal to show us plastic truth under all its faces without renouncing it for the benefit of perspective." A few lines earlier, in the same article, he had insisted that Room 41 was, with Room 43, the most interesting of the Salon des Indépendants, and asked why "all my colleagues, the writers on art, neglect it." (This was

patently untrue, but Apollinaire wanted to be the exclusive spokesman for the new art.) He wrote:

One finds here, however, with more force than anywhere else, not only at the Indépendants but without doubt in the entire world, the mark of the epoch, the modern style. . . . It shapes up at this moment as a bare and sober art where sometimes still rigid appearances will not long wait to humanize themselves. One will speak later of the influence in these works of a Picasso in the development of so new an art. *But the influences that one is able to find in it include also the most noble epochs of French and Italian art, which takes away nothing from the merits of these new painters.* (Emphasis added)

We see in the ideas introduced here by Apollinaire, which he would develop further in his foreword to the June exhibition of the Cubists in Brussels, the beginning of an expanded definition of what the new art is about, an idea in agreement with the recollections of Gleizes, who stressed the long deliberations among his friends on the masters who intervened between the present (1911) and the artists of the Renaissance.

One may also observe that Apollinaire generally tended to be more enthusiastic about the Salon des Indépendants than the juried Salon d'Automne, which often rejected work by his friends among the new artists, to the point where, for example, Delaunay refused to submit work after the refusal of his *Manège* in 1906. It was in this connection that Apollinaire wrote in 1911 that Room 8 was surely the key to the Salon d'Automne, calling it the "room of the Cubists," though pointing out how much stronger it would have been had Delaunay and Marie Laurencin been included, as well as others "who are scarcely spoken of," but "whose influence however makes itself felt: Picasso, Derain, Braque, Dufy." This brief passage is also the first occasion on which Apollinaire mentions Braque, by implication only, in connection with the new Cubism of 1911.

It is extraordinary that Apollinaire, who had actually written the preface to the catalog for Braque's November 1908 exhibition at Kahnweiler's gallery, did not mention Braque's parallel effort sooner and in stronger terms—had he perceived them as strongly analogous—but almost consistently he confused Braque's contribution with Picasso's. This he did most glaringly in October 1911, when again praising the artists showing in Room 8, "known by the denomination of Cubists." He wrote, "In 1908 one saw several paintings of Picasso where there were some houses simply and firmly drawn, giving to the public the illusion of cubes, from which comes the name of our youngest school of painting."[50] Apollinaire was emphasizing that "Cubism is not, as is generally thought by the public, the art of painting in the form of cubes." He recalled Braque's 1908 paintings of houses suggesting the illusion of cubes—but so vaguely did he remember them that he noted them as the work of Picasso! In mentioning them, he might have been implying by the juxtaposition of his sentences that the simplistic relationship between cubes and the young school of painting not only was false and misleading, but also kept one from understanding what the new painting was really concerned with: "In its case, Cubism is in no way a system, but it does form a school, and the painters who compose it wish to renew their art in returning to the principles that concern drawing and *inspiration*, even as the Fauves—and many of the Cubists had been part of this school—had returned to principles with regard to color and composition." Here too, Apollinaire was setting the stage for the true definition of the new painting and restating—as we shall presently see—the major ideas that developed in connection with his acceptance of the term Cubism in his preface to the catalog for the Brussels exhibition of June.

Even beyond the impact they wished to ensure by having their works hung together, Gleizes suggests that "This idea of grouping by tendencies could only serve the interests of *all* the young painters and give back to the salon its contentious excitement, which was in the spirit of its founders. The scattering and the disorder of the preceding years, despite the rare, occasionally well-organized, room had made of the salon a kind of flea market without significance." Gleizes touches here on a very important but insufficiently considered factor in the evolution of how art comes to the attention of the public, an awareness that in his case was conditioned by prior experience in the popular university movement and by the Abbaye de Créteil—that is, he regarded it as the proper business of interested groups to effect change and to control their own affairs. He believed in the salon. He had a suspicion of dealers. In the *Souvenirs*, he goes on to say:

It would be necessary therefore to win a general majority in the course of the meeting of the members when they assembled to elect the hanging committee for the exhibition of 1911.

We had a list of candidates printed among which, of course, we figured, but established with care and fairness. On this list were André Lhote, Segonzac, La Fresnaye, Berthold Mahn, Jean Marchand, and some other painters whom we knew more or less but who appeared to us susceptible to represent if not a tendency then at least a set of values. And then we thought to display a number of announcements during the course of the meeting, clearly carrying our claims, where the names of the candidates whom we were proposing would be able to make a great impression. The wording of these bulletins was decided in common agreement with our literary friends: "Young painters you are misrepresented. Article 13 is denounced. Vote for the hanging committee with the following names and the salon will be organized according to your interests." We painted five or six posters on large sheets of paper.

The evening of the meeting, in a vast hall on the boulevard Raspail in front of a large crowd, the committee presented its report and the president announced that they would move to vote for the next hanging committee. The committee proposed a list, but the character of the bulletins distributed at the entry had alerted them. It foreshadowed a storm, and they sought to divert it. I still see Lebasque [Henri Lebasque, 1865–1937] struggling like the very devil on the platform. The tumultuous atmosphere reached the rafters when the posters were displayed. They had their effect on a large number of the *sociétaires*, and the opposition was obliged to accept the election with the new lists. Things unfolded in the ineluctable way that had been foreshadowed. The voting was not going to be by the customary procedure, as the officers at the ballot boxes had given up all control. Never had plural voting more honor. One voted, left, and then returned to vote again. The bulletins were thrown into the ballot boxes in packets! The monitors made no effort to oppose anything. When this operation was over, we went on to the opening and the count. It didn't matter who did it. We were chosen and scarcely had the collation of the votes begun than the officers, Signac at their head, left and went to bed. We remained there until 2:00 A.M. exhausted, but the battle had been won. Our list had carried by a majority which passed by a good deal the number of voters. Metzinger, as Maximilien Luce would recall to him at the next year's general assembly, was elected by more than 500 votes, out of three hundred and fifty voters! And all the candidates on our list won with majorities on this order. Moreover, no one protested. The committee took it in good humor and bore us no resentment. To such a degree that when the hanging committee assembled, it unanimously named Le Fauconnier as president.

Thus we were able to stand out clearly. We made two sections of exhibitors, at the head of one was Signac and Luce, and the other was composed of artists of the new generation. On one side of the central hall all the rooms were filled with older artists, on the other side, the young artists took on the responsibility to organize the rooms that had fallen to them. For our part, we took Room 41. André Lhote, Segonzac, La Fresnaye, etc., were going to place themselves in the next.

In Room 41, we grouped ourselves, Le Fauconnier, Léger, Delaunay, Metzinger, and me, and we added at the request of Guillaume Apollinaire, who followed this organization with the liveliest interest, Marie Laurencin.

Le Fauconnier showed his large *Abundance*. Léger his *Nudes in a Landscape* where the volumes were treated according to the process of progressively diminishing zones employed in architecture or mechanical models. Delaunay, *The Eiffel Tower* and *The City*. Metzinger, [*Landscape, Nude*, head of a woman, and a still life]. Marie Laurencin, some figure paintings. Me, two landscapes and two figure paintings, *Woman with Phlox* and *Nude Man Leaving His Bath*.

There, very exactly, was the composition of Room 41 at the 1911 Indépendants. In the next room, if my memory is correct, were found Lhote, Segonzac, Moreau.

Although Gleizes's *Souvenirs* was also the source of Golding's account of the general reaction to this Cubist salon of 1911, his autobiographical text contains numerous details and nuances of interest. Golding wrote, "Even without the works of Picasso and Braque the public saw in this manifestation a new departure in art." If we read the original text without regard for history's subsequent identification of Cubism almost entirely with Picasso and Braque, a clear sense of surprise emerges.

During the several days that the hanging was going on, nothing would have indicated the effect our paintings were going to produce on the public. There was evident interest from the painters and critics who walked among the canvases, interest either for or against. But no one would have been able to think that they could provoke a scandal. And we were the first who would never have wished it. At that period one still had a modesty about one's acts, and the fact of exhibiting paintings conceived in a spirit a little different from that of most, did not in any way indicate an intention to stir up the crowds. So, our surprise was great when on the day of the vernissage an explosion was produced.

I arrived at the Cours-la-Reine around 4:00 P.M., the opening of the show having been at 2 o'clock. It was a marvelous spring day in Paris, sunny and warm. I walked across the first rooms, which were not especially crowded. But as I advanced, the crowd became more dense, and finally I met my friends who had arrived earlier than I, and they let me know what was going on. "They are crushed into our room, they cry, laugh, they are indignant, they protest, they indulge in all sorts of manifestations; they push about on the edges to get in, and there are violent disputes between those who approve, defending our position, and those who condemn it." We could understand nothing of it. All afternoon it was like that. Room 41 was always full. We went to the exhibition cafe and calmly waited for things to turn out. At 5:00 P.M. *L'Intransigeant* appeared with an article by Guillaume Apollinaire. He underlined the importance of our manifestation and defended us passionately. In the dailies that appeared next morning, the most easily alarmed—Louis Vauxcelles of *Gil Blas*—attacked us with astonishing violence; the youngest critics, those who held forth in *Comedia, Excelsior, Action, L'Oeuvre*, etc., were more reserved, some welcoming us with sympathy; in *Paris Journal*, André Salmon, a poet and free spirit, wrote an account full of intelligence and sensitivity. In sum, we were at the center of violently taken positions, by the old guard of criticism as much as the young, who in principle, agreed with us. And that was the essential thing.

It was from that day of the vernissage of 1911 that the appellation of "Cubism" dates. People have searched to find a godfather for it and to establish for it an anteriority of two or three years, but these efforts seem to me unavailing of the fact that during those years neither Picasso nor Braque were called Cubists. On the other hand, what is demonstrable is that after 1911, the epithet became current money and, at first reserved for the painters of Room 41, was next attributed to those who, whether near or far, appeared to approach them by appearance if not by spirit. Apollinaire himself was at first reticent to use the appellation and it was only some time after that vernissage of the Indépendants, through an exhibition we were having at Brussels (in the early summer of 1911), that he definitively accepted for himself and for us the *vocable* Cubism by which, ironically, our enemies and our friends designated us. In 1911 the word cubism was born as in 1872 [*sic*] the word impressionism. The painters had nothing to do with it.

Alas! It was not going to be like that for very long, and "isms" were soon going to multiply by the desires of artists seeking more to attract attention to themselves than to realize serious works. Overnight we had become famous. Almost unknown the night before, a hundred mouths hawked our names, not only in Paris, but in the provinces, and in foreign countries. Not only our names, but our portraits. To satisfy general curiosity with regard to us had become one of the cares of the newspapers. Painting that up until then touched only a small number of amateurs, passed into the public domain, and each and every one wanted to be informed, put in the secret of these paintings which, it seemed, represented nothing at all, where it was necessary to guess, as in a rebus, what they signified.

The next step, as Gleizes suggests, was the capitulation of the painters to the foolish name "Cubism," now being used to describe their efforts whether they liked it or not, whether it was truly apt or not. Because of the scandal provoked at the Indépendants of 1911, a movement in painting—Cubism—was now acknowledged to exist. It had been created during the previous two years, in part internally, out of the genuine but still diverse concerns of a group of five artists in continuous communication with one another, but not with Picasso and Braque; yet it was also, and in perhaps larger measure, imposed externally by scandal-mongering journalists who wished to create sensational news.

In his *Souvenirs*, Gleizes continues:

Each year the Belgian independent painters invited several foreign painters. After the [Salon des] Indépendants [Paris, 1911] we were asked to participate in their next exhibition. They grouped us in a particular room and asked Guillaume Apollinaire if he wanted to come to Brussels to give a lecture on us. It was on this occasion that Guillaume picked up the appellation of "Cubists," which had been bestowed on us without our having asked for it, and accepted definitively that the word "Cubism" covered the new aspect of painting that was coming into existence.

The Eighth Annual Salon of the Belgian Indépendants—the Cercle d'art—took place from 10 June to 3 July 1911 in Brussels.[51]

The preface by Apollinaire to the exhibition catalog, presumably related to his lecture, is short and to the point. It represents a major effort to define Cubism, and it provided Apollinaire with many of the ideas, even the sentences, that he was to use over again in his subsequent discussion of the 1911 Paris Salon d'Automne in October.[52]

The new painters who together manifested their artistic ideal this year at the Salon des Artistes Indépendants, accept the name of Cubists that has been given to them.

However, Cubism is not a system, and the differences that characterize not only the talent but even the manner of these artists are an obvious proof.

One trait unites them, however; if the painters that one called the Fauves had, as their principal merit, to return to principles that concern color and composition, the Cubists—to extend still further the domain of an art thus renewed—have wished to return to the principles that concern drawing and inspiration. If I add that most of the Cubists had been formerly counted among the Fauves, I will show the extent of the road covered in so little time by these young artists, and the logic of their conceptions.

From these two artistic movements, which are successive and combine so well, *there has issued a simple and noble art, expressive and measured, ardent in striving for beauty, and ready to approach those vast subjects which the painters of yesterday did not dare undertake, abandoning them to the presumptuous daubers, boring and without style, of the official Salons.* (Emphasis added)

I believe I have given in a few words the true sense of Cubism: a new and very elevated manifestation of art, but not a system constraining talents.

Moreover, it would make no sense that at a time when scientists and thinkers abandon systems, artists would wish to give themselves to these dangerous games.

Archipenko, Delaunay, Segonzac, Gleizes, Le Fauconnier, Léger, Marchand, Lewitska, Luc Albert Moreau—these were the Parisian artists from Room 41 or adjacent rooms who exhibited at Brussels.[53] But Jean Metzinger, who had been termed "the Emperor of Cubism" that spring in Paris, was not among the exhibitors.[54] Why was Jean Metzinger not represented? It seems very unlikely that he was not invited. Did he, in fact, as Golding suggested, abstain?[55] If so, why?

In his *Souvenirs*, Gleizes does not mention the fact that Metzinger was not among the Cubists represented at the Brussels Indépendants, although to Gleizes it was of great importance that it was here, barely a month after the close of the Paris Indépendants, that the term Cubism was accepted on behalf of the Room 41 group. There are, however, several reasons why Metzinger may have refused to exhibit, including even the unlikely possibility that he attached no importance to sending pictures to an art society that had been in close assocation with its Paris counterpart since the days of the Post-Impressionists.

One explanation can be inferred from another section of the Gleizes *Souvenirs*, and it bears sharply on the definition of Cubism proposed by Apollinaire in Brussels and accepted by Gleizes. Apollinaire, on the one previous occasion that he had faced the question of what constituted Cubism, had paraphrased Metzinger's remarks from the *Pan* article. That is, he had defined it in April 1911 specifically in terms of Metzinger, and if not as a system, then literally as a "discipline," yet a "discipline not incompatible with reality."[56] Here, as we have seen above, he wrote that it consisted of communicating plastic truth by showing the spectator "all its faces." In other words, he employed a variation of the idea of mobile perspective, a "cinematic" movement around an object, familiar from Metzinger's 1910 article on Picasso, Braque, Delaunay, and Le Fauconnier. This idea is absent from Apollinaire's Brussels introduction. It has been replaced by a firm rejection of system and an elevation of "those vast subjects" abandoned by the last generation of artists. The weight in Apollinaire's acceptance of Cubism has fallen entirely on the anti-Impressionist concerns of the new painters, not in terms of method, but in terms of a fundamental goal.

Perhaps this was going too far for Metzinger—making Cubism a movement not directly characterized in formal terms. Perhaps it separated the Room 41 Cubists too far from Picasso and Braque, for of all the participants in the Cubist room only Metzinger then knew the degree to which his art related to theirs. Furthermore, in the *Pan* article Metzinger had begun by describing the system of Picasso in terms of a free, mobile perspective, and only afterwards when extending the idea did he relate the new tendency in three stages to time (Braque), to the essential quality of the contemporary period (Delaunay), and finally to history itself (Le Fauconnier).

Gleizes's text describes certain differences between himself and Metzinger that the two explored in the months intervening between the Indépendants and the Salon d'Automne of 1911; those discussions culminated the following summer with the writing and publication of *Du «Cubisme»*. We should, however, first examine the evidence that bears on the question of the extent to which the other Room 41 Cubists were familiar with the work of Picasso and Braque prior to April 1911. In his *Souvenirs* and other sources, Gleizes touches on his relationship to Picasso, which did not begin until September 1911 and did not lead to friendship.[57]

Because of the inclusion of numerous decorative arts en-

sembles at the 1911 Salon d'Automne, the opening was postponed. Toward the end of September, when the paintings, drawings, and sculpture arranged on the first floor of the Grand Palais were all but in final place, it was announced that there would be two inaugurations of the salon because the installation of the furniture and decor on the ground floor was still not completed. Apollinaire, who had been previewing the exhibition, accompanied by Léger, took Gleizes and Le Fauconnier to a nearby bar on the rue d'Antin to present them to Picasso.[58] The artists had presumably been seeing to the final hanging of their paintings in Room 8. After whatever preliminaries took place, Picasso led the entire group to Kahnweiler's gallery behind the place de la Madeleine where Gleizes and Le Fauconnier, at least, looked at the Spaniard's work for the first time. The definitive confirmation of this meeting in the early fall of 1911 is found in an extraordinary article that Gleizes immediately published, for he mentions Picasso and Braque (whose work he must also have seen at Kahnweiler's) in the same connection. The article, clearly indicating Gleizes's understanding of the Cubism with which he was identified, reveals an astonishing view of the intentions of Picasso and Braque.

Titled "L'Art et ses représentants, Jean Metzinger," Gleizes's article begins with a straightforward acknowledgment: "It is . . . easy enough to define a possible direction for painting: after the efforts—although open to discussion, but coming incontestably at the right time—of Picasso, Braque, Derain, it is necessary to point to . . . Jean Metzinger."[59] Gleizes then briefly reviews the flaws of Impressionism, writing that "only Cézanne understood the danger of these fragile researches, exterior and without consequence." He credits Cézanne with rediscovering the French tradition, of rescuing David, Ingres, and Delacroix from the ridicule imposed on them by their academic followers. He quotes Apollinaire's definition of Cubism from the Brussels catalog, pointing out that Cézanne is the link between the Cubists and the great masters of the French tradition (he uses here the term "le trait d'union" in almost exactly the same expression as he does in his Souvenirs forty years later). "With the Cubists we find again and renew structure and inspiration." This leads him to Metzinger, ". . . who perceived early on that painting was floundering about in subversive investigations, touching simply the superstructure, and that the very valuable (but affected) [précieuses] indications of Picasso and of Braque did not, in spite of all, leave behind an impressionism of form which, however, they opposed to that of color."

One does not know precisely which paintings by Picasso and Braque that Le Fauconnier and Gleizes saw, presumably recent work from the summer of 1911, works that are identified now with the summits of so-called analytical Cubism. But for Gleizes, these paintings were so different from his own preoccupations that he regarded the almost unreadable fragmented forms of reality splintered across these canvases as tokens of flickering, transient movement. He saw in them no search for stability or solidity, for fundamental volumetric relationships. He saw no serious attempt to return to or invent grand subjects. The work of Picasso and Braque, although pointing in the right direction by use of sober color, remained insignificant. An "impressionism of form" meant not only lack of true structure, but continued triviality of subject, a tattered treatment of things of indeterminate value, perhaps still lifes or unelevated scenes from daily life. He found the work lacking in inspiration, a term that figured prominently also in the earlier writing of Apollinaire. Everything that Gleizes and Le Fauconnier understood that they were being identified with—by Apollinaire, by Allard, by Metzinger—was, to quote Allard,

"at the antipodes of impressionism," uninterested in imitating "the occasional cosmic episode"—in short, the opposite of the immediate and transient. Gleizes had no more sympathy or understanding for what Picasso and Braque were doing than did his friend Roger Allard.

Nevertheless, in his article Gleizes proceeds to ascribe to Metzinger a method similar to the one that Metzinger had outlined in regard to Picasso in the Pan article almost a year earlier. According to Gleizes, Metzinger was "haunted by the desire to inscribe the total image. . . . He will put down the greatest number of possible planes: to purely objective truth he wishes to add a new truth, born from what his intelligence permits him to know. Thus—and he said it himself: to space he will join time." (Metzinger had written this of Braque!) "In summary," Gleizes goes on to say, "he wishes to develop the visual field by multiplying it, to inscribe them all in the space of the same canvas: it is then that the cube will play a role, for Metzinger will utilize this means to reestablish the equilibrium that these audacious inscriptions will have momentarily broken."

In his first published article, written after seeing Picasso and Braque, Gleizes reveals a naiveté as great as his evident sincerity.[60] He thought Picasso and Braque only approached Cubism for two principal reasons. To begin with, there was, in his eyes, a lack of equilibrium that was manifest in the fluttering appearances of their 1910–11 works, the result of small planes opening one into another to a degree only approached by Metzinger, and rarely in the work of Le Fauconnier or Gleizes. In addition, Gleizes could discern in Picasso and Braque no hint or promise of a return to those "vast subjects" of the "grand epochs" of the past. Describing imitators as "facile adepts," he was sure they would not be able "to quit the gay heart, the confusion, and the license where they find success, for a rigid and determined method, all interior, entirely constructive, fully synthetic and pitiless toward premature or hasty realizations."[61] While he was not specifically writing about Picasso and Braque in cautioning these "adepts," but rather about a growing group of followers, the young puritan must have been aware of the parallel language he used in establishing an opposition between the tentative and flickering forms, still struggling to free themselves from Impressionist transience, and "this return toward the French tradition, of which grandeur, clarity, equilibrium, and intelligence are the pillars."

In returning to the Souvenirs, one can discern in the description of the relationship between Gleizes and Metzinger following the close of the Paris Indépendants some of the intellectual tensions that may, perhaps, account for Metzinger's abstention from the Brussels show. Léger had gone to Normandy; Le Fauconnier had gone briefly to Italy and on his return had been staying in Savoy. Gleizes does not mention where Delaunay went during the summer of 1911, but suggests that every one of the group of painter friends had scattered, except for Metzinger and himself, "who remained near Paris, he at Meudon and me at Courbevoie. We saw a great deal of each other and actually had many discussions of ideas originating in our fashions of understanding painting." A Gleizes painting now in the collection of the Centre Pompidou, Paysage, Meudon (from 1911), is the symbol of these visits from Courbevoie to Meudon. As it was probably exhibited at the Brussels show,[62] it may establish the date of the visits as at least as early as the spring of 1911.

There followed a kind of grinding on the differences that existed between us in spite of a certain number of principles on which we were in agreement—all of us—which had permitted us to realize a momentary homogeneity and to present the group movement of Room

41. But all of us knew very well that we were only at the beginning of an adventure where it was impossible to predict the climax. We knew that what we were accomplishing today was only preparing us for what we would do later, which would be far removed not only technically, but in spirit.

Our divergences in 1911 were not categorical oppositions. They were, rather, propositions on which we could meditate and on which we ourselves should experiment. . . . The "grinding" of which I want to speak, between the ideas of Jean Metzinger and my own about painting at that moment, was the result of the confrontation of our positions. Metzinger was then painting Le Goûter and some large, animated landscapes. Me, I had finished La Chasse and La Femme à la cuisine. From my walks to Meudon I had done a large landscape, Paysage, Meudon. I was about to begin an important portrait, that of Jacques Nayral. In confronting these works of two painters bearing the same label [i.e., Cubist] one will easily understand the sense that it is necessary to give to the word "divergence." Metzinger, and one sees it clearly in Le Goûter, proceeded by the interlocking of cubes; the construction of his painting depended on the orchestration of these geometric volumes, which displaced each other, developed, and penetrated one another according to the moving or shifting of the painter himself. It is possible to see here the consequences of this movement [of the artist] introduced in an art that did not until that time include a plurality of perspectives. These architectural combinations of cubes carried the sensitive image, the torso of a nude woman holding in her left hand a cup while with her other hand she raised to her lips a spoon. Metzinger, and one understands it easily, wished to dominate accident. He insisted that all the parts of his work responded to each other logically, were justified to each other meticulously, that the composition be as rigorous an organism as possible, and that accidents be, if not altogether eliminated, at least controlled. . . .

I avow frankly that this austere and knowing discipline did not respond to my state of mind. Although having already made progress in the sense of the predominance of the laws of construction over accidental episodes of subject, I was not yet able to disassociate these two characters of the painted work and I remained firmly hooked on subject. It was in moving out from it that I tried to arrive at a purified plasticity, the object of my aspirations.

For Gleizes, then, there were principles to be developed out of the internal necessities of certain subjects, while for Metzinger there was a method of plastic construction more or less independent of the subject on which it would be imposed. Gleizes also believed in the method of perspectival shifting, but felt that this grew out of what he wanted to express, and was thus infinitely varied. He gave an example:

I was going to paint the portrait of Jacques Nayral who was to become my brother-in-law . . . his head and all his person seemed to me perfect models to develop the plastic elements that I sought. His face had well-defined planes, making a blazing game of facets; his hair in dark masses standing out lightly in undulations on his forehead, his body solidly structured, suggested to me immediately equivalences, recollections, relationships, penetrations, and correspondences with the elements of environment, the land, the trees, the houses.

But further, it was not just the physical Nayral that lent himself so well to what Gleizes wanted to do—it was because he knew him so well, admired him, "one of the most sympathetic men I had ever met. A strange fellow who seemed astonished at first, who put one off by a mordant irony, yet attracted by a kindness that made him as vulnerable as a child."

How does the idea of incorporating equivalences, recollections, penetrations, and correspondences between the subject and the environment differ from Metzinger's system, first enunciated in the Pan article in terms of Picasso, of moving about an object and employing a free and mobile perspective? The two ideas are compatible, but not identical. Gleizes's conception involves the search for qualities that relate apparently diverse phenomena, comparing and indeed identifying one aspect with something else—for example, the hair of Nayral with the wind-tossed foliage of trees. This is a fundamentally synthetic notion that points to the unity or compatibility of things. Ironically, it is this idea that Kahnweiler was to shape much later as Cubist metaphor in his monograph on Juan Gris. It is also an activity that past painters, particularly those who exploited symbolic devices, had approached, but never before to the extent of actual penetrations or equivalences. It was the method that Metzinger enunciated that permitted, to a degree never realized before, the potential of reading so many analogous meanings in the same forms. Thus, Metzinger carried from Picasso and Braque a technique that immensely enriched the inspirations already operating in the work of the other members of the 1910–11 Cubist group, inspirations, however, that had already yielded several different but related methods designed to release the multi-layered content of modern experience.

Reviewing the two-year period from 1909 to 1911 during which the Cubists of Room 41 came together, discovered their affinities, and exhibited as a group to provoke the awareness of a new movement known as Cubism, this double-sided question seems to have been of fundamental importance: what should be the attitude toward the subject and the consequences that flow from that attitude, and what method of pictorial construction should be employed, with considerations of content playing a secondary role? Looking back at the sequence of written explanations to account for the new art, one sees the emphasis shifting from one side to the other of the question, from regarding Cubism as a method, even a system, to permitting it to be a state of mind, an inspired attitude that would develop a new firm pictorial structure in the course of creating subjects of immense, continuously radiating significance.

In the sequence of written texts the order is as follows: Le Fauconnier, "Das Kunstwerk," which, since it was published in German in early September 1910, must have been written during the summer; Metzinger, "Note sur la peinture," which although appearing in the October-November number of Pan is signed September 1910; Allard, "Au Salon d'Automne de Paris," probably written early in October and showing signs of having absorbed specific ideas from both Metzinger and Le Fauconnier; and finally, seven months later, Apollinaire, who found himself on both sides of the pole more than once, and in accepting the name "Cubism" setting the emphasis on inspiration, on vast subjects, and the noble, measured structure that would arise from them. The painters, and both Allard and Apollinaire at least once, tried to examine the manner in which inspired subject would metamorphose into plastic structure. All were agreed that painting had no longer to deal with imitation of objects; all agreed that the conception, synthesized from experience and recreated in the mind of the observer, was where the great value lay. There was diversity, however, in determining what constituted the experience to be synthesized, whether it was merely contemporary visual phenomena elevated into an idea, a more complete idea, as first expressed by Metzinger in connection with Picasso's mobile perspective, or cultural and historical meditation and hence not purely visual; Metzinger also suggested that Le Fauconnier dislocated historical experiences much as Picasso distorted visual experience in order to synthesize an idea.

For most of the artists of Room 41, although less so for Metzinger, the starting point was with mental experience that was already more than purely visual, and the task was to translate the idea into firm plastic terms, hence the emphasis on

inspiration, on grandeur, on the paroxysms of the epoch. These insights, as opposed to mere sights, could also be synthesized into a new equilibrium, a new unity, but what was required was far more complex than the recombinations of particular points of view to constitute the idea of a whole. It was necessary to possess an understanding of as many aspects of human understanding as possible, to realize how complex, rich, and diverse experience was. These artists of Room 41 were, as Allard put it, not content with an occasional episode, but wished something larger, to fuse not just what they saw in contemporary life into what they knew, but to unite the eternal, or at least the enduring, with the actual. Put another way, they were engaged in the creation of generalizations, even of universals. It flowed from this that some subjects were more transcendent than others. Their respect for particular old masters, the genesis of whose works they debated, focused on David and Ingres. They risked or even courted a reinvention of history painting, believing, indeed, that certain tasks of synthesis were more important than others, that big ideas—the grandiose—incorporating and absorbing minor or lesser equivalences, were more significant. Hence, in Allard, in Gleizes, in Apollinaire, and later in Metzinger ("Cubisme et tradition")[63] there is a growing emphasis on the balance between the eternal and the transient, between classical and modern.

The willingness of the Room 41 Cubists to undertake such serious tasks was the fuel that fed the widely shared excitement among their defenders that French art was undergoing a renaissance and would once again approach the great tradition. The elevated ambition manifest in the work and ideas of the Room 41 Cubists, while linking them to the classical tradition, especially in French art, also made them vulnerable to charges of pretension and subsequently to the attack, launched by Kahnweiler, that their work did not pass beyond the very salon machines that Apollinaire suggested, in the Brussels introduction of 1911, were a travesty of the noble efforts of the past.

The divergencies noted above between Gleizes and Metzinger, which prompted the 1911 discussions that in turn led to the 1912 publication of Du «Cubisme» may, perhaps, best be summarized by another quote from Metzinger's Pan article: "Their [the Cubists'] reason is balanced between the pursuit of the fugitive and the mania for the eternal."[64]

As the paintings assembled in the present exhibition demonstrate, Metzinger worked consistently and carefully to preserve the balance. His enchanting Dancer in a Café of 1912 exults in the exoticism of the moment, playing off the feathers or plumes of fashionably dressed Parisian women in their Worth gowns against an Amerindian pattern on the costume of the dancer, wittily comparing the height of European fashion with the anthropologically arcane. Until the emotion in his pictures becomes very sad—about 1918, presumably following the death of his first wife, followed soon after by the suicide of his daughter—Metzinger's imagination is joyously contemporary, playing with changing spectacles, turning trees into sailboats, jackets into chair caning, chairbacks into arcades, jewelry into cigarettes and smoke. His method of securing the permanent—his "mania for the eternal"—was to emphasize number. But by number he did not mean anything so simple and straightforward as the structure of the picture plane.

Recently, two hitherto unknown letters of July 1916 written by Metzinger to Gleizes, who had been in New York since September 1916, were published.[65] These are immensely interesting, not only because they document the continuing debate between the two friends, but also because they clearly qualify Metzinger's approach during the period of his greatest independent activity, when he was mustered out of the army, re-

sumed painting, and had the security of a contract with Léonce Rosenberg.

In the first of the letters, dated 4 July 1916, Metzinger tells Gleizes of the perspective he has developed:

After two years of study I have succeeded in establishing the basics of this new kind of perspective I have talked about so much. It is not the materialist perspective of Gris, nor the romantic perspective of Picasso. It is rather a metaphysical perspective—I take full responsibility for the word. You can't begin to imagine what I've found out since the beginning of the war, working outside painting but for painting. The geometry of the fourth space has no more secrets for me. Previously I had only intuitions, now I have certainty. . . .

The actual result? A new harmony. Don't take this word harmony in its ordinary, everyday sense, take it in its original sense. Everything is number. The mind hates what cannot be measured: it must be reduced and made comprehensible.

That is the secret. There is nothing more to it. Painting, sculpture, music, architecture, all lasting art is never anything more than a mathematical expression of the relations that exist betweeen what is inside and what is outside, the self and the world.

It is clear that the "fourth space" for Metzinger was the space of the mind; the new perspective was a mathematical relationship between the ideas in his mind and the exterior world.[66]

In the second letter, dated 26 July 1916, Metzinger goes further. Fearing that Gleizes, whose reply to the first letter is lost, was advancing a theory of painting as an end in itself, he counters:

If painting was an end in itself it would enter into the category of the minor arts which appeal only to physical pleasure.

It is a good thing to get away from photographic imitation; but not if it is to substitute for the natural world a painterly world which can never be as rich in its proportions or its emotional value as the poorest of natural flowers, or the tiniest of animals.

What pictorial harmony can be worth the structure of an insect, the elegance of a bird, the architecture of mountains? Eh?

Léger is running after "pure painting" . . . try putting beside the prisms he juxtaposes a couple of natural crystals.

No. Painting is a language—and it has its syntax and laws. To shake up that framework a bit to give more strength or life to what you want to say, that isn't just a right, it's a duty; but you must never lose sight of the End. The End, however, isn't the subject, nor the object, nor even the picture—the End, it is the idea.

Continuing, Metzinger reasonably writes that he cannot determine how great the current difference is between himself and Gleizes because he has not seen any of Gleizes's recent work. He notes: "Someone from whom I seem always further away is Juan Gris. I admire him: but I can't understand why he wears himself out breaking objects down. Me, I am moving toward a synthetic unity . . ."

At the conclusion of his letter, he writes:

May the stupidity of the present day bring on in all things—by reaction and necessity—the rule of Mind.

I don't say Intelligence, which is only a part of Mind. Nor do I mean that you must be a mathematician to be a painter. The Douanier was an ordinary man, even though he was closer to Mind than Cézanne or Renoir! The Douanier did not have great things to say; but he painted to express those things and not just to give us ocular—I nearly said culinary—delights. (Emphasis added)

The remark about Rousseau is apt for Metzinger himself. He was very intelligent and at the same time not entirely comfortable with deliberately great ideas, the kind of generalizations about space, time, society, and history that governed the highest ambitions among his Room 41 colleagues. In his memoirs he wrote that during the act of painting Gleizes's social and

mystical views fortunately didn't persist—that he was saved by his equal obsession with painterly problems.[67]

However, on this score Metzinger was wrong. It was the social and the mystical in combination with the purely pictorial that led Delaunay and Gleizes into abstraction, abstraction based on vast or epic synthetic ideas, while Metzinger more modestly undertook to continue to mediate between the fugitive and the eternal.

Because of his Nantes background and the military and government figures in his family, he had a horror of bourgeois pretension. He was, as a result, unusually sardonic and, at the same time, open to all the idioms that he considered genuinely popular. He searched for the visual equivalent of argot, knowing full well that this would be the first to pass. But he retained a conception of that which endures: "The art that does not pass leans on mathematics. . . . Whether the result of patient study or of flashing intuition, it alone is capable of reducing our diverse, pathetic sensations to the strict unity of a mass (Bach), a fresco (Michelangelo), a bust (antiquity)."[68]

Jean Metzinger, then, was at the center of Cubism, not only because of his role as intermediary among the orthodox Montmartre group and the right bank or Passy Cubists, not only because of his great identification with the movement when it was recognized, but above all because of his artistic personality. His concerns were balanced; he was deliberately at the intersection of high intellectuality and the passing spectacle.

1. See Leo Steinberg, "The Philosophic Brothel," Art News, Sept. 1972, 20–29, and Oct. 1972, 38–47. See also Leo Steinberg, "Resisting Cézanne: Picasso's Three Women," Art in America 66 (Nov. 1978): 114–33, and 67 (Mar. 1979): 114–27; and William Rubin, "Pablo and Georges and Leo and Bill," Art in America 67 (Mar. 1979): 128–47.

2. Robert Rosenblum, "Picasso and the Typography of Cubism," in Roland Penrose and John Golding, eds., Picasso in Retrospect (New York, 1973).

3. Douglas Cooper, The Cubist Epoch (London, 1970), 71.

4. Henri Le Fauconnier, "Das Kunstwerk," preface to exhibition catalog for the Neue Künstlervereinigung 11, Munich, Sept. 1910, reprinted in Lothar-Günther Buchheim, Der Blaue Reiter und die NKV, München (Munich, 1959). See also Ann Murray, "Le Fauconnier's 'Das Kunstwerk': An Early Statement of Cubist Aesthetic Theory and Its Understanding in Germany," Arts 56 (Dec. 1981): 125–33.

5. See Lynn Gamwell, Cubist Criticism (Ann Arbor, 1980), 16–35.

6. In Jean Metzinger, "Note sur la peinture" ["Note on painting"], Pan, Paris, Oct.-Nov. 1910, 649–51, reprinted in Edward Fry, Cubism (London, 1966), trans. Jonathan Griffin, 59–61. Unless cited as Fry, quotations from the original French have been translated by Daniel Robbins.

7. Cooper, 75. The "jackdaw" image is in quotation marks in Cooper's text, although without attribution to Apollinaire. See n. 41 below.

8. John Golding, Cubism: A History and an Analysis, 1907–1914 (London, 1959), 27.

9. See Gustav Vriesin and Marc Imdahl, Robert Delaunay: Light and Color (New York, 1969).

10. Metzinger, "Note sur la peinture," 651–52.

11. Jean Metzinger, Le Cubisme était né: Souvenirs par Jean Metzinger (Chambéry, 1972), 14. Hereafter referred to as Metzinger's memoirs in the text.

12. Louis Chassevent, "22e Salon des Indépendants, 1906," Quelques petits salons (Paris, 1908), 32.

13. Louis Vauxcelles, "Exposition Braque, chez Kahnweiler," Gil Blas, Paris, 14 Nov. 1908, in Fry, 50.

14. Robert Herbert, Neo-Impressionism (New York, 1968), cat. no. 162, p. 221. The Metzinger passage quoted by Desvallières was reprinted in La Grande Revue, vol. 124 (1907).

15. See Winthrop Judkins, Fluctuant Representation in Synthetic Cubism: Picasso, Braque, Gris, 1910–1922 (New York, 1976), revision of Ph.D. diss., Harvard, 1954.

16. See Daniel Robbins, "Sources of Cubism and Futurism," Art Journal 41, no. 4 (Winter 1981): 324–27.

17. This is the gallery cited in Fry, 58, where a small Picasso exhibition was held in May 1910. The exhibition was reviewed by Léon Werth, who used the adjective "cubic" to describe Picasso's treatment of roofs and chimneys.

18. Rousseau's subject matter did affect Delaunay as, for example, in the 1907 Vue de Marne with airplane and dirigible, and in The Eiffel Tower. See Sherry A. Buckberrough, Robert Delaunay: The Discovery of Simultaneity (Ann Arbor, 1982), 16–18, 29–37.

19. Albert Gleizes, Souvenirs, le cubisme 1908–14, Cahiers Albert Gleizes 1 (Lyon, 1957), 14.

20. The author was Eugène Sue, and Rousseau's naive confusion is triply wrong, taking Rodin for Victor Hugo, and Hugo for Sue.

21. H. Sevin MS, 41–42. However, Le Fauconnier gave the rue Visconti address in the catalog of the 1911 Brussels Indépendants.

22. See Daniel Robbins, Albert Gleizes, 1881–1953: A Retrospective Exhibition (New York, 1964), cat. no. 20, p. 28.

23. Memoirs of Juliette Roche Gleizes, MS, Collection Albert Gleizes Fondation, Paris. Juliette Roche was a student at the Julian after 1906.

24. Metzinger, Le Cubisme était né, 44.

25. Vriesin and Imdahl, 29. Information based on Delaunay memoirs.

26. Le Fauconnier postcard, Archives of Musée Calvet, Avignon.

27. Vriesin and Imdahl, 16.

28. Metzinger, Le Cubisme était né, 43–44.

29. Ibid., 58. Not only does the text give the date 1906 for Gleizes admiring Metzinger's paintings at the Salon des Indépendants, but so does the typescript sent to the publisher Henri Viaud by Suzanne Metzinger. This would have Gleizes admiring the same Neo-Impressionist paintings condemned by Chassevent at a time when Gleizes was still more concerned for l'art social than for structure. Furthermore, if Gleizes invited Metzinger back to his Courbevoie studio and made the remark quoted above about Pascal, of which Metzinger writes, "Pressentait le cubisme et condamnait par anticipation ceux qui n'y virent que l'application d'un mot d'ordre," he would have been at a very different stage in his evolution than, in fact, was possible. In the spring of 1906 Gleizes was anxious to be away from Courbevoie and his parents; he was in close association with the socially oriented writers and poets with whom he was already planning the as-yet-unlocated Abbaye de Créteil. Thus it seems likely that in transcribing the manuscript, a typist changed a "9" to a "6." As the events occurred long before Mme. Metzinger married, and the manuscript was published long after Metzinger had died in 1956, such an explanation seems plausible. The 1909 Indépendants was an exhibition in which Gleizes did not participate, but which he certainly visited, for it was here that Le Fauconnier's portrait of Jouve made such a deep impression on him. Metzinger was represented with two works, a Landscape and a Bathers, where "le souci de ne pas altérer le plan mural était fort accusé." It was only at the following Salon des Indépendants (1910) that Gleizes joined the ranks of the exhibitors for the first time.

30. Ibid.

31. Le Fauconnier showed two rocky landscapes of Brittany and two portraits of his mistress, Mlle. Maroussia; Delaunay, a St. Severin, ville and an Eiffel Tower; Gleizes, an almost life-size portrait of his friend and Abbaye colleague, the poet René Arcos, The Tree and a drawing for it, The Quai, two drawings of Bagnères de Bigarre, and a painting titled In the Pyrenees; and Léger, two still lifes, two "Etudes," and a Reclining Woman.

32. Metzinger's portrait of Apollinaire is probably contemporaneous with Picasso's portrait of Vollard, usually dated 1909–10. It probably predates Picasso's portrait of Uhde, dated spring 1910. Apollinaire was subsequently (in Les Peintres Cubistes, pub. 1913) to refer to it as the first Cubist portrait. Gleizes also refers to it in this way (Souvenirs, 11). Metzinger gives an account of painting it in Le Cubisme était né, 46. He wrote that he met Apollinaire at Max Jacob's in 1907. The two rapidly became friendly and discussed poetry: "Did we not squabble a hundred times on the subject of Fernand Fleuret in whom I obstinately could see no more than a bookish versifier. There I see the proof of his sincerity, his naiveté. . . . He interested himself in my painting, defended it with all his talent in the reviews, and even—and this was not without courage—in a daily when he began to write for it. I began to execute his portrait. A friend in common had hoped that he would be posed clothed in purple and crowned with roses; I approved because of the game of colors that the costume would have favored; but he protested: he did not wish to resemble a sideshow emperor [a reference to the treatment he had received already from Picasso]. I had to content myself with his severe gray costume."

33. Louis Vauxcelles, "Le Salon des Indépendants," Gil Blas, 18 Mar. 1910; see Golding, 22.

34. Guillaume Apollinaire, "Le Salon des Indépendants," L'Intransigeant, 18 Mar. 1910, reprinted in Guillaume Apollinaire, Chroniques d'art (1902–1918), ed. L. C. Breunig (Paris, 1960), 73–76. Translations by Daniel Robbins.

35. Apollinaire, Chroniques, 76.

36. Ibid., 9.

37. Known only through a photograph reproduced in Fry, ill. 35; Gamwell, ill. 9. See no. 23 in this catalog where the painting is listed as Nude.

38. One of Le Fauconnier's landscapes was purchased, Gleizes notes, by the "famous" Russian collector, Choukine, for the "then-important sum of 600 francs (gold)."

39. See Robbins, Albert Gleizes, cat. no. 16.

40. Quoted also in Golding, 23, and there dated 1–2 Oct. 1910.

41. Guillaume Apollinaire, "Le Salon d'Automne," Poésie, Toulouse, Autumn 1910, 74–75, reprinted in Apollinaire, Chroniques, 125–26.

42. Roger Allard, "Au Salon d'Automne de Paris," L'Art libre, Lyon, no. 12 (Nov. 1910): 441–43. See also Golding, 23; Fry, 62; Gamwell, 22.

43. Fry, who reproduced a portion of Allard's article (p. 62), commented that Allard was "the first writer to use the term 'analytical' in a sense similar to that in which critics of today apply it to the Cubism of 1909–12." However, this is not the case. Allard rejects "analytical," restricting it to relationships that exist among objects, and granting it little importance to the picture itself. By implication he equates "analytical" with the Impressionist concern for transience.

44. Gleizes, Souvenirs, 12.

45. From the biographical data assembled by Mme. Delaunay. See Golding, 23; Vriesin and Imdahl, 20.

46. Gleizes, Souvenirs, 12. Gleizes described a Léger Bather in the Mediterranean that proves the extent to which Impressionism operated on him. Christopher Green in Léger and the Avant-Garde (London, 1976), discussing how Léger "covered his tracks," has not been able to discover any comparable early painting.

47. Golding, 24–25, based upon Gleizes, Souvenirs, 15–21.

48. Golding, 24.

49. Apollinaire, *Chroniques*, 125–26.

50. Ibid., 198, entry for 11 Oct. 1911.

51. Emile Verhaeren, one of the inspirers of the Abbaye de Créteil group, was one of the three honorary members of its committee.

52. It is unfortunately not included in Fry; however, see Gamwell, 25, 155 n. 28.

53. Jean Plumet, Henri Ottmann, Jean Planche, and Paul Charles Braindeau were also invited by the Belgians but not associated with Room 41 or 43. Archipenko showed *Maternité*; Delaunay, *St. Severin* and *La Tour*; Segonzac, a nude and a still life; Gleizes, *Church, Landscape* and *Le Chemin*; Le Fauconnier, *Head of a Woman, Landscape*, and *Portrait of P.(aul) C.(astiaux)*; Léger, a landscape, a still life, and two drawings; Luc Albert Moreau, a drawing. Marchand's and Lewitska's works were not listed because not furnished by press time.

54. As early as 3 October 1911 in *Paris Journal*, André Salmon had referred to Metzinger as "le jeune prince du Cubisme." See Gamwell, 155 n. 29.

55. Golding, 25.

56. Guillaume Apollinaire, "La Jeunesse artistique et les nouvelles disciplines," *L'Intransigeant*, 21 Apr. 1911, reprinted in *Chroniques*, 165. See also Gamwell, 23, 154 n. 20.

57. Gleizes, in an unpublished fragment of his *Souvenirs*, written around 1944. Only a fragment has been published, but it does not contain this story (see n. 16 above). It is confirmed in the following sources: Albert Gleizes, "L'Epopée. De la forme immobile à la forme mobile," *Le Rouge et le noir*, Oct. 1929, 63; Golding, 28; Pierre Cabanne, *L'Epopée du Cubisme* (Paris, 1963), 163; Metzinger, "Le Cubisme apporta à Gleizes le moyen d'écrire l'espace," *Arts spectacles*, no. 418, 3–9 July 1953 (an obituary of Gleizes), where Metzinger

confirms the late 1911 meeting, but adds that he himself had probably presented Juan Gris to Gleizes a little earlier. See Metzinger, *Le Cubisme était né*, 57, where Metzinger contradicts himself, writing that Gleizes knew neither Picasso nor Juan Gris.

58. Apollinaire's account of the delay and a preview of the exhibition appeared in *L'Intransigeant*, 30 Sept. 1911, reprinted in *Chroniques*, 195. Precisely when Léger met Picasso is uncertain. Green, in *Léger and the Avant-Garde*, follows Douglas Cooper, *Fernand Léger et le nouvel espace* (Geneva, 1949), 35, and Golding, 28, believing in a late 1910 date at least for knowledge of the paintings, if not the artist.

59. Albert Gleizes, "Art et ses représentants, Jean Metzinger," *La Revue indépendante* 4 (Sept. 1911): 161–72. This journal counted Alexandre Mercereau, Roger Allard, and Jacques Nayral among its contributors.

60. See Cabanne, 158–61, for a reprint of André Arnyvelde's 1911 interview with Gleizes.

61. Gleizes, "Art et ses représentants," 169.

62. It is likely that this painting was no. 88 (*Le Chemin*) in the exhibition catalog.

63. Jean Metzinger, "Cubisme et tradition," *Paris Journal*, 16 Aug. 1911.

64. Metzinger, "Note sur la peinture," 649. Also translated in Gamwell, 30, 160 n. 65.

65. Peter Brook, in *Cubism 8* (Belfast, spring 1985).

66. For a complete discussion of the fourth dimension in art, see Linda Dalrymple Henderson, *The Fourth Dimension and Non-Euclidean Geometry in Modern Art* (Princeton, N.J., 1983).

67. Metzinger, *Le Cubisme était né*, 60.

68. Ibid., 23.

CHRONOLOGY

1883
Born in Nantes, 24 June

c. 1900
Studies painting at the local academy with portraitist Hippolyte Touront

1903
Exhibits in the Salon des Indépendants (20 Mar.–25 Apr.)
Moves to Paris after successful showing at the Salon des Indépendants; asked to exhibit at the Gallery of Père Thomas

1904
First group exhibition, Galerie Berthe Weill, Paris, with Dufy, Lejeune, and Touront (19 Jan.–22 Feb.)
Exhibits in the Salon des Indépendants (21 Feb.–24 Mar.)
Exhibits in the Salon d'Automne (15 Oct.–15 Nov.)
(Address: rue du Faubourg Saint Martin, 160)*

1905
Exhibits in the Salon des Indépendants (24 Mar.–30 Apr.)

1906
First elected to hanging committee of the Salon des Indépendants (20 Mar.–30 Apr.)
Exhibits in the Salon d'Automne (6 Oct.–15 Nov.)

1907
Exhibits with Robert Delaunay, Galerie Berthe Weill, Paris (14 Jan.–10 Feb.)
Exhibits in the Salon des Indépendants (20 Mar.–30 Apr.)
Exhibits in the Salon d'Automne (1–22 Oct.)
Meets Max Jacob; through him was to meet Apollinaire, Picasso, and Gris
(Address: Savigny-sur-Orge)

1908
Exhibits with Marie Laurencin, Galerie Berthe Weill, Paris (6–31 Jan.)
Exhibits in the Salon des Indépendants (20 Mar.–2 May)
Exhibits in the Salon d'Automne (1 Oct.–8 Nov.)
Group exhibition with Braque, Sonia Delaunay, Derain, Dufy, Herbin, Pascin, and Picasso, Galerie Notre-Dame-des-Champs, Paris (21 Dec.–15 Jan. 1909)
(Address: 77 bis, rue Legendre)

1909
Exhibits in the Salon des Indépendants (25 Mar.–2 May)
Exhibits in the Salon d'Automne (1 Oct.–8 Nov.)
Probable date of first meeting with Albert Gleizes

1910
Exhibits in the Salon des Indépendants (18 Mar.–1 May)
Group exhibition, Galerie Berthe Weill, Paris (28 Apr.–28 May)
Exhibits in Izdebsky Salon, St. Petersburg (2 May–7 June) and Riga (25 June–20 July)
Exhibits in the Salon d'Automne (first time he is listed in catalog as sociétaire) (1 Oct.–8 Nov.)
(Address: 123, rue Lamarck)

1911
Exhibits in the Salon des Indépendants (21 Apr.–13 June)
Exhibits in the Salon d'Automne (1 Oct.–8 Nov.)
Exhibits with 19 artists including Duchamp, Gleizes, Léger, Picabia, the Villon brothers in "Société Normande de Peinture Moderne," Galerie d'art ancienne et d'art contemporain, Paris (20 Nov.–16 Dec.)
Meets with the Puteaux group at Villon's studio

1912
Exhibits in the Salon des Indépendants (20 Mar.–16 May)

*All addresses for Jean Metzinger are as listed in the Salon d'Automne catalogs.

Group exhibition, Galeries J. Dalmau, Barcelona (20 Apr.–10 May)
Exhibits in the Salon d'Automne (1 Oct.–8 Nov.); paintings in André Mare's Salon Bourgeois at the Salon d'Automne
Exhibits in Moderne Kunst Kring, Stedelijk Museum, Amsterdam (6 Oct.–7 Nov.)
Exhibits in Salon de "La Section d'Or," Galerie La Boétie (10–30 Oct.)
Publishes Du «Cubisme» with Albert Gleizes
Teaches at Académie de la Palette at same time as Le Fauconnier (among their pupils were Russians Oudaltova and Popova); later taught at the Académie Arenius)
(Address: 121, avenue Félix Faures)

1913
Exhibits with Gleizes and Léger, Galerie Berthe Weill, Paris (17 Jan.–1 Feb.)
Meets Herwarth Walden in Paris
Exhibits in the Salon des Indépendants (19 Mar.–18 May)
Group exhibition, Budapest (Apr.-May)
Exhibits in first American exhibition of Cubism, Gimbels Department Store, Milwaukee (May)
Exhibits in Erster deutscher Herbstsalon, Der Sturm, Berlin (20 Sept.–1 Dec.)
Exhibits in the Salon d'Automne (15 Nov.–5 Jan. 1914)

1914
Exhibits with Duchamp, Duchamp-Villon, Gleizes, and Villon, Galerie Groult, Paris (6 Apr.–3 May)
Exhibits with Delaunay, Gleizes, Mondrian, Archipenko, Brancusi, and Duchamp-Villon in Cubist show sponsored by Manes Society, Prague, organized by Mercereau (Feb.-Mar.)
Exhibits in the Salon des Indépendants (1 Mar.–30 Apr.)
Exhibits with the Salon des Artistes Indépendants de Paris, Galerie Georges Giroux, Brussels (16 May–7 June)

1915
Group exhibition, Carroll Gallery, New York (March-April)
Drafted as a medical orderly and stationed at Ste. Menehould between February and May; invalided out of service later that year
First solo exhibition in Paris, Galerie de l'Effort Moderne; begins association with Léonce Rosenberg
Close association with Juan Gris

1916
Group exhibition with Crotti, Duchamp, and Gleizes (called "The Four Musketeers"), Montross Gallery, New York
Group exhibition "Advanced Modern Art," McClees Gallery, Philadelphia (17 May–15 June)
Gathers at Lipchitz studio on Sundays with Gris, Picasso, Rivera, Matisse, Modigliani, Reverdy, Salmon, Jacob, Cendrars

1917
Participates in the first exhibition of the "Society of Independent Artists," Grand Central Palace, New York

1918
In June visits with Gris and Lipchitz at Beaulieu-près-Loches

1919–24
Listed as sociétaire of the Salon d'Automne, but exhibits no paintings

1920
Exhibits in the Salon des Indépendants

1921
Exhibits for first time with Société Anonyme, Worcester Museum, Smith College, Detroit Institute of Fine Arts, and MacDowell Club
Exhibits at Galerie de l'Effort Moderne, Paris, (Feb.)

1923
Exhibits in "Exposition des Franco-Scandinaves," Paris
Meets Suzanne Phocas in Montparnasse where he asks her to pose for him; she becomes his student
Contributes frequently to Bulletin de l'Effort moderne (through 1927)
Société Anonyme exhibitions: Vassar College, Poughkeepsie, New York (4 Apr.–12 May); Detroit Institute of Fine Arts (31 Aug.–9 Sept.)

1924
30th exhibition organized by the Société Anonyme (13 Feb.–6 Mar.)

1925
Exhibits at the Salon d'Automne
Société Anonyme exhibition, Baltimore Museum of Art (9 Jan.–1 Feb.)
Marries Suzanne Phocas

1926
Société Anonyme exhibition, Brooklyn Museum, New York; Albright-Knox Art Gallery, Buffalo; and Toronto Art Gallery

1927
Exhibits in the Galerie de l'Effort Moderne, Paris
Exhibits in the Salon d'Automne
Works sold in "John Quinn Collection" sale, American Art Association, New York

1930
Exhibits in the De Hauche Gallery, New York
Solo exhibition in Leicester Galleries, London

1932
Solo exhibition in the Hanover Gallery, London

1935
Exhibition at the Galerie Claussen, Paris

1937
Exhibits mural-size canvas (4.70 × 4 meters), Mystique de voyage, in the Salle de cinéma of the Palais de Chemins de Fer, of the 1937 Exposition Internationale des Arts et des Techniques

1939
Participates in the anniversary exhibition of the Société Anonyme entitled "Some New Forms of Beauty 1909–1936" at the George Walter Vincent Smith Art Gallery, Springfield, Massachusetts

1943
Exhibits in the Galerie Hessel, Paris, in "Oeuvres récentes et anciennes de Jean Metzinger"

1944–46
Exhibits in the Salon d'Automne
(Address: 7, rue Antoine Chantin, 14e)

1947
Publishes book of poems, Ecluses, with foreword by Henri Charpentier
Second French edition of Du «Cubisme», with afterword by Metzinger

1949–53
Exhibits in the Salon d'Automne
(Address: 18, rue de Régard, 6e)

1951
Exhibits in the Galerie Rive Gauche, Paris, "Un Maître du Cubisme: Jean Metzinger"

1953
Exhibits in the Musée National d'Art Moderne, Paris, in "Le Cubisme 1907–1914"

1956
Dies in Paris

1958
Included in the Salon d'Automne, retrospective of the 50th salon

1964
First solo exhibition in the United States at the International Galleries, Chicago

10. *Parc Montsouris*, c. 1906

11. *Parc Monceau*, c. 1906

16. *Paysage pointilliste*, c. 1906–07

17. *Les Ibis*, c. 1907

40. *La Fumeuse* (The Smoker) c. 1913—14

133. *Village, église et deux personnages*, dated 1913 (on verso)

128. *Cubist Landscape* (Le Village), c. 1911–12

139. *Landscape*, c. 1916–17

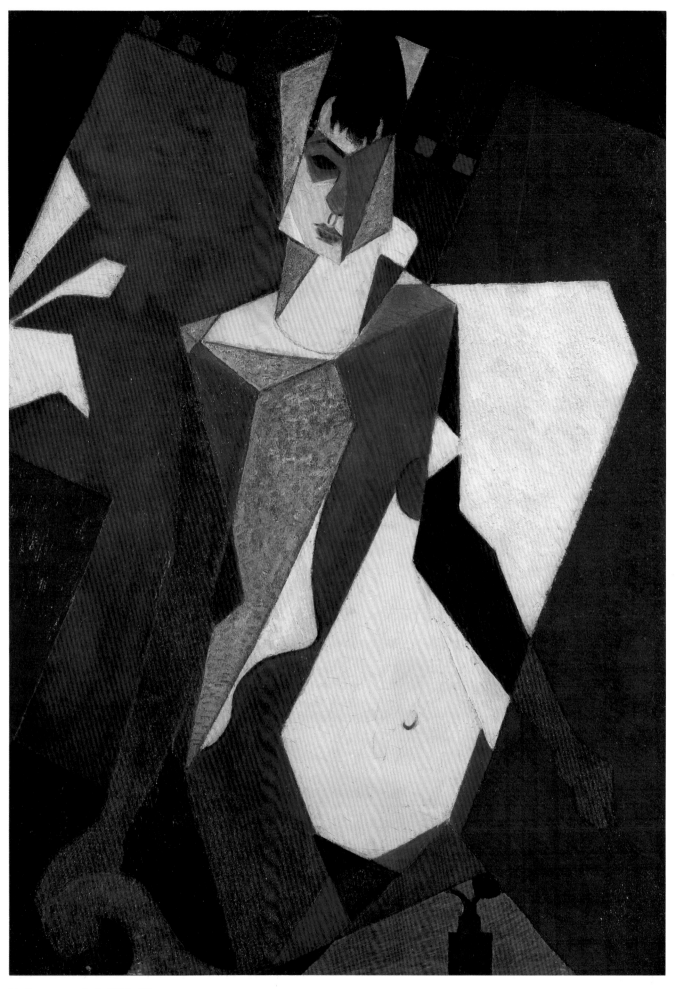

64. *Femme au miroir*, 1916–17

30

154. *Le Château*, c. 1918

167. *City Landscape,* 1919–20

217. *Still Life with Roulette Wheel* (Abstraction with Roulette), 1926

CATALOG OF PAINTINGS AND DRAWINGS

Titles in bold face indicate works in the exhibition. Works included in part of the exhibition tour are designated by the following abbreviations of the participating museums: UI (The University of Iowa Museum of Art); UT (Archer M. Huntington Art Gallery, University of Texas at Austin); UC (The David and Alfred Smart Gallery, The University of Chicago); and CI (Museum of Art, Carnegie Institute).

Titles are provided in the language (English or French) used by the owner or source of photograph. Alternative titles are given in parentheses; descriptive titles provided for the purpose of this catalog are not italicized.

Where publications are cited in support of dates for works, the following abbreviations are used: BEM, *Bulletin de l'Effort moderne*; WG, Waldemar George, "Jean Metzinger," *L'Esprit nouveau* 15 (February 1922): 1781–89; AGJM, Albert Gleizes and Jean Metzinger, *Cubism* (London: T. F. Unwin, 1913), first English edition of *Du «Cubisme»* (Paris: Figuière, 1912); JG, John Golding, *Cubism: A History and Analysis, 1907–1914* (London: George Wittenborn, 1959); GB, Gelett Burgess, "The Wild Men of Paris," *Architectural Record*, May 1910, 412; EF, Edward Fry, *Cubism* (London: Thames and Hudson, 1966); MR, Maurice Raynal, *Modern French Painters*, trans. Ralph Roeder (New York: Brentano's, 1928).

Dates given in quotation marks are as inscribed by the artist on the face of the work.

Dimensions are given in inches followed by centimeters in parentheses. Height precedes width.

PRE-CUBIST WORKS, 1904–1909

Born in Nantes on 24 June 1883, Jean Metzinger was a grandson of the French general who conquered Madagascar. His favorite subject at the lycée was mathematics, but he also studied painting at the local art academy with the portraitist Hippolyte Touront. In 1903 he moved to Paris, after having an enthusiastic response from art dealers to the paintings he had sent to the 1903 Salon des Indépendants.[1]

Although entries for Metzinger are listed in Salon catalogs, it is difficult to relate them to specific paintings. The titles from the 1903 and 1904 Salons indicate that his earliest works were landscapes and seascapes. The entries in the Salon catalogs list some of the regions depicted: Caen, Houlgate, and Arromanches in Calvados (Normandy) and Le Croisic in Brittany. *Bord de mer* (5),* or *Fauve Landscape* (4), for example, might have been painted at Houlgate, a resort that owes its popularity to splendid stretches of fine sand and a promenade that extends up to the foot of the cliffs, Les Falaises des Vaches Noires. *Paysage marin* (6) suggests the rocky promontory and deep water of Arromanches-les-Bains. Le Croisic has a busy fishing and sailing harbor, suggesting that seascapes with sailboats, such as *Paysage avec bateaux à voile* (8a) might have been painted there, at a beach not far from the artist's birthplace, Nantes. This early group of seascapes seems to date from the years 1904–06.

The only work that can be assigned with some certainty to 1904 is *Landscape* (2), which is signed and dated on the verso. Because Metzinger seems to have dated very few works before 1915 on the works themselves, the possibility exists that this date was added later. If this work is indeed from 1904, it suggests that Metzinger was strongly influenced by the Cézanne retrospective at the 1904 Salon d'Automne, especially by Cézanne's color, composition, and brushstroke.

Two other works whose compositions and forms suggest the influence of Cézanne are *Nature morte* (1) and *Paysage* (3). In the former, the distortions of form in the fruitbowl and glass are reminiscent of the multiple viewpoints and adjustments of form for compositional purposes that characterize Cézanne's still lifes. In the latter, the vertical format and light colors of the houses and sky create a flattening of space reminiscent of Cézanne's landscapes, while the solid, block-like houses and geometrization of the other forms recall Cézanne's search for order, permanence, and discipline in all his work.

By 1905 Neo-Impressionism was enjoying a significant resurgence. There had been an exhibition of the work of Maximilien Luce at the Galerie Druet in March 1904 and a large Signac exhibition in December 1904. In the 1905 Salon des Indépendants, Seurat was given a major retrospective, and at the same time Henri-Edmond Cross was given a one-man show at the Galerie Druet. By the time of the 1905 Indépendants, contemporary critics already regarded Metzinger's work as part of the Neo-Impressionist tradition. The dense brushwork and heavy impasto of *Fauve Landscape* (4) suggest that Metzinger may have seen and been influenced by the Vincent Van Gogh retrospective in the 1905 Salon des Indépendants.

By 1906 Metzinger had already developed a full-blown Divisionist style of painting, as is evident in his *Portrait of Delaunay* (9) exhibited in the Salon d'Automne of that year. This painting as well as three portraits of Metzinger by Delaunay, also from 1906, document the close association of the two artists in 1906–07. There are references to Chevreul and Rood in their correspondence, and their closely related paint-

* Numbers in parentheses refer to listings in the catalog.

ings testify to each one's adoption of Divisionist technique.[2] The large, mosaic-like brushstrokes that characterize both Delaunay's and Metzinger's paintings of this time seem to reflect the influence of Henri-Edmond Cross who used bold, rectangular blocks of color as early as 1901. Delaunay's *Portrait of M. Henri Carlier*, dated 1906, is characterized by green and purple tonalities punctuated by touches of brilliant red, suggesting that Metzinger's *Parc Montsouris* (10), *Parc Monceau* (11), and *Landscape with Fountain* (12) with similar tonalities, might also be dated 1906.

In a statement made around 1907 about his mosaic-like brushwork, Metzinger called upon parallels with literature that had characterized the relationship between Neo-Impressionist artists and Symbolist writers twenty years before: "I ask of divided brushwork not the objective rendering of light, but iridescences and certain aspects of color still foreign to painting. I make a kind of chromatic versification and for syllables I use strokes which, variable in quality, cannot differ in dimension without modifying the rhythm of a pictorial phraseology destined to translate the diverse emotions aroused by nature."[3] Robert Herbert interprets this statement as follows: "What Metzinger meant is that each little tile of pigment has two lives: it exists as a plane where mere size and direction are fundamental to the rhythm of the painting and, secondly, it also has color which can vary independently of size and placement."[4]

This statement seems to relate directly to such works as *Bacchante* (14), *Two Nudes in a Garden* (15), and *Landscape* (13a). In the two latter works, the sun is composed of mosaic-like blocks radiating outward as in Delaunay's *Landscape with a Disc* of 1907 (Musée National d'Art Moderne, Paris). The subject of classical nudes in a landscape was popular with both the Fauves and the Neo-Impressionists, in such paintings as Matisse's *Luxe, Calme, et Volupté* of 1905 and Henri-Edmond Cross's *Nymphs* of 1906 (exhibited in 1906, Salon des Indépendants), and the appearance of this theme in Delaunay's *Nudes with Ibises* (Louis Carré Collection, Paris) of 1907 suggests that these three works by Metzinger as well as his four other works with ibises or flamingos (16, 17, 18, and 19) might also date to 1907. The use of this exotic theme by Delaunay has been traced to a painting by Henri Rousseau of 1907, *Flamingos* (Mr. and Mrs. Charles Payson Collection, New York).[5] Delaunay met Rousseau in 1906, and it is probable that Metzinger became acquainted with Rousseau at this time as well.

The freer, more expressive brushstrokes of *Les Ibis* (17), *Paysage coloré aux oiseaux aquatiques* (18), and *Le Flamant rose et le voilier* (19) suggest a loosening of the Divisionist rigor that had characterized the mosaic-like paintings of 1906 and possibly early 1907. By the end of 1907 many avant-garde artists in Paris were reassessing their own work in relation to that of Paul Cézanne, who died that year. After Cézanne's retrospective at the Salon d'Automne of 1904, Emile Bernard's conversations and theoretical writings on Cézanne began to appear in *L'Occident* and *Le Renovation esthétique*. Cézanne's current work was exhibited in the Salons d'Automne of 1905 and 1906, followed by two commemorative retrospectives after his death in 1907. Several of Delaunay's paintings of that year introduce the complex spatial relationships and form structures explored by Cézanne, and Delaunay's sudden switch from portraits and landscapes to still lifes might also be attributed to Cézanne's influence. The extent to which Metzinger also renewed his interest in Cézanne at this time is a matter of

speculation, although he does seem to have transformed the theme of classical nudes in a landscape into a more formalistic theme of bathers, as evidenced by his Salon entries of 1908 and 1909 as well as *Baigneuses* (21) of 1908–09.

It is difficult to pinpoint exactly when Metzinger abandoned his Neo-Impressionist style of painting and began to work with the faceting of forms associated with the early years of analytic Cubism. A conversation between Metzinger and the American writer Gelett Burgess in late 1908 or early 1909 reveals a strong affinity for the Fauvism of Matisse:

Instead of copying Nature . . . we create a milieu of our own wherein our sentiment can work itself out through a juxtaposition of colors. It is hard to explain it, but it may perhaps be illustrated by analogy with literature and music. . . . [M]usic does not attempt to imitate Nature's sounds, but it does interpret and embody emotions awakened by nature through a convention of its own, in a way to be aesthetically pleasing. In some such way, we, taking our hint from Nature, construct decoratively pleasing harmonies and symphonies of color expressive of our sentiment.[6]

One painting Burgess saw during his visit to Metzinger's studio reveals that he had by that time abandoned his Neo-Impressionist, mosaic-like brushwork for a flattening and simplification of landscape and figural forms outlined in dark lines (21).

His concurrent interest in the work of Cézanne and the tenets of Fauvism suggests a means by which Metzinger made the transition from Neo-Impressionism to Cubism. By 1908 Metzinger had begun to frequent the Bateau Lavoir, and he exhibited in a group exhibition with Braque at the Berthe Weill Gallery.[7] Although the titles of his Salon entries from 1908–09 are too general to associate with specific paintings (for example, *Paysage*, *Tete de femme*, *Baigneuses*), it is possible that such paintings as *Landscape* (22), or *Nu* (20), which seem to relate to Braque's work of 1907–08, represent the means by which Metzinger transformed his musical analogies and his decorative Neo-Impressionist style into the more robust, analytic Cubism seen in his work of 1910. Burgess's description of Metzinger's work at the time of his visit reveals his method of painting:

Metzinger once did gorgeous mosaics of pure pigment, each little square of color not quite touching the next, so that an effect of vibrant light should result. He painted exquisite compositions of cloud and cliff and sea; he painted women and made them fair. . . . But now, translated into the idiom of subjective beauty, into this strange Neo-Classic language, those same women, redrawn, appear in stiff, crude, nervous lines in patches of fierce color. . . . Picasso never painted a pretty woman, though we have noticed that he likes to associate with them. . . . Derain sees them as cones and prisms, and Braque as if they had been sawn out of blocks of wood by carpenters' apprentices. But Metzinger is more tender towards the sex. He arranges them as flowers arranged on tapestry and wall paper; he simplifies them gently past the frontier of Poster Land to the World of the Ugly so tenderly that they are not much damaged—only more faint, more vegetable, more anaemic.[8]

This description of a painting of a female model by Metzinger might well apply to such a work as *Nu* (20), which seems a transition between the elegant, curvilinear forms of *Baigneuses* (21) and the heavier, more angular forms of *Landscape* (22). The vigorous, parallel brushstrokes and bold outlining of form with heavy, dark lines in *Landscape* are strongly reminiscent of Braque's landscapes from L'Estaque (exhibited by Kahnweiler in November 1908), or perhaps even more clearly of Braque's famous *Nude* of 1907–08 (Collection of Alex Maguy, Paris).

J. M.

1. There is a question about the date of Metzinger's first exhibition at the Galerie Berthe Weill in Paris. Donald E. Gordon gives the date of this exhibition as 19 Jan.–22 Feb. 1903 (*Modern Art Exhibitions: 1900–1916* [Munich: Prestel-Verlag, 1974], 2: 58). However, at this time Metzinger was still living in Nantes and had just sent paintings to the 1903 Salon des Indépendants (*Le Cubisme était né: Souvenirs par Jean Metzinger* [Paris: Editions Présence, 1972], 24.) Later in the *Souvenirs* (p. 34) Metzinger mentions that he exhibited with Berthe Weill only after he had moved to Paris, and after a brief association with the gallery of Père Thomas.

2. Sherry Ann Buckberrough, "Robert Delaunay: The Early Years" (Ph.D. diss., Univ. of California–Berkeley, 1978), 29. Buckberrough's dissertation was published as *Robert Delaunay: The Discovery of Simultaneity* (Ann Arbor, Mich.: UMI Research Press, 1982). She suggests that Metzinger was the more skillful of the two artists during these years, and that Delaunay tended to follow Metzinger's lead.

3. Statement quoted by Georges Desvallières in *La Grande Revue*, vol. 124 (1907), and quoted in Robert Herbert, *Neo-Impressionism* (New York: The Solomon R. Guggenheim Foundation, 1968), 221.

4. Herbert, 221.

5. Buckberrough, 44.

6. Gelett Burgess, "The Wild Men of Paris," *Architectural Record* (May 1910), 413.

7. In the 1908 catalog of the Salon d'Automne Metzinger lists his address as 77 bis, rue Legendre, Paris 17ᵉ, which was close to the Bateau Lavoir.

8. Burgess, 413.

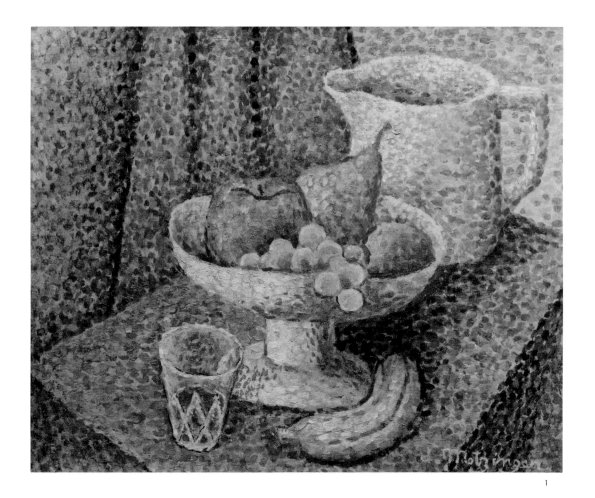

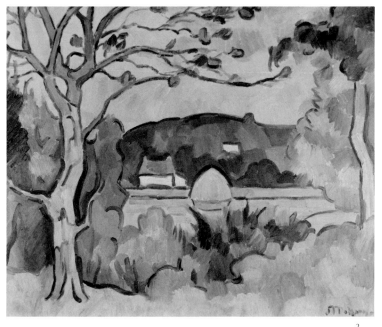

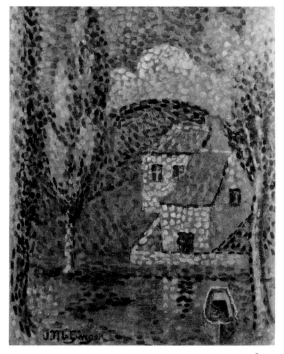

1. **Nature morte**, 1904–05
Oil on canvas
14½ × 17¾ (36.8 × 45.1)
Lent by Mr. and Mrs. Arthur G. Altschul

2. *Landscape*, 1904
Oil on canvas
21⁵⁄₁₆ X 25⅝ (54.0 X 65.1)
The Ackland Art Museum, The University of
North Carolina at Chapel Hill, Ackland Fund

3. *Paysage*, c. 1904–05
Oil on canvas
16⅛ × 13 (41.0 × 33.0)
Musée d'Art Moderne de Troyes. Gift of P.
and D. Levy

6

7

5

4. *Fauve Landscape*, c. 1905
Oil on canvas
8½ X 10½ (21.5 X 26.7)
Collection of Mr. and Mrs. Arthur G.
Altschul

5. *Bord de mer*, c. 1906
Oil on canvas
25⅞ × 35¹⁵⁄₁₆ (65.7 × 91.3)
Indianapolis Museum of Art: The Holliday
Collection

6. *Paysage marin*, c. 1906
Oil on canvas
25¼ × 36¼ (64.0 × 92.0)
Private collection, Paris

7. *Paysage*, c. 1906
Oil on canvas
25½ × 36¼ (65.0 × 92.0)
Private collection

4

8a

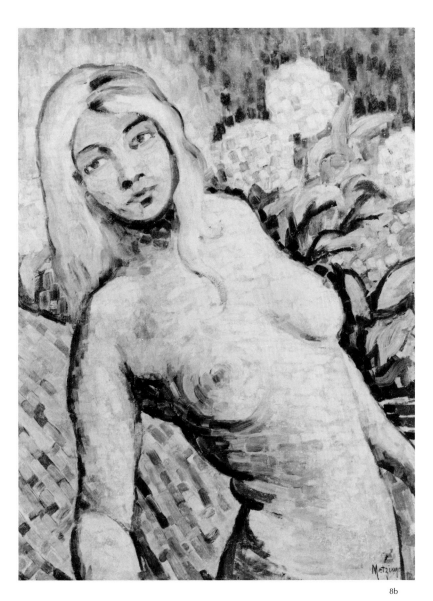

8b

8a. **Paysage avec bateaux à voile**, c. 1906
Oil on canvas
18½ × 25 (47.0 × 63.5)
Lent by Mr. and Mrs. Thomas H. Dittmer

8b. **Nu** (verso of *Paysage avec bateaux à voile*), c. 1906

9. *Portrait of Delaunay*, 1906
Oil
25½ × 21 (64.8 × 53.3)
Location unknown

10. *Parc Montsouris*, c. 1906
Oil on canvas
19⅛ × 26 (48.6 × 66.0)
Private collection, New York
(illus. p. 25)

9

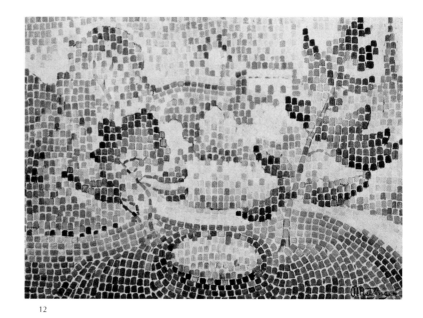

12

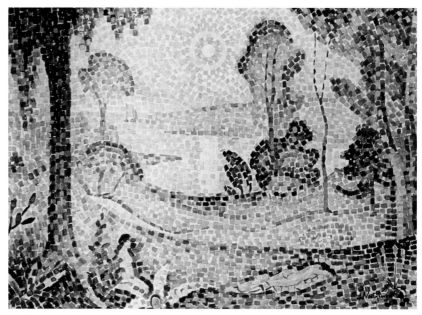

13a

11. *Parc Monceau*, c. 1906
Oil on canvas
20½ × 28 (52.1 × 71.1)
Private collection, New York
(illus. p. 25)

12. *Landscape with Fountain*, c. 1906–07
Oil on canvas
21 × 29 (53.3 × 73.6)
Private collection, New York

13a. *Landscape*, c. 1906
Oil on canvas
28½ X 39¼ (72.5 X 100.0)
Collection Rijksmuseum Kröller-Müller,
Otterlo, The Netherlands

13b. *Coucher de soleil no. 1*
(verso of *Landscape*, 13a)

13b

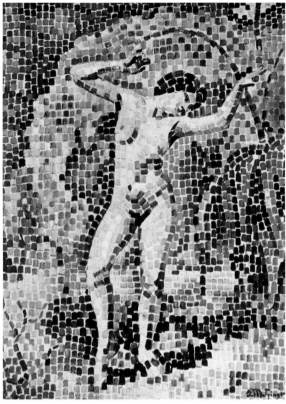

14

14. *Bacchante*, c. 1906
Oil on canvas
28¼ × 20¾ (72.0 × 53.0)
Collection Rijksmuseum Kröller-Müller,
Otterlo, The Netherlands

15. **Two Nudes in a Garden** (Two Figures in
a Garden), c. 1906
Oil on canvas
36 × 25⅛ (91.4 × 63.8)
The University of Iowa Museum of Art, Iowa
City. Gift of Owen and Leone Elliott

16. **Paysage pointilliste**, c. 1906–07
Oil on canvas
21½ × 28¾ (54.5 × 73.0)
Lent by Mr. and Mrs. Herbert M. Lyman
(illus. p. 26)

17. **Les Ibis**, c. 1907
Oil on canvas
21¼ × 28¾ (54.0 × 73.0)
Private collection, Wayzata, Minnesota
(illus. p. 26)

18. **Paysage coloré aux oiseaux aqua-
tiques**, c. 1907
Oil on canvas
29⅛ × 39 (74.0 × 99.0)
Musée d'Art Moderne de la Ville de Paris

19. *Le Flamant rose et le voilier*, c. 1907
Oil on canvas
25½ × 36¼ (65.0 × 92.0)
Private collection, Paris

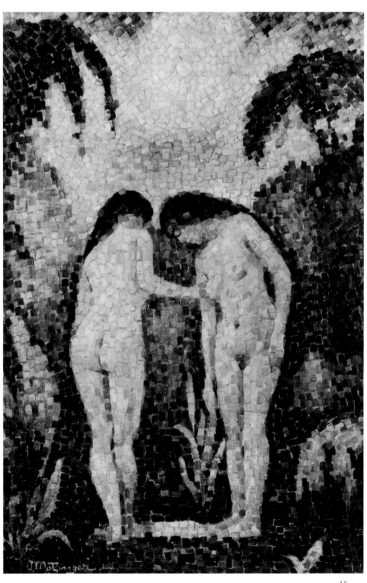

15

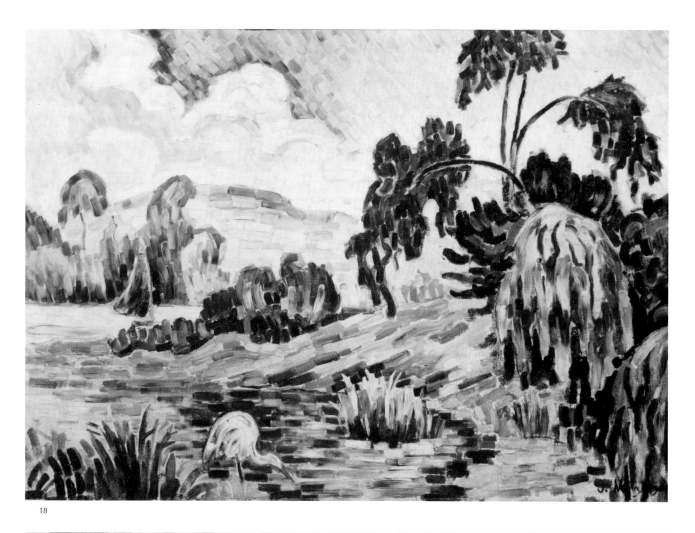

18

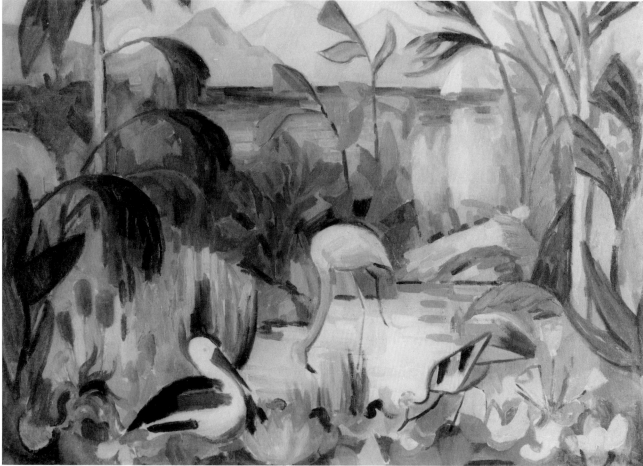

19

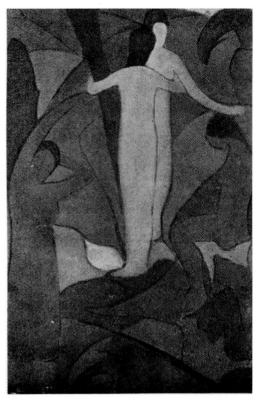

21

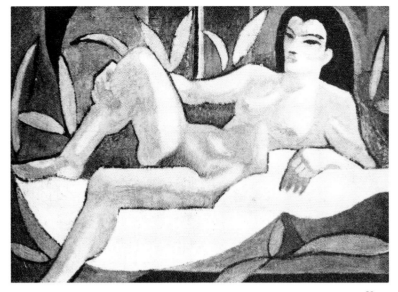

20

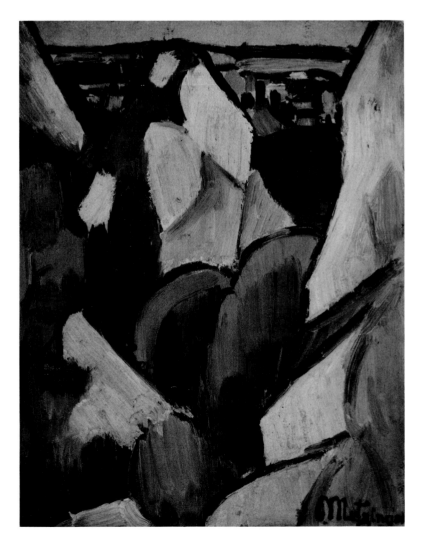

22

20. *Nu*, c. 1908
Oil on canvas
21¼ × 28¾ (54.0 × 73.0)
Location unknown

21. *Baigneuses*, c. 1908–09 (GB)
Location unknown

22. **Landscape**, c. 1909
Oil on cardboard
10⅝ × 8½ (27.0 × 21.5)
Collection Rupertinum, Salzburg

CUBIST WORKS, 1910–1921

Few of Metzinger's early Cubist paintings can be dated with certainty, but some important works can serve as touchstones. The first datable, identifiable works in the Cubist style are Metzinger's *Nude* (23) exhibited in the 1910 Salon d'Automne and his *Portrait of Apollinaire* shown in the Salon des Indépendants that year.[1] *Tea Time* (Le Goûter) (31) was exhibited in the Salon d'Automne of 1911, *Dancer in a Café* (53) in the Salon d'Automne of 1912, and *L'Oiseau bleu* (55) was in the Salon des Indépendants of 1913. *Portrait of Albert Gleizes* (44) and *La Plume jaune* (36) were exhibited in the 1912 Salon de la Section d'Or. *Portrait of an American Smoking* (43) was illustrated on the cover of an exhibition catalog from the Bobbs and Buhl department store, Philadelphia, for an exhibition beginning 10 July 1913, dating this painting to 1911–12.[2]

Metzinger's *Nude* of 1910 is perhaps his closest approach to the analytical Cubist style and concerns of Picasso and Braque. The breakdown of the figure into facets and planes that are integrated with background planes, denying the illusionism of Renaissance perspective and presenting multiple aspects of an object simultaneously, was an approach to painting that Metzinger described in his writing and attempted in this painting.[3]

By 1911, however, in such a work as *Tea Time* (Le Goûter) it is apparent that Metzinger was no longer following the lead of Picasso and Braque in their "hermetic" approach to abstraction that led to the almost total disintegration of recognizable forms. In 1911 Metzinger seems to have begun reintegrating the facets and planes of his previous year's work into more solid, recognizable forms distinct from their surrounding space.

Years later, Metzinger took note of his thoughts about planes and volumes when he was working on *Nu debout* (28) in 1911:

At the time when I worked on this painting, I was thinking of painting since the Renaissance as an illusionistic art. Representing a ball on a flat surface seemed to defy common sense. Only a two-dimensional object can be depicted on a plane, without trickery. Did we have to revert to the flat images of frescoes and antique stoneware? That could not satisfy my sensibility. So I tried to analyze the natural volumes into planes, which by their differences in lighting, dimensions, and placement would allow the viewer to reconstruct the original volumes mentally and to imagine within space the object I had looked at.[4]

Thus the two portraits of Mme. Metzinger (24, 25), which might at first seem to predate the 1910 *Nude* because of their solidity of form, in fact are more closely related to *Tea Time* (Le Goûter) and probably date from 1911 as well. As with *Tea Time*, the facets of the face have a definite geometric quality. The pentagonal form of the plane from the nose bridge to the chin of the Philadelphia portrait (24) is strongly reminiscent of the circles, triangles, and rectangles that characterize the planes of *Tea Time*. Just as Metzinger's compositions retain the monumentality and stability of Renaissance portraiture, his forms retain a sense of solid geometry.[5]

Metzinger seems to be taking a more mathematical, quasi-scientific approach to abstraction that, in comparison with the work of Picasso and Braque, has been considered by some to represent a misunderstanding of Cubism.[6] However, as Richard West has astutely observed:

The continuing confusion between Cubism as a style of painting and Cubism as an aesthetic theory—actually theories—makes it unwise . . . to regard every deviation from the style of Picasso and Braque as a "misunderstanding." . . . Whatever Cubism had to do with the painters of the Section d'Or, it was not operative as a cohesive set of principles about painting but rather as a stimulus. The problems the artists set for themselves and the solutions they adopted, clarified in numerous aesthetic discussions in the studios at Puteaux, Passy, and Montmartre, were of a different nature and indeed different context than those motivating Picasso and Braque.[7]

The period from late 1910 through 1911 was one of the few times when Metzinger's concern for form overcame his love of color. Throughout his pre-Cubist period, color had assumed a major role both as an expressive and a decorative device. Even in one of his earliest Cubist works it played a major role; his controversial *Portrait of Guillaume Apollinaire* exhibited at the 1910 Salon des Indépendants has been described as "streaked with harsh, crude discordant tones."[8] Color in the two portraits of Mme. Metzinger and *Tea Time* (Le Goûter) closely approaches the monochromatic tonalities usually associated with analytic Cubism; but already by 1912, in such works as *Portrait of an American Smoking* (43), *La Plume jaune* (36), *Dancer in a Café* (53), and *Portrait of Albert Gleizes* (44), color has begun to reassert its importance as a compositional and expressive device.

These four paintings, all almost certainly from 1912, suggest that changes came very quickly in Metzinger's style at this time, and that Metzinger probably was working with several different ideas simultaneously. For a brief time in 1911–12, Metzinger seems to have been interested in depicting motion, perhaps under the influence of the Futurists. In both *Le Cycliste* (51) and *Dancer in a Café* (53), he chose subjects for which motion was a natural expressive device. In the former painting the transparency of planes and boldly thrusting diagonals create a sense of a figure passing quickly through one's field of vision, while the audience in the background remains static. In the latter painting, the movement is more staccato because of the repetitious patterns and lines. The wealth of anecdotal detail looks forward to *L'Oiseau bleu* (55) of 1913, which comprises a compendium of motifs found in earlier and later paintings by Metzinger: bathers, fan, mirror, ibis, necklace, a boat with water, foliage, and an urban scene. It is a mélange of interior and exterior elements integrated into one of Metzinger's most intriguing and successful compositions.

Metzinger's predilection for creating numerous variations on a theme was already apparent in his Neo-Impressionist works. The series of women with fashionable accessories, such as a fan, a feather, a striking piece of jewelry, a lace decoration, a cigarette (30–41), suggests his continuing involvement with the fashionable life of Paris while he was exploring the highly intellectual, pseudo-scientific principles of composition and abstraction based on the Golden Section. Within this group it is difficult to establish a chronological sequence, since only *La Plume jaune* (36) can actually be dated. It would seem, however, that *Jeune Femme au collier* (32) was probably done toward the beginning of the sequence, because of its monochromatic colors, the geometric faceting of form, and the naturalistic details of the face and dress. If one assumes that color was becoming more important for Metzinger, and that he was using it in a progressively bolder manner, then the paintings with brighter, more varied colors, such as both versions of *Woman with a Fan* (37, 38) and *La Fumeuse* (40), would be slightly later than both versions of *La Plume jaune* (35, 36). This assumption would also lead one to observe that patterning, in the background as well as on the figure itself, becomes

more important in the later works, and also that there is greater abstraction of form and flattening of space. This line of development appears to be confirmed by Guillaume Apollinaire, who wrote in 1913: "His art, always more and more abstract, but always charming, raises and attempts to solve the most difficult and unforeseen problem of aesthetics."[9]

A group of male portraits from this time seems to show a similar development from the more subtle tonalities and more naturalistic details of *Portrait of an American Smoking* (43) and *Portrait of Albert Gleizes* (44), both from 1912, to the more intensely colored, more highly abstracted *Portrait of Max Jacob* (47) and *Man with Pipe* (48), in which decorative patterning assumes a major role in the composition.[10] *Soldier at a Game of Chess* (49) can probably be dated to 1915–16 because of Metzinger's brief military service in 1915. By that time, Metzinger was moving away from the highly decorative patterning of the previous two years toward a more restrained use of patterning and surface texture, and larger, flatter abstract planes less controlled by geometric forms or rectilinear grids than in his earlier portraits.

It is possible that the *Soldier at a Game of Chess* is a self-portrait. Photographs and paintings of Metzinger almost invariably show him with a cigarette hanging out of the side of his mouth, as, for example, in Delaunay's portrait of Metzinger from 1906 (*Man with a Tulip*, Private collection, Paris) and the portrait by Suzanne Phocas from the 1920s (frontispiece). A cigarette seems to have been a more distinctive trait than a pipe, which appeared much more frequently in Cubist portraits and was not necessarily an identifying characteristic of the sitter. The pipe appeared frequently in the poetry of Mallarmé and, like the siphon, was used as a sexual pun by several of the Cubist painters because of its phallic shape.

The question of identity in Metzinger's portraits is further obscured by titles they have acquired over the years. For example, the study for *Portrait of Apollinaire* (42) would seem to be a study for the *Portrait of an American Smoking* (43), a title which was given the painting as early as 1913.[11] Although Apollinaire did smoke a pipe, the man portrayed in the drawing does not have the round cheeks and double chin characteristic of Apollinaire. The later *Man with Pipe* (48) would seem to resemble Apollinaire more closely, yet it is obviously the same sitter as the *Portrait of Max Jacob* (47). The female portraits of this time all seem to be of Mme. Metzinger, suggesting a personality development from the sweet, modest young woman of the 1911 portraits to the more urbane, sophisticated sitter of *La Fumeuse* (40). The theme of the stylish woman continues in Metzinger's oeuvre through 1917, and reappears in the 1920s with his second wife Suzanne Phocas as the model.

Although still life elements appear in most of Metzinger's figure paintings, at times quite prominently, there seem to be relatively few still life paintings before 1916–17. One work that does appear to be from 1911–12 is the drawing *Composition à la carafe et verre de vin* (79). The resemblance of the carafe and the wineglass to mechanical forms, such as gears and pulleys, suggests a relation to the forms used by Marcel Duchamp in such paintings as *Nude Descending a Staircase* or *Coffee Grinder*. In fact this drawing might well relate to a project initiated by Raymond Duchamp-Villon in which he asked several artists of the Puteaux group—Gleizes, Metzinger, La Fresnaye, Léger, and Duchamp—to make pictures to decorate his kitchen in Puteaux. Marcel Duchamp made an exploding coffee grinder in which the gear wheels are above and the knob is seen simultaneously at several points in its circuit. Furthermore, the drawing technique in *Composition à la carafe*

et verre de vin—bold lines, abstracted forms, and strongly shaded areas—is much like the drawings for the *Portrait of Albert Gleizes* (45, 46), almost certainly dating from 1911–12.

Based on a comparison with *La Fumeuse*, Metzinger's *Coffee Grinder, Coffee Pot, Cigarettes, and Glass* (82) seems to be of a slightly later date, perhaps 1914–15. The rectangular divisions of the canvas, the simultaneous views of a single object, the heavily textured application of paint, and the handling of the cigarette box suggest that these paintings might have been done at approximately the same time. But the diagonal elements at each of the four corners in *Coffee Grinder* are a device common to Metzinger's work of 1915 and thereafter, such as *Landscape through a Window* (137), dated 1915, and *Still Life* (83), dated 1916.

As with the still lifes, there are few early dated landscape paintings upon which to structure a chronology of Metzinger's development. *Cubist Landscape* (128) was reproduced in the *Bulletin de l'Effort moderne* of April 1924 and dated 1912. *The Harbour* (123) was reproduced in the original 1912 version of *Du «Cubisme»*, and *Landscape* (125) was reproduced in the 1913 English version of this book. *The Bathers* (127) is dated 1913 on the stretcher, and *Village, église, et deux personnages* (133) is also dated 1913 on the verso.[12] *Landscape through a Window* is dated 1915 on the canvas, and it is not until 1917 that we have other dated landscapes.

Because *Du «Cubisme»* was published in 1912 and *The Harbour* (123) was reproduced in it, one can assume that this painting dates from 1911, or perhaps early 1912 at the latest. Its flattening of space and strong reliance on line to define form relate it to a group of landscapes (121, 122, 124–127) that probably also date from that time. Of this group, the three that have been located (121, 124, 127) are all painted in relatively subdued tonalities: *Sailboats* (121) primarily in blue and green tones, *Paysage cubiste* (124) in grays with other muted colors, and *The Bathers* (127) in tones of brown and orange. This use of color, line, and space relates these works to such paintings as *Tea Time* (Le Goûter) (31) and *Portrait of an American Smoking* (43). The more varied pastel colors of *Cubist Landscape* (128), however, relate it to such works as *La Plume jaune* (36) and *Dancer in a Café* (53), also from 1912.

The increasing importance and variety of color in Metzinger's work of late 1912 and 1913 lead one to question the date of 1913 written on the stretcher of *The Bathers* (127). Also inscribed on the verso of this painting is "Meudon," a suburb of Paris where Metzinger spent his summers from 1911 to 1913, and where Albert Gleizes came to visit him on several occasions, resulting in Gleizes's *Landscape at Meudon* of 1911 (Musée National d'Art Moderne, Paris). The cylindrical chimney form next to a body of water in *Bathers* (127) and *Sailboats* (121) suggests that both scenes are of Meudon, and the strong stylistic similarities between the two paintings indicate that both may have been done in 1912, prior to Metzinger's *Cubist Landscape* (128), in which there is a greater sense of deep space, solid form, and varied colors. Furthermore, the rectilinear geometric abstraction of form in *Bathers* relates it more closely to Metzinger's work of 1911–12, such as *Tea Time* (Le Goûter), than to the less regular forms in his paintings of 1913.

Village, église, et deux personnages (133) provides a touchstone for Metzinger's landscapes of 1913. Two landscape drawings (130, 131) seem to provide a link between this painting and the earlier *Bathers* (127) and *Cubist Landscape* (128). Trees become an important framing device at the right and left edges of the composition, and an angular path leads the eye back into space. With the exception of *Landscape* (132), all the

compositions are characterized by a bird's-eye view of the scene, highly stylized foliage, and angular forms.

A serious question arises, however, when this group of landscapes (130–134) is compared to *Le Village* (158), dated 1919 on the verso, and two other landscapes dated 1919 (161, 162). There are enough similarities between the two groups of landscapes to question whether they may not be closer in date. The shapes of the buildings in *Le Village* are similar to those in *Landscape* (132) and *Village, église, et deux personnages* (133). The treatment of the brick wall in the latter two paintings is much like that in *Paysage* (162). There is a strong similarity in the stylization of the tree foliage in both groups, and the textural patterns of *Paysage* (134) are reminiscent of those in the 1919 landscapes (161,162). Perhaps the discovery of additional dated landscapes will resolve this uncertainty.

The increasing emphasis on bold textures and decorative patterns in Metzinger's works of 1914 indicate that *Paysage* (134) may have been done in late 1913 or 1914. The use of abstracted trees as framing devices and the heavily textured foliage of the trees in *Landscape* (136) link the two paintings, although the "avis" ("warning") sign in the center foreground suggests that *Landscape* was done after the beginning of World War I, when such signs appeared in the countryside. The zigzag path at the lower left of this painting relates it to the earlier group, but now the path is more of a landscape pattern than a device for leading the eye into space. The strong emphasis on diagonals that organize the composition relates this work to *Landscape with Roofs* (135), in which space is also flattened by the overall patterning of form. The diagonal elements in each of the corners serve as a framing device that characterizes Metzinger's landscapes and many of his other works from 1914 through 1918.

The bold patterning, heavy textures, strongly defined planes, and bright colors of such paintings as *Portrait* (59) or *Cubist Portrait* (60) create a sense of frenzied activity on the picture plane, much like the dynamism of the Guggenheim *Landscape* (136). Although the earlier female portraits were readily identifiable as Mme. Metzinger, the abstract forms and patterns of these two paintings so dominate the composition that the identity of the sitter becomes secondary. Especially in the Fogg *Portrait* (59), visual puns and double entendres enhance the complexity of the composition. The wood-grained, rectangular form in the central part of the composition resembles a picture frame from which the sitter's head emerges. The light-colored area extending down the center from the top edge through the sitter's neck suggests the form of a wineglass. A prominent flower adorns a rather masculine top hat on the sitter's head, while a wallpaper-like flower pattern decorates the hairdo of the *Cubist Portrait* (60) from Dartmouth. As in the case of the male portraits of 1914, these bright, active, colorful paintings seem to mark a time just before the reality of World War I sobered Metzinger's palette.

Head of a Woman (61), exhibited at the Carroll Gallery in New York in April 1916, reveals that by late 1915 or early 1916, probably just after Metzinger's military service, he began to move away from strong emphasis on texture, pattern, and surface activity. Color retains a prominent role in his compositions, but it is more restrained and harmonious. The owner of this painting has observed that its colors are "jewel-like," reminiscent of amethysts, rubies, sapphires, and emeralds, in keeping with the theme of the jeweled necklace worn by the sitter. This painting seems to mark a transition between the earlier portraits of stylish women and the later, more intimate female portraits, such as the several versions of *Femme au miroir* (64, 65, 66). While the earlier portraits emphasized clothing, pat-

terns, and accessories—the public image—the later figures are shown nude, grooming themselves—the private person. One is tempted to speculate that Metzinger's stint as a medical orderly in 1915, and the continuing atmosphere of disruption, loss, and destruction, was a sobering experience that redirected his interest from the externals of the gay Parisian life to a more introspective approach to his subjects. The simultaneously clothed and unclothed figure in *Head of a Woman* (61) seems to link the two groups not only thematically, but stylistically as well. The color areas of the later works are larger and more cohesive, and the shapes are much less related to geometric forms.

Beginning in 1916 many more still lifes by Metzinger are dated on the canvas, allowing for a more precise chronology of his stylistic development. In fact the inclusion of months as part of the dates sometimes allows us to document changes within a single year. The two paintings dated June 1917 (86, 87) and the two dated October 1917 and November 1917 (88, 89) reveal that Metzinger became much more interested in bold patterning and decorative detail toward the end of that year, and was more likely to integrate typography into the composition. There are fewer touchstones in 1918, but the two paintings dated February 1918 (93) and April 1918 (94) suggest that decorative patterning remained important for Metzinger, at least in the first half of that year. Small circular forms, representing pipe bowls, bottle openings, cup rims, clocks, fruit, or simple dot patterns, unite various areas of the composition, at times suggesting witty visual puns, such as eyes or olives. As in the figure paintings of 1918, oval forms and the oval format become more prominent.

On the verso of *Fruit and Jug on Table* (99) is inscribed "Peint par moi en 1916 Metzinger." The muted colors, the arrangement of still life items on a table distinct from the floor and background areas, and the dominance of curvilinear rather than angular forms relate this painting more closely to those of 1918. It is probable that Metzinger wrote this inscription many years later when his memory of the exact year was imprecise.

If one knew more details of Metzinger's life, it might be easier to identify the locales of his landscapes; but without such information, one can only guess. Tiled roofs, bright colors, and the presence of water seem to suggest southern France, perhaps the area around Bandol where Metzinger had a second home.[13] Those elements are present in a group of impressive paintings (138–141) from around 1916, all of which appear to depict the same locale. The Fogg *Landscape* (141) seems to be a compendium of motifs from the other three paintings juxtaposed in a vertically compartmentalized structure.[14] There is a playful aspect to this group of paintings, such as the double entendre of trees and sailboats in the Museum of Modern Art *Landscape* (138), the transformation of the bench-like form in the Fogg *Landscape* (141), the tree trunks at the left in the St. Louis painting (139) that resemble gun or cannon barrels, and the highly stylized tree foliage that suggests clouds or hills. The bold compositional device of juxtaposing strongly contrasting perspectives, scales, textures, and colors seems to be unique to the Fogg painting, although the juxtaposition of brightly colored and monochrome gray areas appears at least once again in a painting of 1917, *The Factory* (145).

Beginning in 1917 the scene of Metzinger's landscapes changes to a more urban, industrialized region. The checkered flag of a French railroad crossing recurs frequently, and utility poles, factories, smokestacks, and railroad tracks become prominent motifs. The smokestack and aqueduct in *L'Usine* (142) are reminiscent of Metzinger's earlier work *The Bathers* (127), depicting Meudon, which might or might not be the

locale represented in these works of 1917. *Vue des toits et des maisons* (144) and *The Factory* (145) seem to be transitional works between the earlier rural landscapes and the urban ones of 1917.

Toward the end of 1917 the scene of Metzinger's landscapes seems to change once again. In a painting dated September 1917 (152), Metzinger portrays a rural setting that appears to be different from that of his earlier landscapes. Darker, more somber earth tones replace the bright, intense colors reminiscent of southern France. The paintings convey a cooler atmosphere with larger, more prominent trees and more subdued light. The area depicted might be the region around Beaulieu-près-Loches in the Loire Valley, where Metzinger went to visit Juan Gris and his wife.[15] Entrance to the medieval city of Loches is through the thirteenth-century Porte Royale with its twin towers, which might be the subject represented in *Coin du rue* (150). The two elongated arched windows in *Paysage village* (153) might represent the church at Loches, while the château represented in *Le Château* (154) is doubtless the château at Loches, which overlooks the river from the summit of a hill in the center of town. The latter work is dated January 1918 on the stretcher, suggesting that the area around Loches might have been the locale of Metzinger's landscape paintings in late 1917 through early 1918.

A painting dated 18 April, *Paysage oval* (156), is very different in style, color, and mood from the Loches landscapes, indicating still another locale. The angular forms and strongly decorative patterning relate directly to one of Metzinger's most abstract works, *Composition* (155), which probably also dates from 1918.

By 1918 decorative patterns reemerge as important compositional elements in such works as *Homme assis devant la table* (67) and *Woman with Compote* (68), while still life elements assume a greater role in the composition. Also the colors have become more subdued, even somber, at this time.[16]

Metzinger's tendency to repeat themes in paintings several years apart complicates the task of dating works of art by analogy. Thus the drawing *Woman with a Fan* (71) might seem to relate to *Head of a Woman* (61), c. 1916, or *Femme à la dentelle* (62), c. 1916, if one were not aware of the painting *Woman with Necklace and Fan* (73), dated 1919. Although the drawing is dated 1916 beneath the signature, it is quite unlikely that three years intervened between it and the painting. Another related drawing (72) is undated, but stylistically the two drawings and the painting are much more closely tied to Metzinger's work of 1919 than to any work of 1916. The oval format appeared rarely, if at all, in Metzinger's work before 1918, and since the forms relate closely to other dated works of 1918-19, it seems prudent to accept the accuracy of the date on the painting and question the date of the drawing.

In 1919 surface textures and a relatively thick application of paint continue to be an important aspect of Metzinger's painting style, but decorative patterning becomes somewhat more restrained. The still life composition of objects on a table becomes more distinctly separate from the background, which is usually reduced to abstract tonal areas. Although several works are dated 1919, and by comparison we can date numerous other works to that year, only *Nature morte à la mandoline* (114) is dated by month. The forms in this painting are larger and more simplified than in the earlier still lifes, and decorative patterning has been reduced to the block-like brushwork texture that enlivens the flat color areas. Balance and simplicity replace activity and details, pointing the way to the classicism that characterizes Metzinger's work of the early 1920s.

By 1920 the sharp angularity of the earlier still lifes has been replaced almost completely by curvilinear rhythms. Objects are beginning to be shaded and to resume a sense of three-dimensional form. In three still lifes dated 1921 (118-120), shading and perspective space become progressively more important as the table with objects emerges even more distinctly from the surrounding space. Only traces of Cubism remain in the greatly simplified faceting of some forms, and classical modeling and stable form have clearly replaced the Cubist abstraction of Metzinger's earlier work.

The two landscapes dated 1919 (161, 162) mark the beginning of a series of landscapes that preoccupies Metzinger through 1921. Characterized by simplified, highly stylized, quasi-geometric forms, these landscapes focus on the exterior walls and roofs of buildings, trees, brick walls, and sometimes a port or harbor with boats.[17] The landscapes of 1919-20 reveal a greater emphasis on the prominent patterning of brushwork, while the scenes from 1921 are somewhat more curvilinear in form and composition.

Metzinger's work from 1918-21 can be described as "classical Cubism," a term that characterizes most of the work by artists in the Léonce Rosenberg circle after 1916. This style has been described as "an alliance between Cubist pictorial method and classical aesthetics."[18] His work represents a dialogue between abstraction and representation expressed through an emphasis on clarity, purity, and structure in a synthetic Cubist idiom. Metzinger's landscapes of 1920-21 retain only the most tenuous relation to Cubism. The best of them, however, attain a sense of balance, harmony, and even mystery that deserves recognition as an important achievement in Metzinger's development.

While Metzinger was one of the earliest and most articulate spokesmen for Cubism, his work did not go unnoticed. By 1920 he had garnered substantial recognition and acclaim as an artist. In a letter to the art dealer Kahnweiler, Juan Gris remarked that he himself had been "somewhat passed over at the Indépendants. There's no explanation for Metzinger's success: even he must be rather surprised."[19]

J. M.

1. The present location of both paintings is unknown. *Nude* (23) was discussed by Roger Allard in his review "Au Salon d'Automne de Paris," *L'Art libre*, Nov. 1910, 442. Apollinaire hailed this portrait as the first Cubist portrait in *Les Peintres cubistes* of 1913, but his reaction at the time it was first shown was less accepting of the new approach it represented, as expressed in *L'Intransigeant*, 1 October 1910.

2. Aaron Sheon, "Forgotten Cubist Exhibitions in America," *Arts Magazine*, March 1983, 94. The exhibition opened at Gimbels in Milwaukee on 11 May 1913, so it is probable that the painting was completed by the end of 1912. This might be the painting titled "L'Américain" that was shown in the exhibition at the Galerie Berthe Weill in January 1913.

3. Jean Metzinger, "Note sur la peinture," *Pan*, Paris, October-November 1910.

4. Jean Metzinger in *Le Cubisme 1911–1918* (Paris: Galerie de France, 1945). (A l'époque où j'exécutai ce tableau, je considérais la peinture depuis la Renaissance, comme un art d'illusionniste. Le fait de représenter une boule sur une surface plané me semblait un defi au bon sens. Sur un plan on ne peut, sans truquage, représenter qu'un object sans épaisseur. Fallait-il revenir aux images plates des fresques et des poteries antiques? Ma sensibilité ne pouvait s'en contenter; alors je tentais de décomposer les volumes naturels en plans qui, par leurs différences d'éclairage, de mésure, de situation, devaient permettre aux spectateurs de reconstruire mentalement ces volumes, d'imaginer dans l'espace le corps considéré.)

5. For an excellent analysis of Metzinger's involvement with geometry at this time, see Linda Dalrymple Henderson, *The Fourth Dimension and Non-Euclidean Geometry in Modern Art* (Princeton, N.J.: Princeton University Press, 1983), 85ff.

6. For example, Douglas Cooper in *The Cubist Epoch* (New York: Phaidon,

1971), 76–77, evaluates Metzinger as follows: "Metzinger was a painter of little imagination and no originality, who seized on the plane and faceting in the analytical painting of Braque and Picasso and tried to use the same technique himself. . . . Metzinger did not properly comprehend the pictorial logic or structural significance of Picasso's methods."

7. Richard W. West, *Painters of the Section d'Or: The Alternatives to Cubism* (Buffalo, New York: Albright-Knox Gallery, 1967), 9.

8. G. Lemaître, *From Cubism to Surrealism in French Literature* (Cambridge, Mass.: Harvard University Press, 1941), 78.

9. Guillaume Apollinaire, *Apollinaire on Art: Essays and Reviews 1902–1918*, ed. Leroy C. Breunig (New York: Viking Press, 1960), 35.

10. A painting titled *Le Fumeur* (which may be one of these two paintings) was exhibited by Metzinger in the 1914 Salon des Indépendants.

11. In 1912 Walter Pach escorted Walt Kuhn and Arthur B. Davies through the studios of the Puteaux Cubists to make selections for the forthcoming Armory Show. Perhaps this is a portrait of one of these three Americans. Although Picasso recommended that Metzinger be included in the Armory Show (Walt Kuhn papers, Archives of American Art, reproduced in *Archives of American Art Journal* 20, no. 1 [1980]: 15), and Metzinger's name was included in the press release of 12 Dec. 1912 that announced the participants in the Armory Show, no works by Metzinger were shown in this important exhibition.

12. The painting is signed on the recto and signed again and inscribed on the verso: "Je certifie que ce tableau a été exécuté par moi en 1913." The wording of this inscription suggests that Metzinger may have added it at a later date. The script is such that the date might be read as 1918.

13. Juan Gris moved to Bandol in 1920, but it is possible that Metzinger had a home there several years earlier.

14. The Fogg *Landscape* has traditionally been dated 1912, based on information the donor of the painting received from the Paris gallery from which he bought the painting. As documentation for the 1912 date, the gallery cites the reproduction of this painting on "p. 95" of Herwarth Walden's *Einblick in Kunst* of "1912," which is an inaccurate reference since this book was published in 1917 and the reproduction of this painting is on p. 111.

15. There is some question about the actual date of this visit to Gris. Irene Patai in *Encounters: The Life of Jacques Lipchitz* (New York: Funk and Wagnalls, 1961), 179–80, states that Metzinger, Jacques Lipchitz, Victor Huidebro and his wife, and Maria Blanchard visited Juan Gris in Beaulieu in April 1917. However, in the *Letters of Juan Gris: 1913–1927*, trans. and ed. Douglas Cooper (London: 1956), there is no indication that Gris was in Beaulieu-près-Loches at this time. In a letter of 21 June 1918 to Paul Dermée (p. 55), Gris states that Metzinger had just arrived, not indicating whether it was his first visit or not.

16. It is thought that Metzinger's first wife died in the flu epidemic of 1918, which suggests a possible reason for the more somber tonalities.

17. Shortly before his death in 1956, Metzinger signed a certificate for *City Landscape* (167) that states that the painting was done in 1915. Stylistic analogies make it clear that it is part of the group of landscapes from 1919–21. This would seem to be an instance when Metzinger's memory failed him.

18. Christopher Green, *Léger and Purist Paris* (London: The Tate Gallery Publications Dept., 1970), 32.

19. *The Letters of Juan Gris*, 77.

24

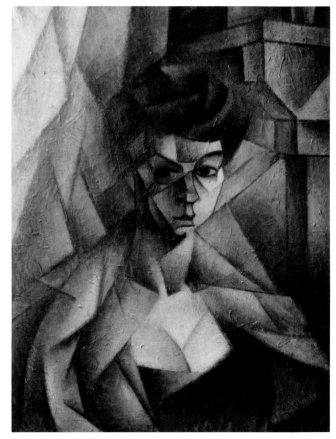

25

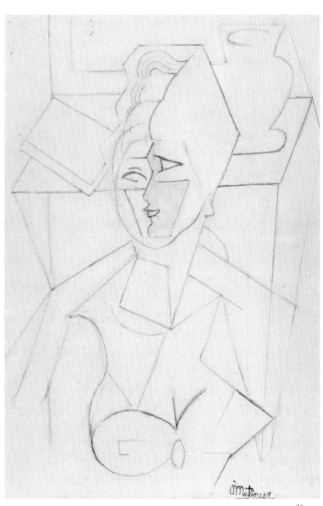

26

23. *Nude* (Nu à la cheminée), 1910 (EF)
Oil on canvas
Dimensions unknown
Location unknown

24. *Madame Metzinger*, c. 1911
Oil on canvas board
10½ X 8¼ (26.7 × 21.0)
A.E. Gallatin Collection, Philadelphia Museum of Art

25. *Dame au décolleté*, c. 1911
Oil on canvas
28¾ × 23⅝ (72.9 × 60.0)
Private collection, New York

26. *Portrait de femme*, c. 1911
Pencil on paper
12¼ × 9½ (31.0 × 24.0)
Collection of Herman Goldsmith, New York

27. *Two Nudes*, 1910–11 (JG)
Oil
Location unknown

28. *Nu debout*, 1911 (AGJM)
Location unknown

29. *La Femme au cheval*, 1911 (AGJM)
Location unknown

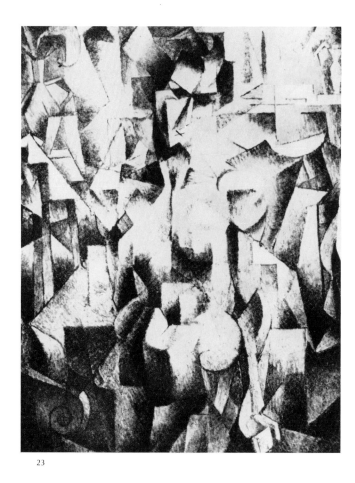

23

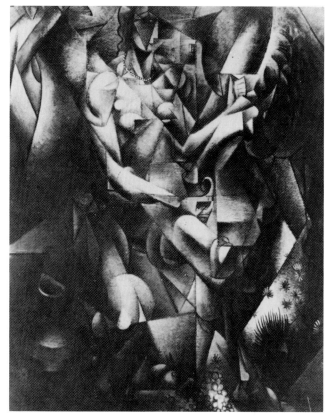

29

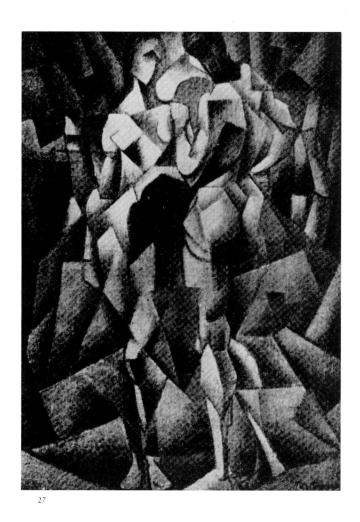

27

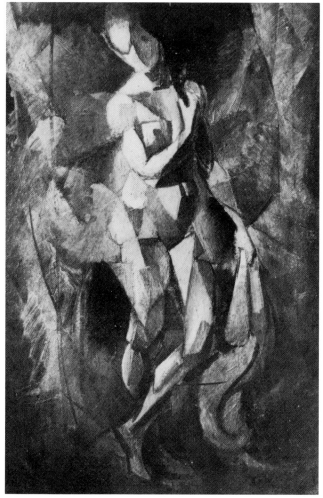

28

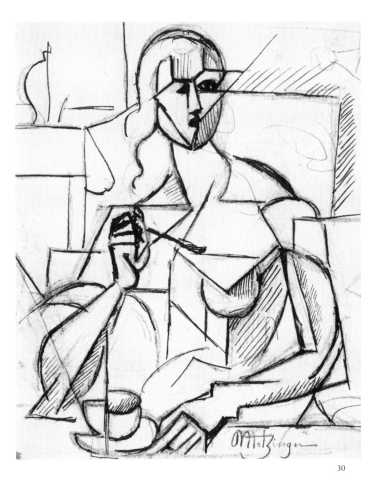

30

30. Study for Tea Time (Le Goûter), c. 1911
Pencil and ink on grey paper
7½ × 6 (19.0 × 15.0)
Lent by the Musée National d'Art Moderne,
Paris
UI, UT only

31. Tea Time, (Le Goûter, Woman with a
Teaspoon, La Joconde du Cubisme, Mona
Lisa with a Teaspoon), 1911
Oil on cardboard
29⅞ × 27⅜ (75.9 × 70.2)
Lent by the Philadelphia Museum of Art,
Louise and Walter Arensberg Collection
UI, CI only

31a. Jacques Villon, French (1875–1963)
Seated Woman (after Metzinger, *Tea Time*),
1929
Color aquatint
21 x 20 (53.3 × 50.8)
Lent by the Bass Museum of Art, Gift of John
and Johanna Bass
(not illus.)

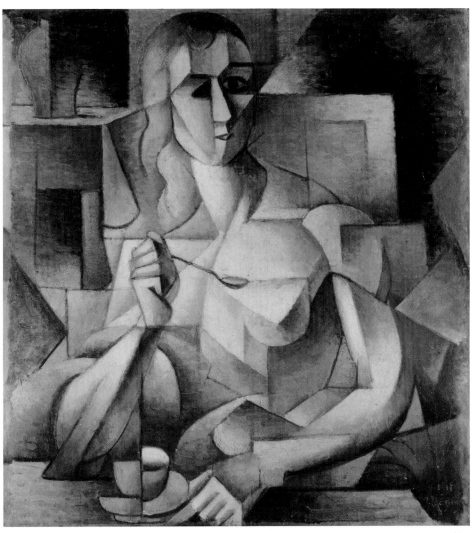

31

32. *Jeune Femme au collier*, 1912
Oil on canvas
28¾ × 21¼ (73.0 × 54.0)
Petit Palais, Geneva

33. **Tête d'une fille**, c. 1913
Charcoal on paper
18¾ × 12¾ (47.6 × 32.4)
Lent by David Markin

34. **La Femme à la fenêtre** (Maternité),
c. 1911–12
Oil on canvas
36 × 25½ (91.5 × 63.5)
Lent by Murray A. and Ruth Gribin

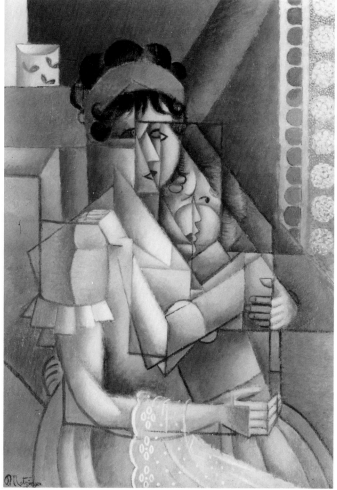

34

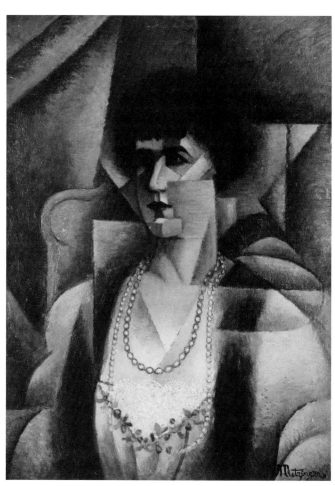

32

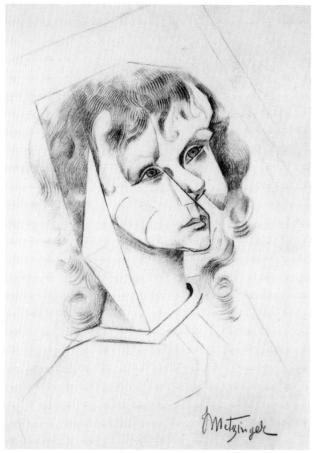

33

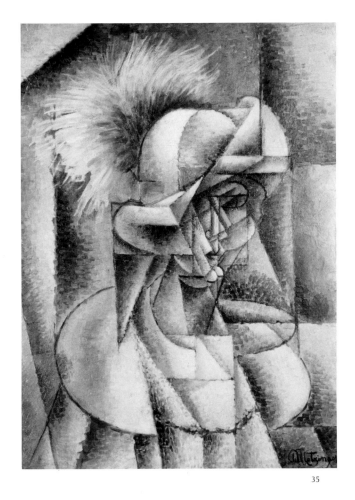

35

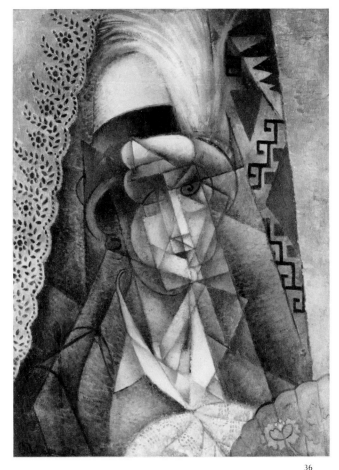

36

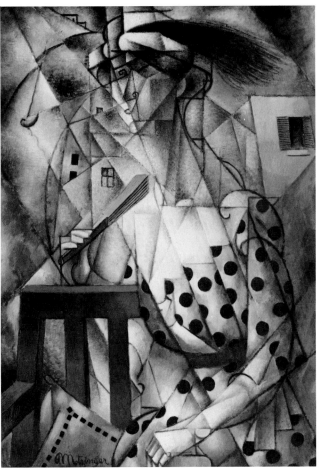

37

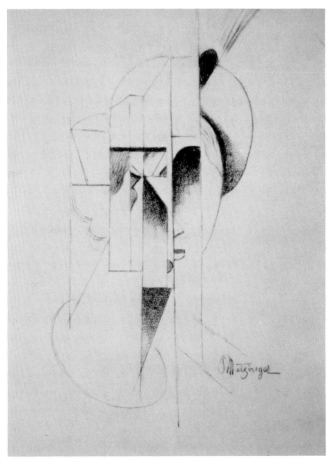

39

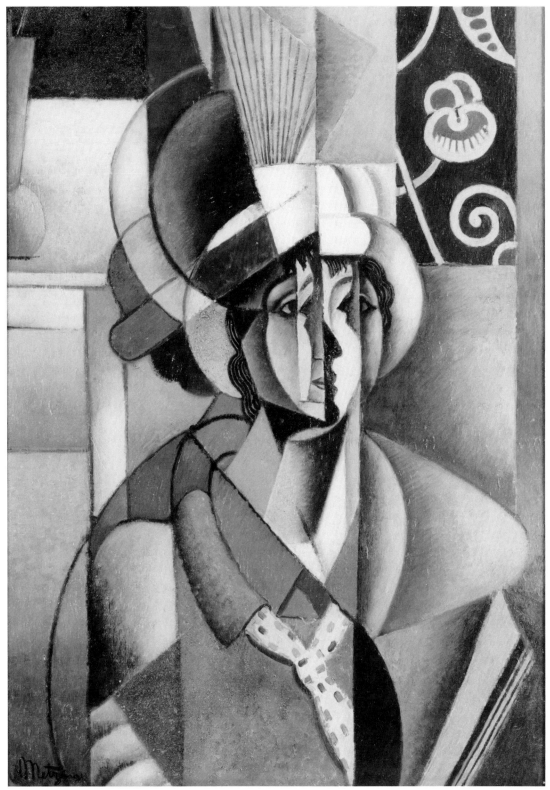

38

35. *The Yellow Feather* (La Plume jaune), c. 1912
Oil on canvas
28 × 20½ (71.1 × 52.1)
Private collection, Chicago

36. **La Plume jaune**, 1912
Oil on canvas
28¾ × 21¼ (73.0 × 54.0)
Lent by Mr. and Mrs. R. Stanley Johnson
(front cover illustration)

37. *Woman with Fan*, 1912–13
Oil on canvas
35¾ × 25¼ (90.7 × 64.2)
Gift of Solomon R. Guggenheim, 1938. Solomon R. Guggenheim Museum, New York

38. **Woman with Fan** (La Femme à l'éventail), c. 1913
Oil on canvas
36½ × 25⅝ (92.8 × 65.2)
Courtesy of the Art Institute of Chicago. Gift of Mr. and Mrs. Sigmund W. Kunstadter

39. **Femme au chapeau**, c. 1912–13
Charcoal on buff paper, mounted on board
23¼ × 18⅛ (61.0 × 47.5)
Private collection, Geneva

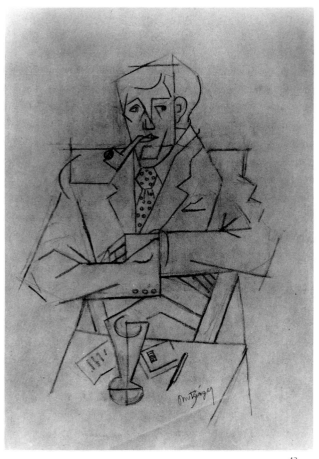

42

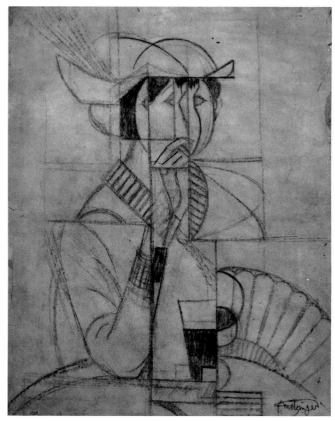

41

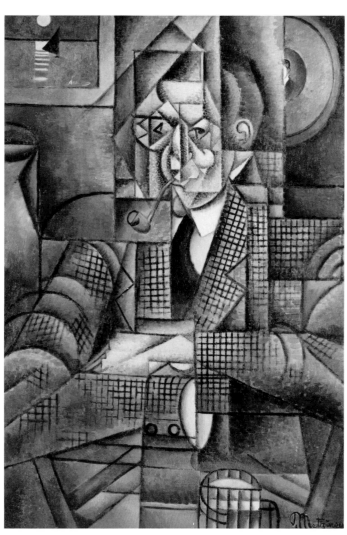

43

40. **La Fumeuse** (The Smoker), c. 1913–14
Oil on canvas
36 × 25½ (92.0 × 65.0)
Collection Margit and Rolf Weinberg,
Switzerland
(illus. p. 27)

41. Study for *The Smoker* (La Fumeuse),
c. 1913–14
Charcoal
22⅛ × 17¾ (56.1 × 45.2)
Collection, The Museum of Modern Art,
New York. The Joan and Lester Avnet
Collection

42. Study for *Portrait of Apollinaire*,
c. 1911–12
Pencil on pink paper
28¾ × 11¾ (42.0 × 30.0)
Musée National d'Art Moderne, Paris

43. **Portrait of an American Smoking**,
c. 1912
Oil on canvas
36½ × 25¾ (92.7 × 65.4)
Lent by Lawrence University, Appleton,
Wisconsin

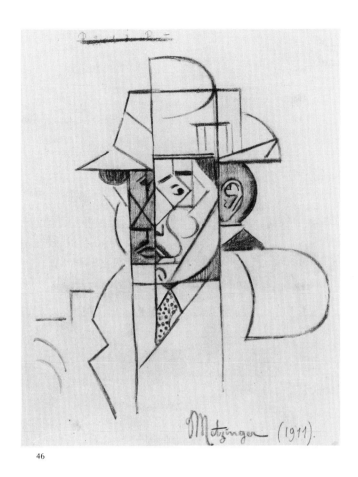

46

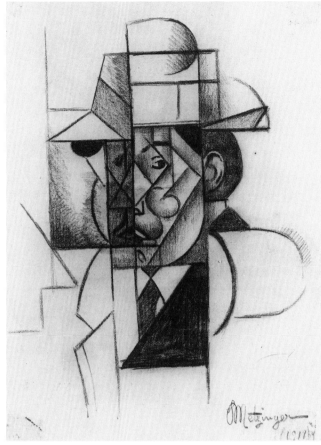

45

44. *Portrait of Albert Gleizes*, c. 1911–12
Oil on canvas
25¼ × 21¼ (65.0 × 54.0)
Lent by the Museum of Art, Rhode Island
School of Design, Paris Auction Fund and
Museum Works of Art Fund, 66.162

45. Study for *Portrait of Albert Gleizes*, 1911
Pencil on paper
7⅞ × 6⅛ (20.0 × 15.5)
Musée d'Art Moderne de la Ville de Paris

46. Study for *Portrait of Albert Gleizes*, 1911
Pencil on cream paper
8¼ × 6⅛ (21.0 × 15.5)
Musée National d'Art Moderne, Paris

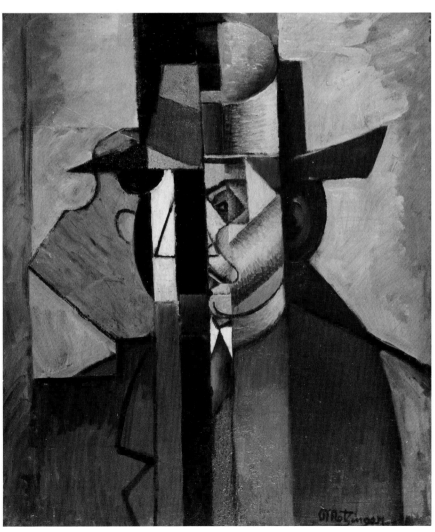

44

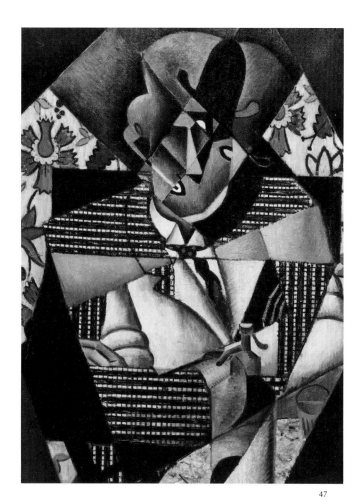

47

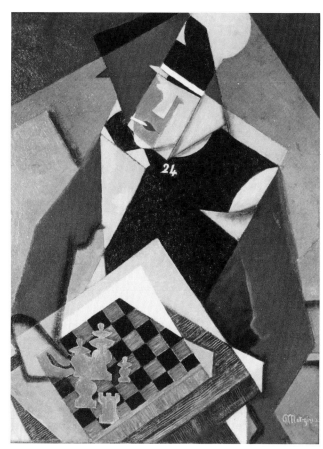

49

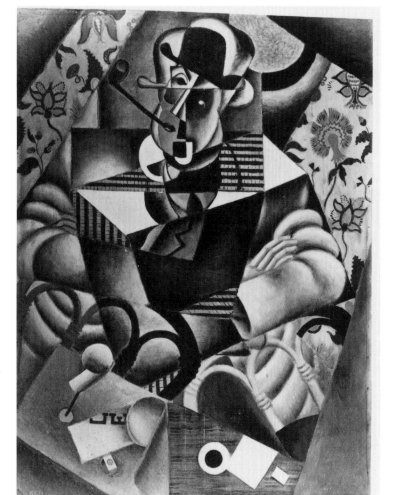

48

47. **Portrait of Max Jacob**, c. 1913–14
Oil on canvas
36½ × 25¾ (92.7 × 65.4)
Collection of Mr. and Mrs. Joseph Randall Shapiro
UI, UC only

48. **Man with Pipe**, c. 1913–14
Oil on canvas
51½ × 38¼ (130.8 × 97.2)
Lent by the Museum of Art, Carnegie Institute, Pittsburgh. Gift of G. David Thompson
UI, CI only

49. **Soldier at a Game of Chess**, 1915–16
Oil on canvas
32 × 24 (81.3 × 61.0)
Lent by The David and Alfred Smart Gallery, The University of Chicago, Chicago, Illinois. The John L. Strauss Collection

50

51

50. **Study for *Le Cycliste***, c. 1911–12
Charcoal on paper
13⅝ × 11 (34.5 × 28.0)
Lent by Mr. and Mrs. R. Stanley Johnson

51. *Le Cycliste*, 1911
Pencil and charcoal on beige paper
15 × 10¼ (38.0 × 26.0)
Musée National d'Art Moderne, Paris
UI, UT only

52. *The Racing Cyclist* (The Cycle-Racing
Track, Au vélodrome), c. 1911–12
Oil with sand and paper on canvas
51⅜ × 38¼ (130.4 × 97.2)
Peggy Guggenheim Collection, Venice; The
Solomon R. Guggenheim Foundation, New
York

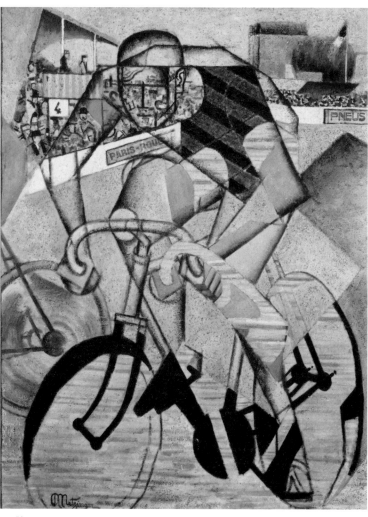

52

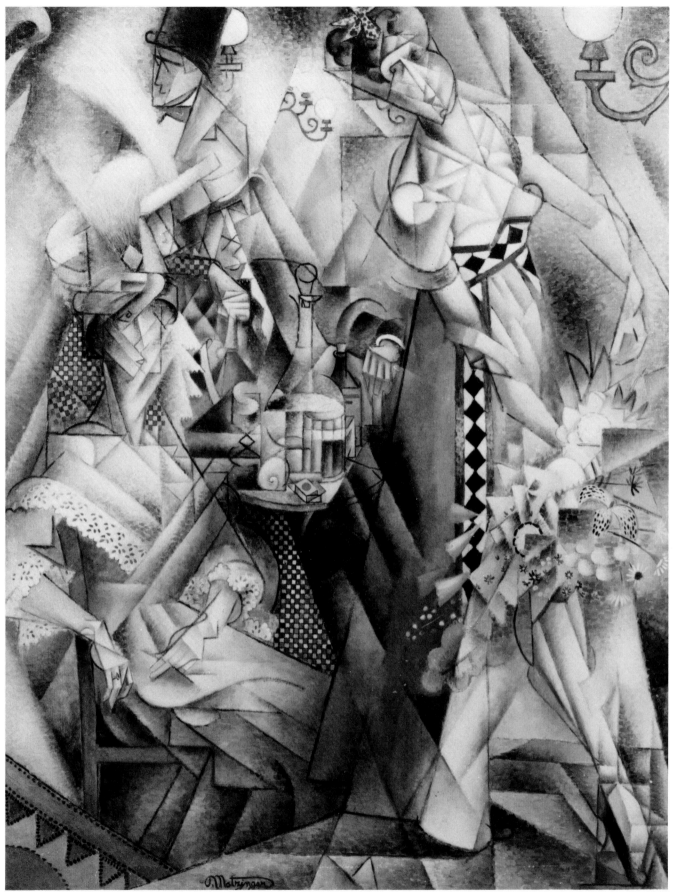

53. *Dancer in a Café*, 1912
Oil on canvas
57½ × 45 (146.1 × 114.3)
Collection of Albright-Knox Art Gallery, Buffalo, New York. General Purchase Funds, 1957
(back cover illustration)

54. **Study for *L'Oiseau bleu***, 1913
Pen drawing with watercolor on cream paper
14½ × 11⅜ (37.0 × 29.5)
Musée National d'Art Moderne, Paris
UI, UT only

55. *L'Oiseau bleu*, 1913
Oil on canvas
90½ × 77⅛ (230.0 × 196.0)
Musée d'Art Moderne de la Ville de Paris

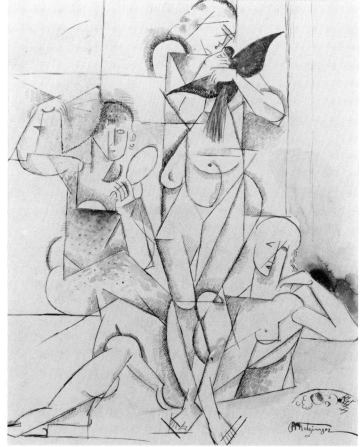

54

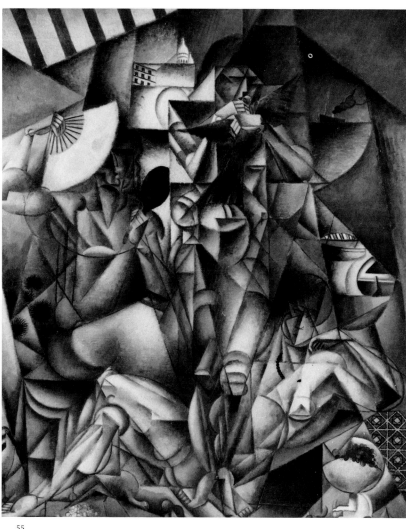

55

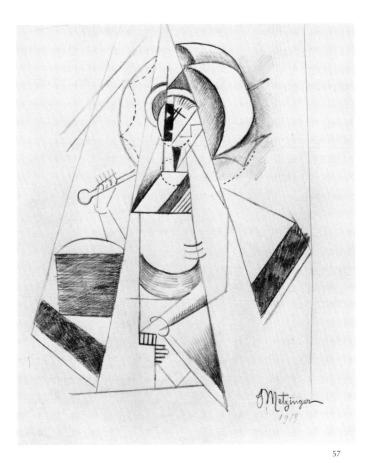

57

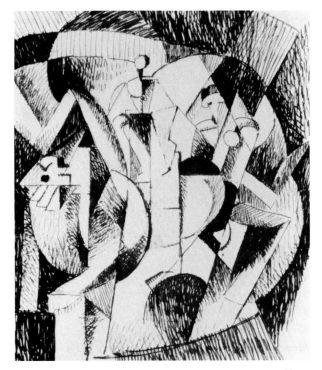

56

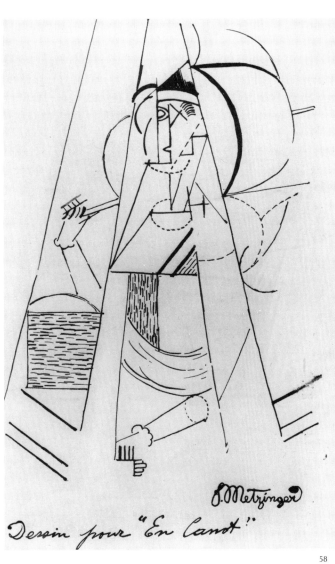

58

56. *Le Cirque*, c. 1913
Ink
Location unknown

57. Study for *Le Canot*, 1913
Pencil on grey paper
11 × 9¼ (28.0 × 23.5)
Musée National d'Art Moderne, Paris

58. **Drawing for *En canot*** (Femme au canot
et à l'ombrelle), 1913
Ink on paper
10 × 7½ (25.5 × 19.0)
Musée d'Art Moderne de la Ville de Paris

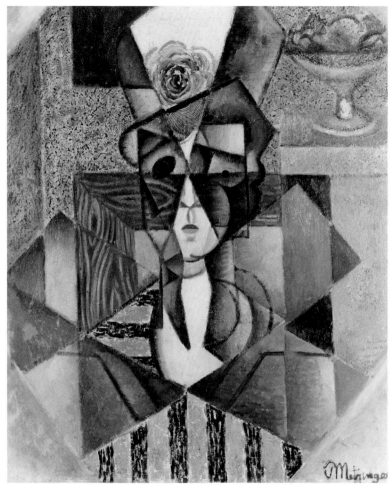

59

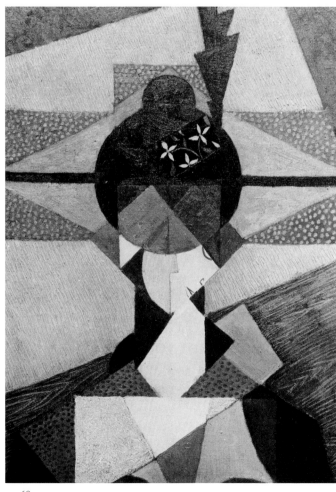

59. *Portrait*, c. 1913–14
Oil on canvas
25½ × 21¼ (64.8 × 54.0)
Courtesy of the Fogg Art Museum, Harvard
University. Gift–Mr. and Mrs. Joseph H.
Hazen

60. *Cubist Portrait*, c. 1914
Oil on canvas
28½ × 12½ (71.6 × 31.8)
Hood Museum of Art, Dartmouth College,
Hanover, New Hampshire. Gift of Joseph H.
Hazen

60

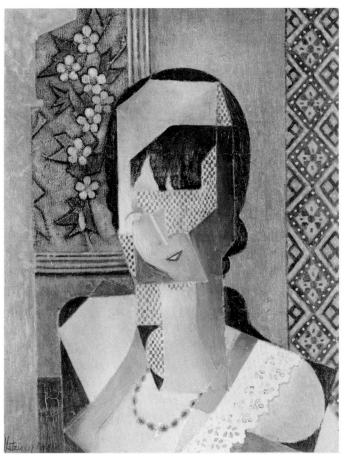

62

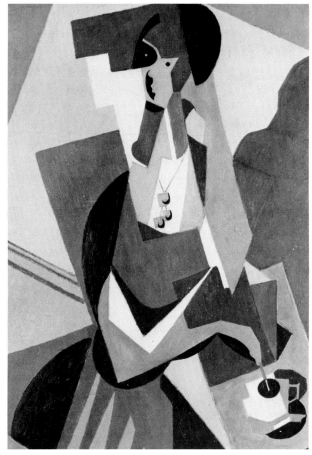

63

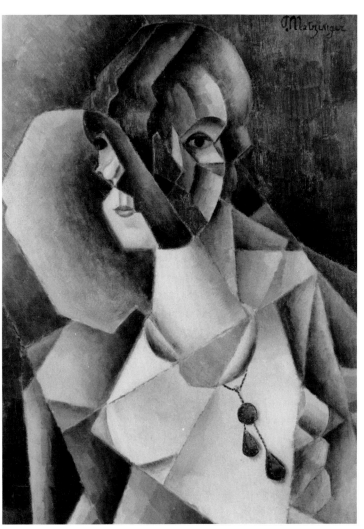

61

61. **Head of a Woman**, 1916–17
Oil on canvas
29 × 21 (73.7 × 53.3)
Private collection, New York

62. *Femme à la dentelle*, 1916
Oil on canvas
25½ × 21¼ (65.0 × 54.0)
Musée d'Art Moderne de la Ville de Paris.
Gift of Henry Thomas

63. *Le Goûter*, 1917
Oil on canvas
36¼ × 25½ (92.0 × 65.0)
Location unknown

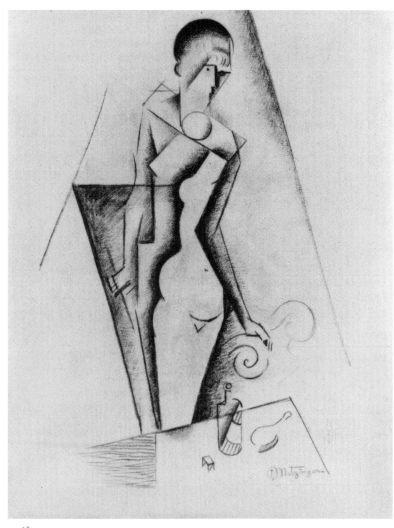

65

66

64. **Femme au miroir**, 1916–17
Oil on canvas
36⅜ × 25⅝
Lent by Mr. and Mrs. M. Thomas Lardner
(illus. p. 30)

65. **Femme devant le miroir**, c. 1914
Pencil on paper
23¾ × 18¾ (60.3 × 47.6)
Lent by Victor Skrebneski
UI only

66. *Femme au miroir*, 1916–17
Oil on canvas
32 × 25½ (81.3 × 64.8)
Collection of Donn Shapiro

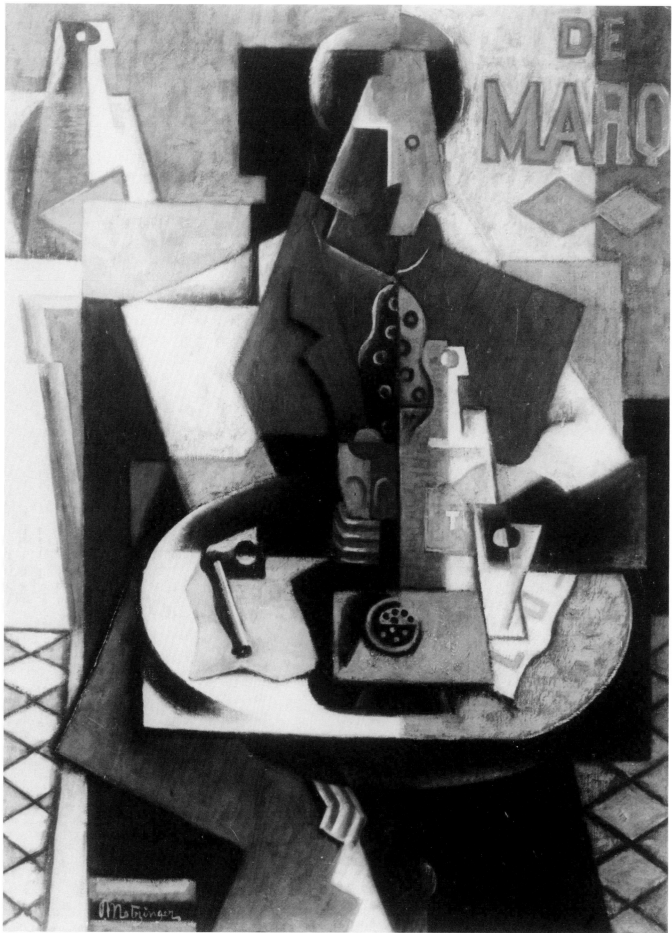

67

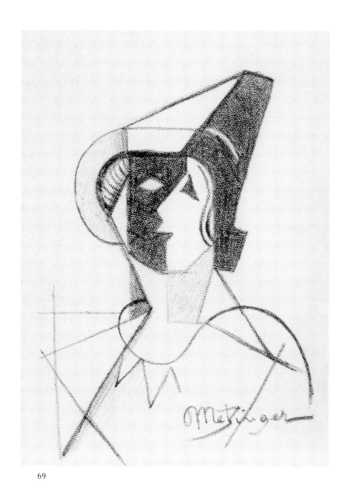

69

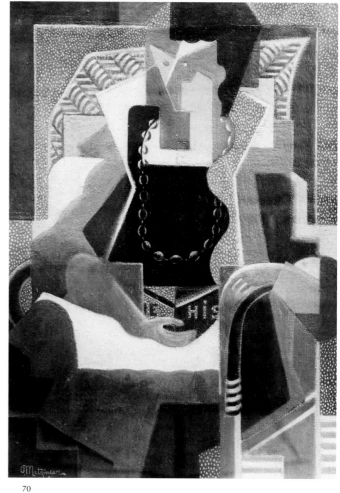

70

67. **Homme assis devant la table**,
c. 1918—19
Oil on canvas
39½ × 28¾ (100.3 × 73.0)
Lent by Mr. and Mrs. Marshall Padorr

68. *Woman with Compote*, 1918
Oil on canvas
31½ × 20⅞ (80.0 × 53.0)
Private collection, Massachusetts

69. *Clown*, c. 1918
Pencil on paper
15 × 12 (38.1 × 30.5)
Collection of James Goldschmidt, Green-
wich, Connecticut

70. **Seated Woman** (Femme assise), 1919
Oil on canvas
36½ × 25¾ (92.7 × 65.4)
Lent by the San Francisco Museum of Mod-
ern Art. Gift of Sally Hellyer in memory of
Arthur J. Cohen, Jr.

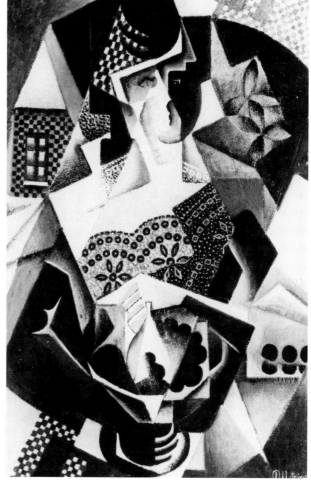

68

71

71. **Woman with a Fan**, c. 1919
Pencil and charcoal on paper mounted on board
11¾ × 9⅝ (29.8 × 24.4)
Lent by The Chrysler Museum, Norfolk, Virginia. Gift of Walter P. Chrysler, Jr.

72. *Femme à l'éventail*, c. 1919
Pencil on paper
12¼ × 8⅝ (31.0 × 22.0)
Collection Folker Skulima, Berlin

73. *Woman with Necklace and Fan*, 1919
Oil on canvas
Dimensions unknown
Location unknown

74. *Woman with a Coffee Pot* (La Femme à la cafetière, La Tasse de thé), c. 1919
Oil on canvas
45⅝ × 31⅞ (116.0 × 81.0)
The Tate Gallery, London

75. *La Tricoteuse*, c. 1919
Oil on canvas
45⅞ × 31⅞ (116.5 × 81.0)
Musée National d'Art Moderne, Paris

72

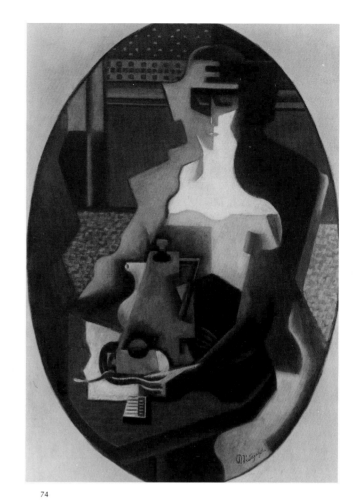

74

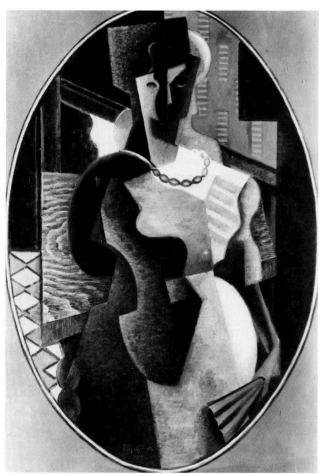

73

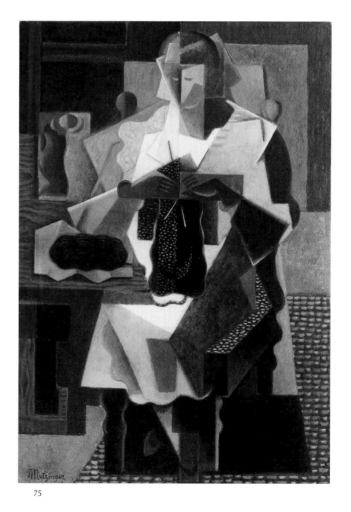

75

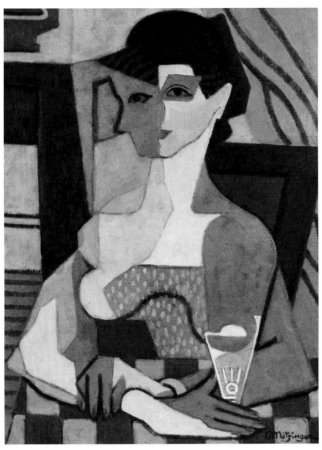

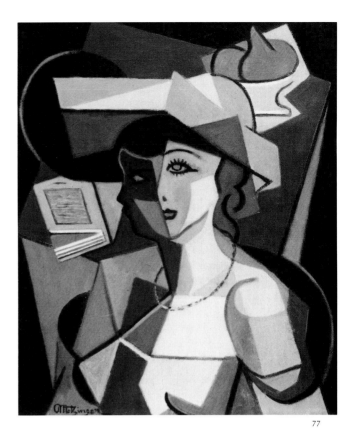

77

76

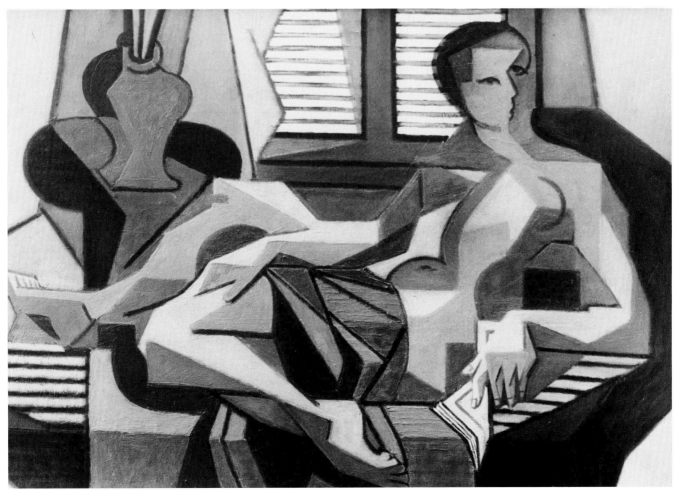

78

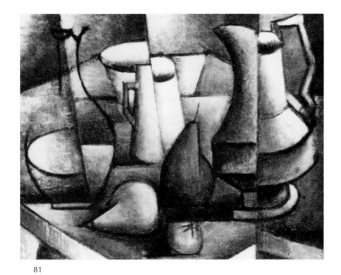

81

80

76. *Femme, face et profil* (Femme au verre),
c. 1919
Oil on canvas
25⅝ × 19⅝ (65.0 × 50.0)
Musée National d'Art Moderne, Paris

77. *Jeune Femme au chapeau*, dated 1919
(on verso)
Oil on canvas
24 × 19⅝ (61 × 50)
Collection of Thomas R. Monahan, Chicago

78. *La Femme à la persienne*, c. 1919
Oil on canvas
Dimensions unknown
Collection of Mrs. Monroe Geller

79. **Composition à la carafe et verre de
vin**, c. 1911–12
Charcoal on buff paper
21¼ × 16¾ (54.0 × 42.5)
Courtesy Sidney Janis Gallery, New York

80. *Nature morte*, 1912
Pencil on paper
8¼ × 9⅞ (21.0 × 25.0)
Musée National d'Art Moderne, Paris

81. *Nature morte aux cruches*, c. 1912–14
Medium unknown
13 × 16¼ (33.0 × 41.0)
Location unknown

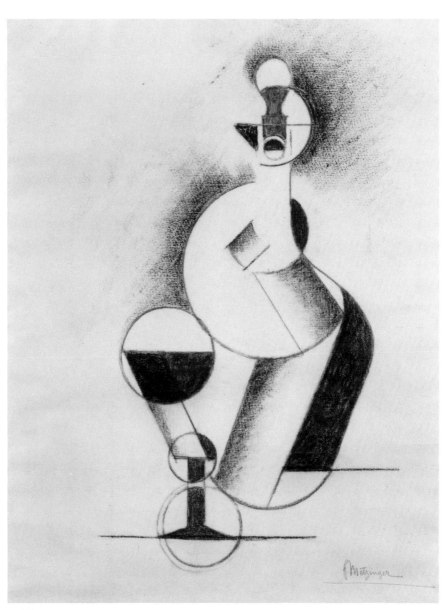

79

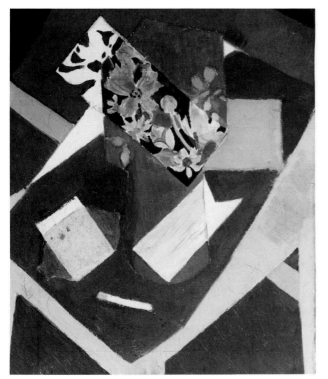

85

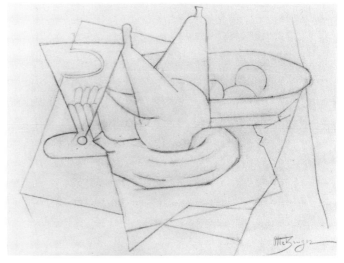

84

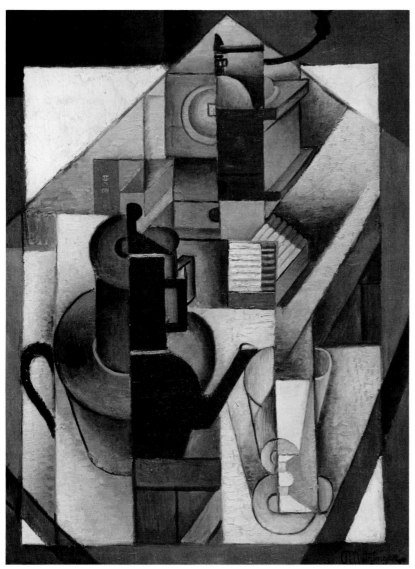

82

82. **Coffee Grinder, Coffee Pot, Cigarettes, and Glass**, c. 1914
Oil on canvas
27⅝ × 20⅝ (70.3 × 54.4)
Lent by the Solomon R. Guggenheim Museum, New York

83. **Still Life**, 1916
Oil on canvas
28¾ × 21¼ (73.0 × 54.0)
Lent by Yale University Art Gallery. Gift of Jeffrey H. Loria, B.A. 1962

84. *Nature morte au compotier*, c. 1916–17
Pencil on paper
10¼ × 13¾ (26.0 × 35.0)
Collection of Herman Goldsmith, New York

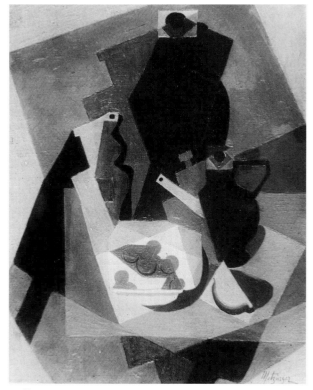

86

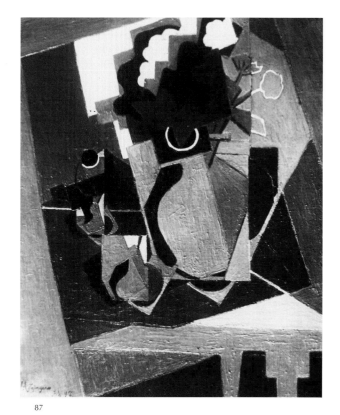

87

85. *Cigarette Package and Flowers*,
c. 1916–17
Oil on canvas
11 × 13 (28.0 × 33.0)
Private collection, Providence, Rhode Island

86. Still life with fruit and pitcher, dated
"Juin 1917"
Location unknown

87. *Fruits et fleurs*, dated "Juin 1917"
Oil on canvas
31⅞ × 25⅝ (81.0 × 65.0)
Location unknown

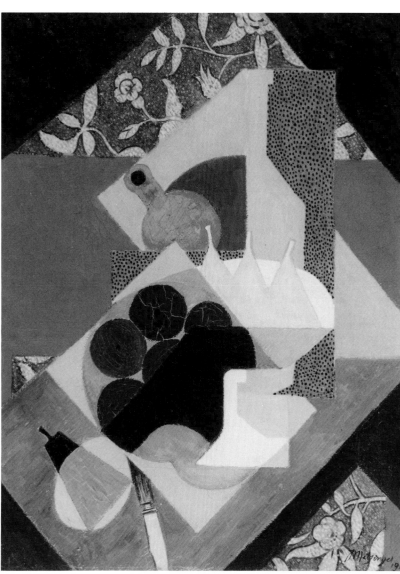

83

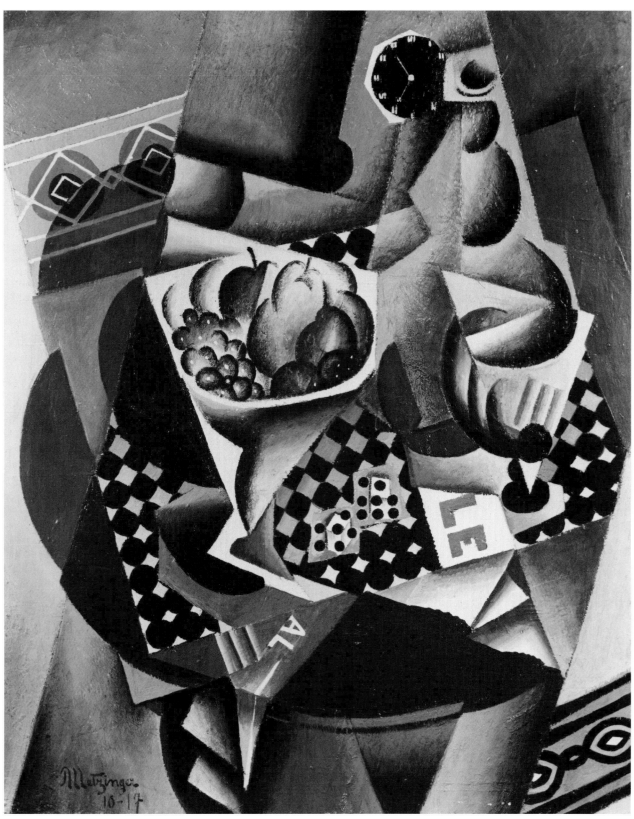

88

88. Still life with clock and bowl of fruit,
dated "10–1917"
Location unknown

89. *Still Life*, dated "11–17"
Oil on canvas
32 × 25⅝ (81.3 × 65.1)
The Metropolitan Museum of Art. Purchase,
Funds received from the M. L. Annenberg
Foundation, the Joseph H. Hazen Founda-
tion, and Joseph H. Hazen, 1959

90. *Nature morte*, dated "Novembre 1917"
(on verso)
Medium unknown
31½ × 25½ (80.0 × 64.5)
Location unknown

91. **Still Life with Box** (Nature morte avec
boîte, Cubist Composition), 1918
Oil on canvas
20½ × 31½ (52.0 × 80.0)
Lent by the New Orleans Museum of Art.
Gift of Richard M. Wise and Mrs. John N.
Weinstock in memory of Madelyn C. Kreisler

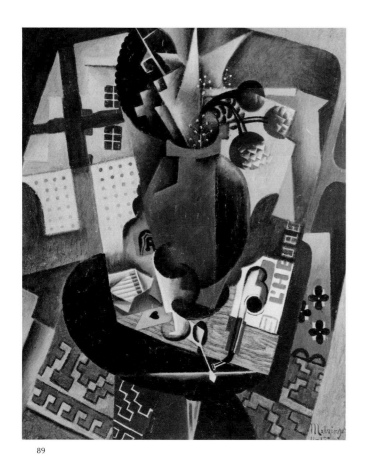

89

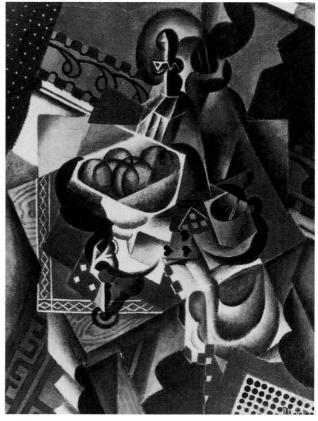

90

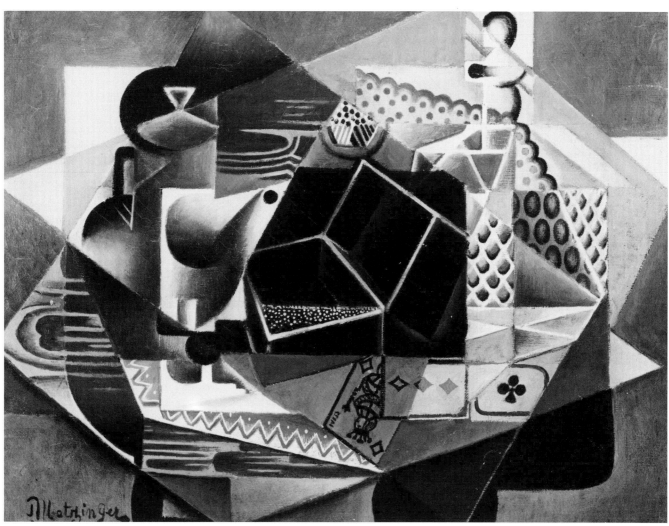

91

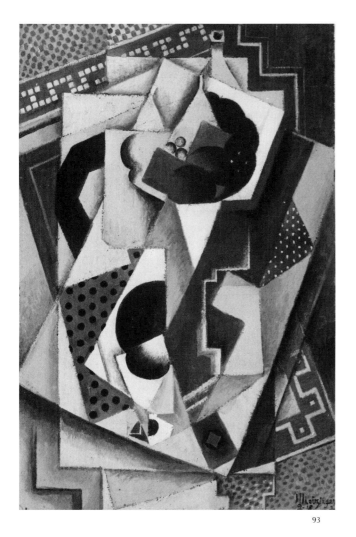

93

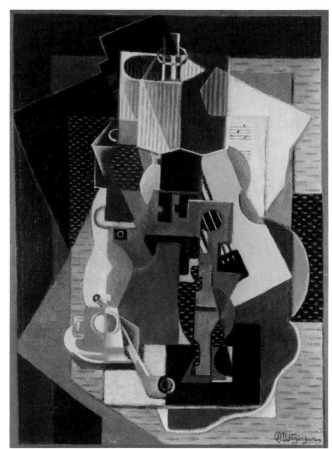

92

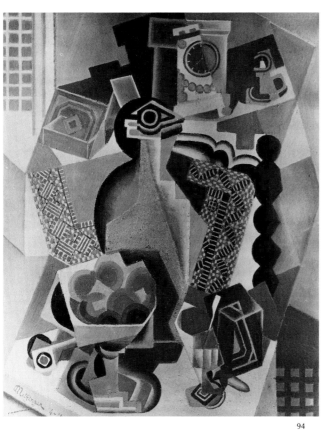

94

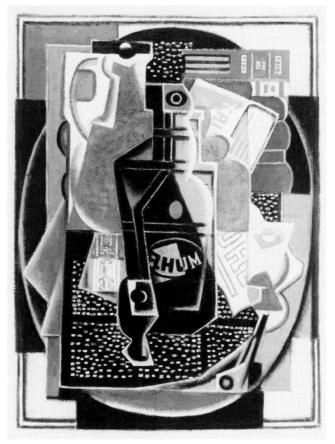

95

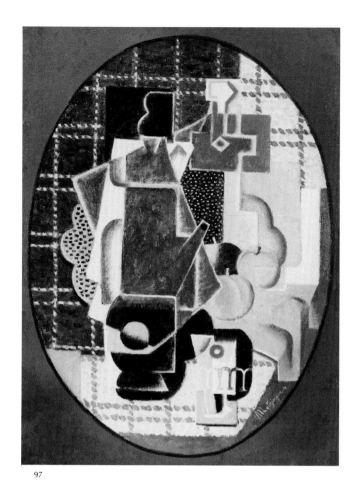

97

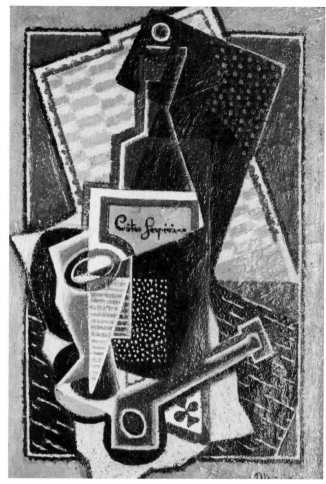

96

92. *Still Life with Lamp*, c. 1917–18
Oil on canvas mounted on composition board
32 × 23⅞ (81.2 × 60.5)
Collection, The Museum of Modern Art, New York. Gift of Mr. and Mrs. Harry Lewis Winston

93. *Still Life*, dated "2–18"
Oil
31½ × 21 (80.0 × 54.0)
Location unknown

94. *Nature morte*, dated "4–1918"
Location unknown

95. *Nature morte: Rhum*, 1918
Oil on canvas
28¾ × 21⅜ (73.0 × 54.3)
Art Gallery of Ontario, Toronto. Gift of Sam and Ayala Zacks, 1970

96. *Still Life with Pipe*, c. 1918
Oil on canvas
21 × 14½ (53.3 × 36.8)
The Winston-Malbin Collection, New York

97. *Still Life*, 1918
Oil on canvas
28¾ × 21⅜ (73.0 × 54.5)
Courtesy of the Art Institute of Chicago. Gift of Harry L. Winston

98. *Nature morte à la cafetière* (Ferme normande), c. 1918
Oil on canvas
20¾ × 28¼ (53.5 × 72.0)
Location unknown

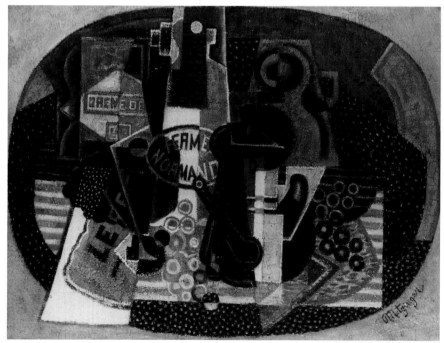

98

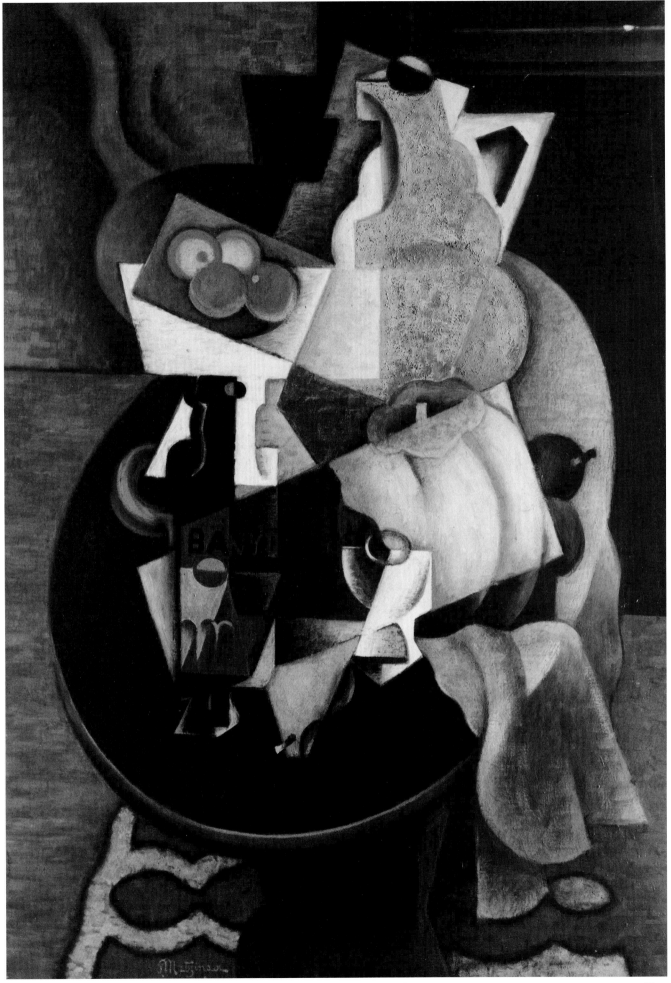

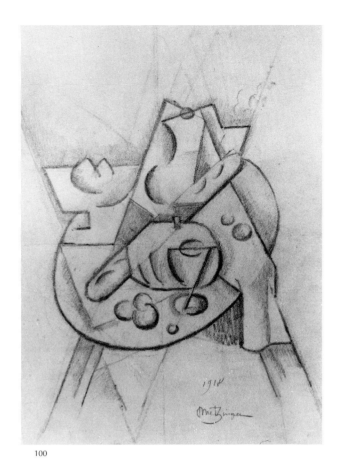

100

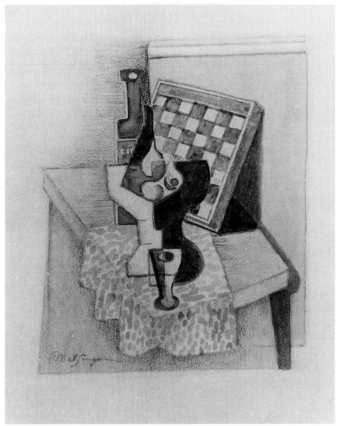

102

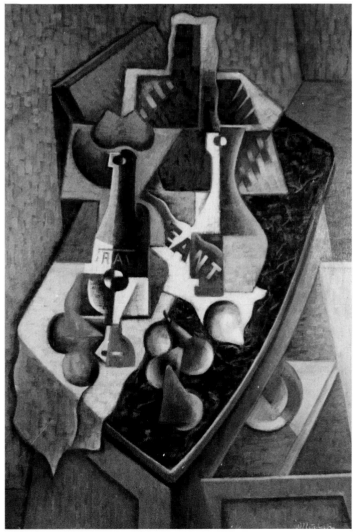

99. *Fruit and Jug on a Table*, c. 1918
Oil on canvas
45⅝ × 31⅝ (116.0 × 80.5)
Courtesy, Museum of Fine Arts, Boston.
Fanny P. Mason Fund, 57.3.

100. *Nature morte*, 1918
Oil crayon on cream paper
11⅞ × 8¼ (30.0 × 21.0)
Musée National d'Art Moderne, Paris

101. *Still Life with Pears*, c. 1918
Oil on canvas
45¾ × 32 (116.2 × 81.3)
The Winston-Malbin Collection, New York

102. *Nature morte au damier*, 1918–19
Watercolor
11⅜ × 9¼ (29.0 × 23.5)
Musée National d'Art Moderne, Paris

101

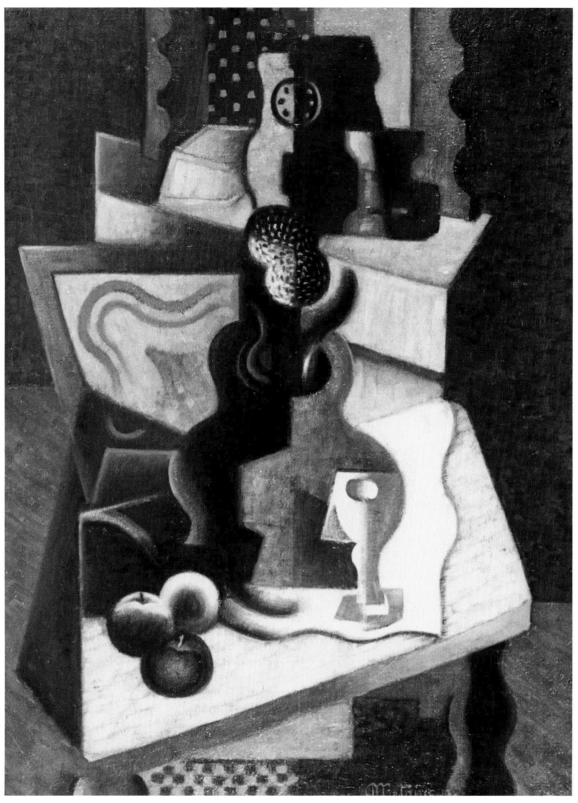

103

103. **Still Life with Apples**, 1919
Oil on canvas
39¼ × 29¼ (100.0 × 74.0)
Collection Rijksmuseum Kröller-Müller,
Otterlo, The Netherlands

104. *Composition*, c. 1919
Pencil heightened with charcoal on white
paper
12½ × 9½ (31.8 × 24.0)
Musée National d'Art Moderne, Paris

105. *Cubist Composition in Oval*, c. 1918
Black chalk
23⅝ × 18⅛ (60.0 × 46.0)
Collection Rijksmuseum Kröller-Müller,
Otterlo, The Netherlands

106. **Still Life in an Oval**, 1919
Oil on canvas
23½ × 32 (60.0 × 81.0)
Collection Rijksmuseum Kröller-Müller,
Otterlo, The Netherlands

104

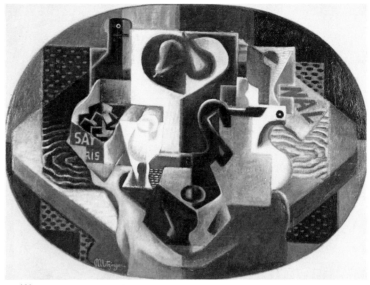

106

105

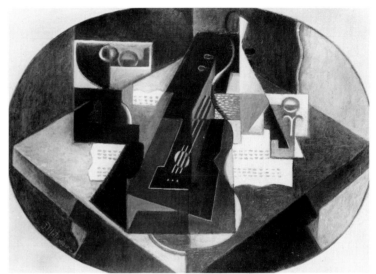

108

107. Still life with pears and apples, c. 1919
Oil
28¾ × 21¼ (73.0 × 54.0)
Location unknown

108. Still life with guitar, 1919
Location unknown

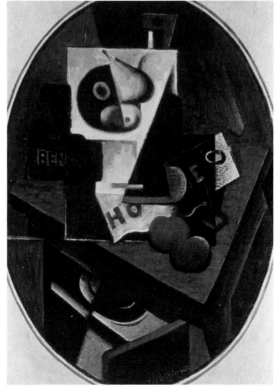

107

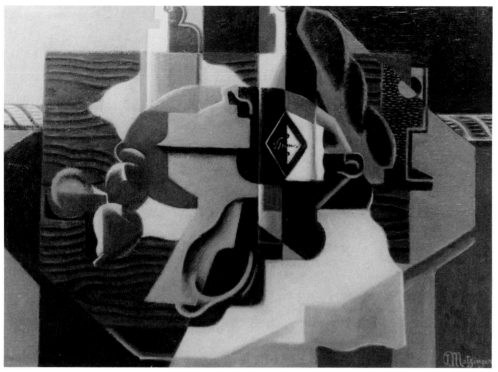

109

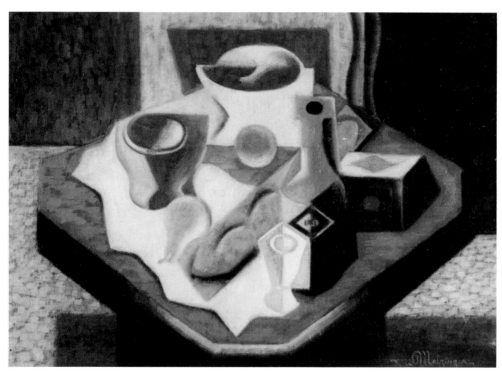

110

109. *Still Life*, c. 1919
Oil on canvas
Dimensions unknown
Collection of Mrs. Monroe Geller

110. *Still Life*, c. 1919
Oil on canvas
25¼ × 36 (64.1 × 91.4)
The Minneapolis Institute of Arts, Gift of Mr.
and Mrs. Theodore W. Bennett, 74.4

111. *Still Life*, 1919
Oil on canvas
28⅝ × 23¾ (72.5 × 60.5)
Private collection, New York

112. *Still Life*, c. 1919
Oil on canvas
32 × 25¾ (81.3 × 65.4)
Collection of Seymour and Tamara Pristin

113. *Still Life with Jug and Pipe*, 1919
Oil on canvas
32 × 23½ (81.0 × 60.0)
Collection Rijksmuseum Kröller-Müller,
Otterlo, The Netherlands

114. *Nature morte à la mandoline*, November 1919
Oil on canvas
36¼ × 28¾ (92.0 × 73.0)
Location unknown

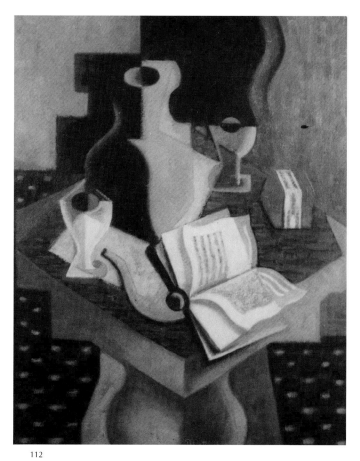

112

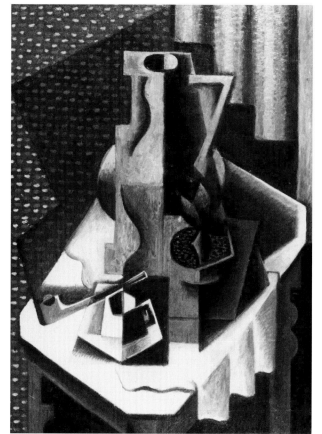

113

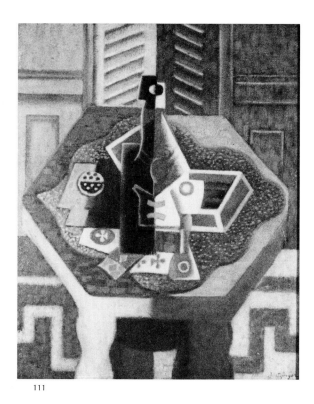

111

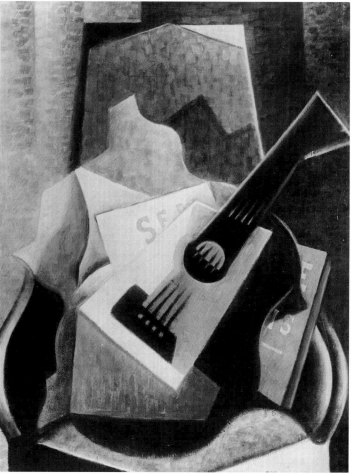

114

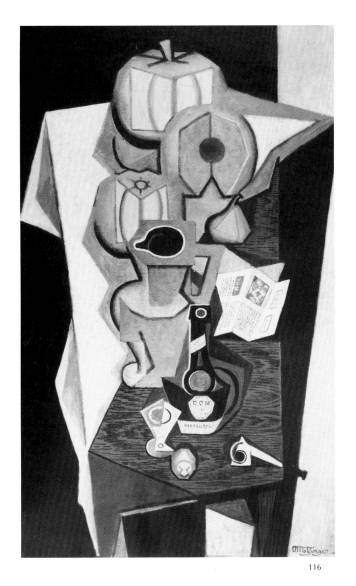

116

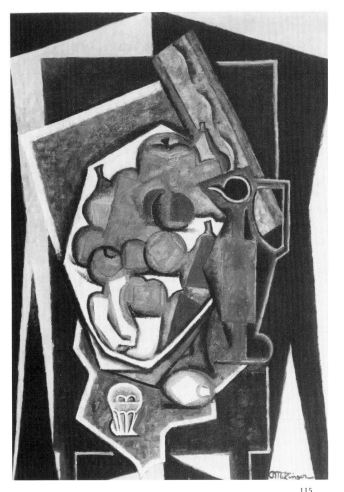

115

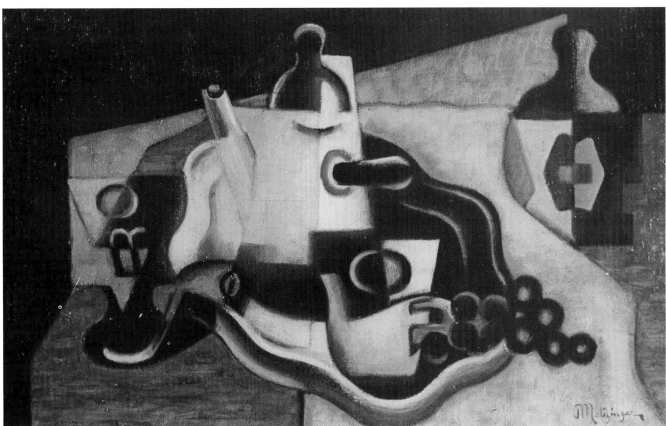

117

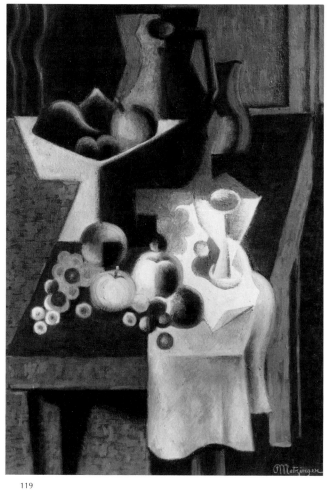

119

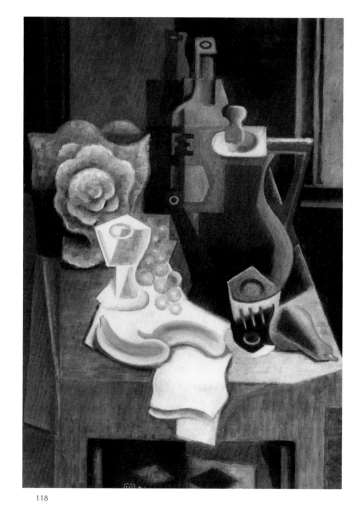

118

115. *Still Life*, c. 1919
Oil on canvas
45¾ × 31¾ (116.2 × 80.7)
Cincinnati Art Museum, Gift of Louis E.
Kahn

116. *Still Life*, c. 1919
Oil on canvas
63⅜ × 38 (161.0 × 96.5)
Kunsthalle Bremen, Federal Republic of
Germany

117. *Still Life with Tray*, c. 1920
Oil on canvas
15 × 24 (38.0 × 61.0)
Collection Rijksmuseum Kröller-Müller,
Otterlo, The Netherlands

118. *Nature morte*, 1921 (WG)
Location unknown

119. *Nature morte*, 1921 (WG)
Location unknown

120. *Nature morte*, 1921 (WG)
Location unknown

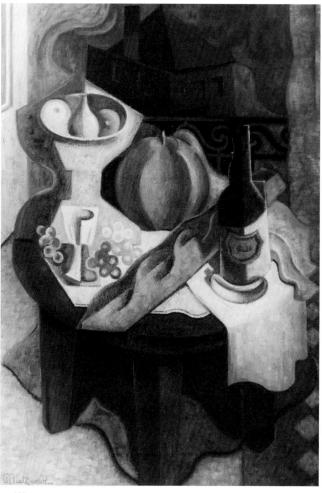

120

122

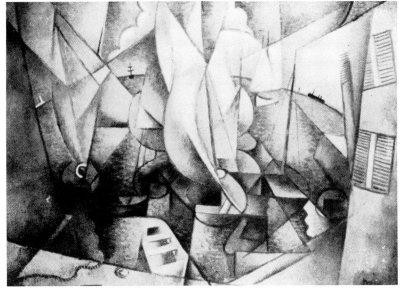

123

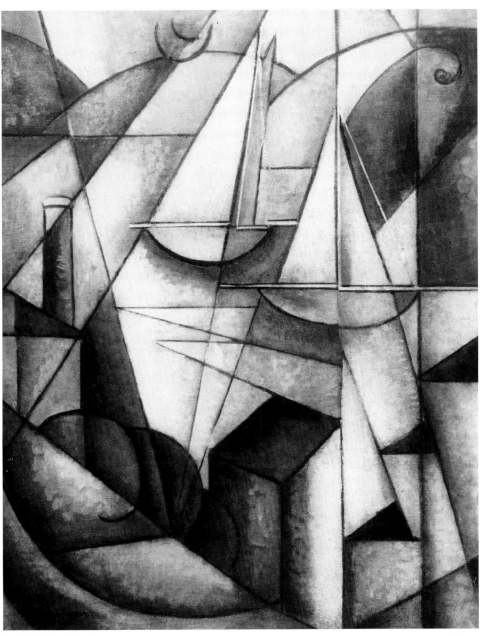

121

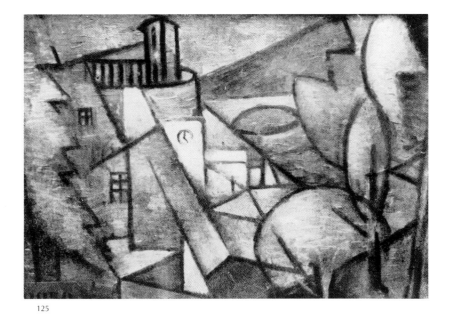

125

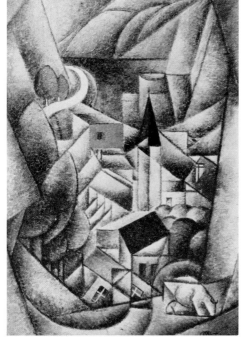

126

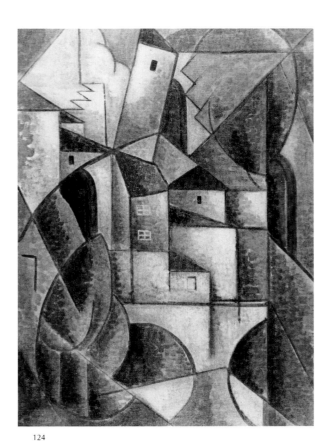

124

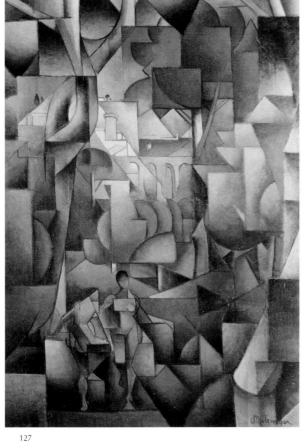

127

121. **Sailboats** (Scène du port), c. 1912
Oil on canvas
21½ × 18 (54.6 × 45.7)
Lent by the Herbert F. Johnson Museum of
Art, Cornell University, Ithaca, New York.
Membership Purchase Fund

122. *Composition aux voiliers*, c. 1912
Location unknown

123. *The Harbour*, c. 1911–12 (AGJM)
Location unknown

124. *Paysage cubiste*, c. 1912
Oil on canvas
28⅝ × 21¼ (72.0 × 54.0)
Josefowitz Collection, Lausanne

125. *Landscape*, c. 1912 (AGJM)
Location unknown

126. *Landscape*, c. 1912–13
Location unknown

127. *The Bathers* (Les Baigneuses),
c. 1912–13
Oil on canvas
58¼ × 41¾ (148.0 × 106.0)
Philadelphia Museum of Art. Louise and
Walter Arensberg Collection

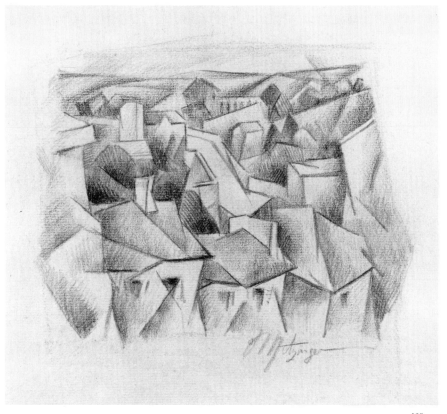

129

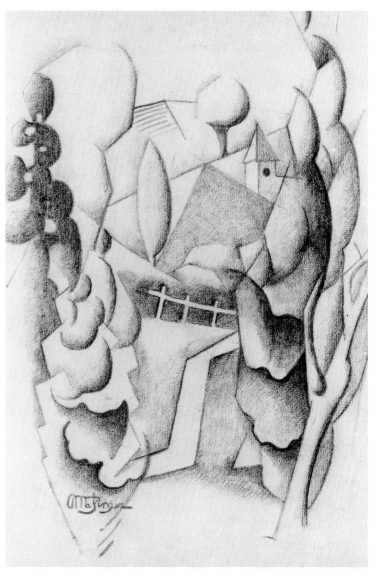

131

128. **Cubist Landscape** (Le Village),
c. 1911–12
Oil on canvas
32 × 39 (81.3 × 99.0)
Courtesy Sidney Janis Gallery, New York
(illus. p. 29)

129. *Paysage*, c. 1911–12
Pencil on grey paper
7⅞ × 8⅞ (20.0 × 22.5)
Musée National d'Art Moderne, Paris

130. **Cubist Landscape**, c. 1912–13
Pencil and black chalk on paper
16½ × 11¼ (41.9 × 28.6)
Lent by Hope and Abraham Melamed

131. *Landscape*, c. 1912–13
Charcoal on buff laid paper
16¾ × 11⅜ (42.5 × 29.5)
Location unknown

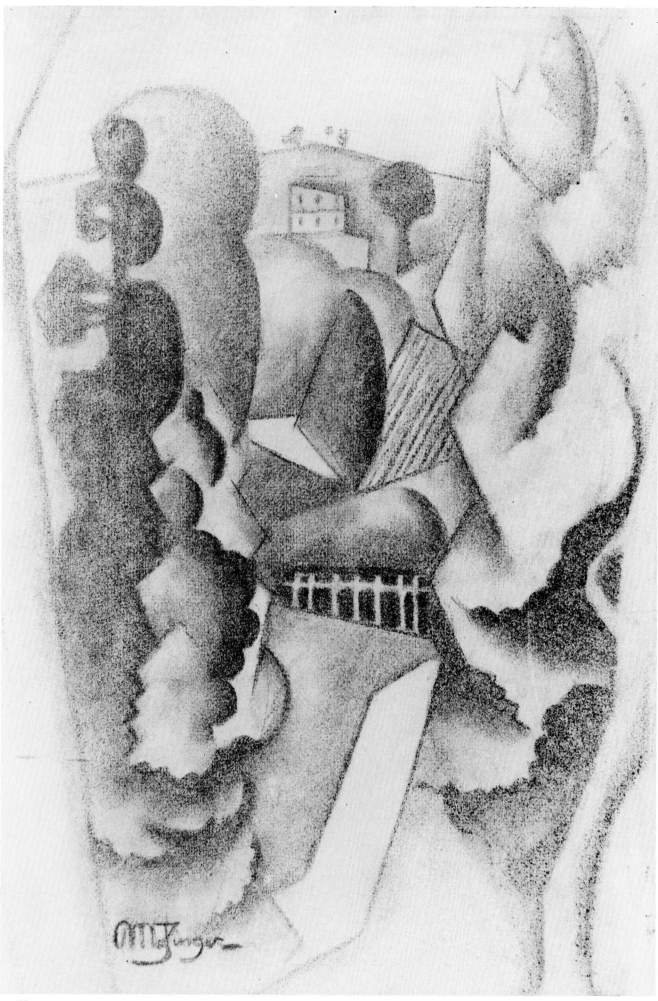

130

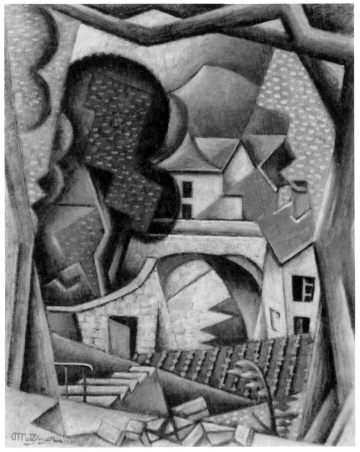

134

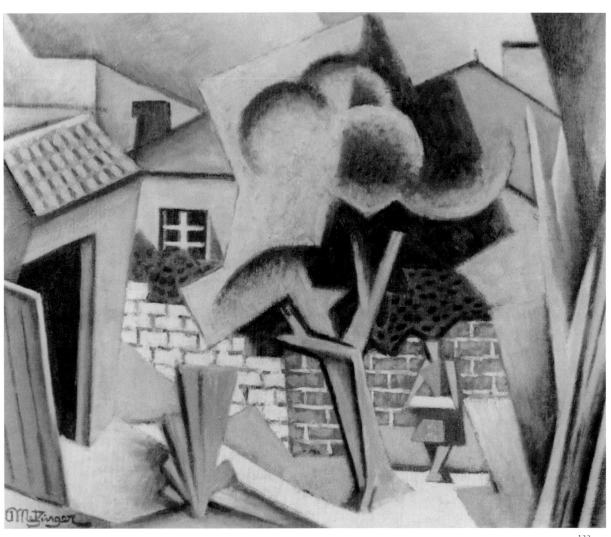

132

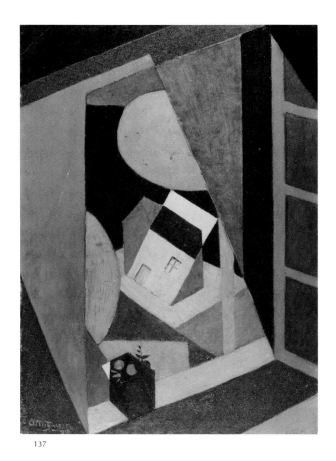

137

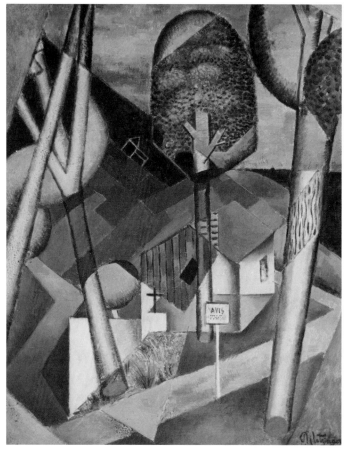

136

132. **Landscape**, c. 1913–14
Oil on canvas
17½ × 21 (44.5 × 53.3)
Lent by Mrs. Monroe Geller

133. **Village, église et deux personnages**,
dated 1913 (on verso)
Oil on canvas
32 × 23⅝ (81.3 × 60.0)
Private collection, Los Angeles
(illus. p. 28)

134. *Paysage*, c. 1913–14
Oil on canvas
29 × 23¾ (73.7 × 60.2)
Collection of Alexander Kahan

135. **Landscape with Roofs** (The Church
Spire), c. 1914–15
Oil on wood
16⅛ × 12⅞ (14.0 × 32.7)
Lent by the Philadelphia Museum of Art. The
Louise and Walter Arensberg Collection
UI, CI only

136. *Landscape*, c. 1916–17
Oil on canvas
36⅛ × 28¾ (91.7 × 73.0)
Solomon R. Guggenheim Museum, New
York

137. *Landscape through a Window*, 1915
Medium unknown
29 × 21 (73.7 × 53.3)
Location unknown

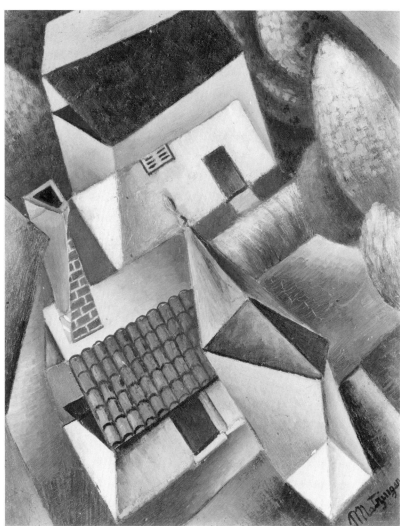

135

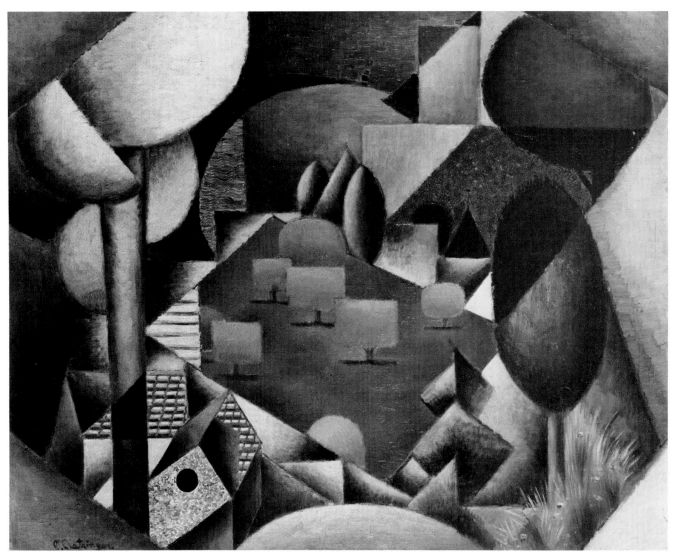

138. **Landscape**, c. 1916–17
Oil on canvas
28¾ × 36¼ (73.0 × 92.1)
The Museum of Modern Art, New York. Gift
of T. Catesby Jones, 1941

139. **Landscape**, c. 1916–17
Oil on canvas
32⅛ × 39½ (81.6 × 99.4)
Lent by the Saint Louis Art Museum. Purchase: Funds given by Mr. and Mrs. Sydney
M. Schoenberg and Mr. and Mrs. Sydney M.
Schoenberg, Jr., by exchange
UI, UT, CI only
(illus. p. 29)

140. Landscape, 1916–17
Oil on canvas
23½ × 29 (59.7 × 73.7)
Courtesy of the Art Institute of Chicago. Gift
of Mrs. Sigmund W. Kunstadter in memory
of Sigmund W. Kunstadter

141. **Landscape** (Composition cubiste),
c. 1916–17
Oil on canvas
20¼ × 27 (51.4 × 68.6)
Courtesy of the Fogg Art Museum, Harvard
University. Gift–Mr. and Mrs. Joseph H.
Hazen

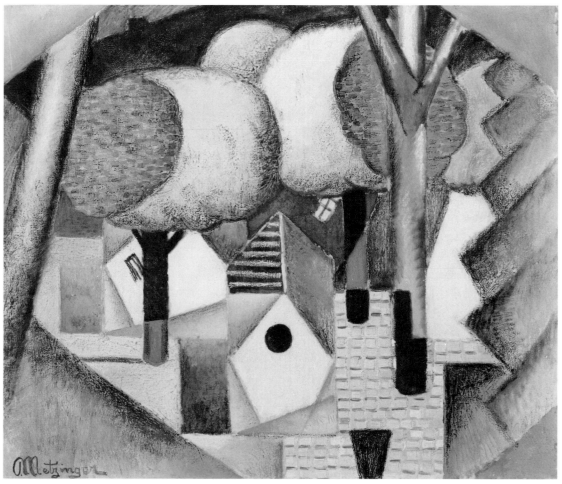

140

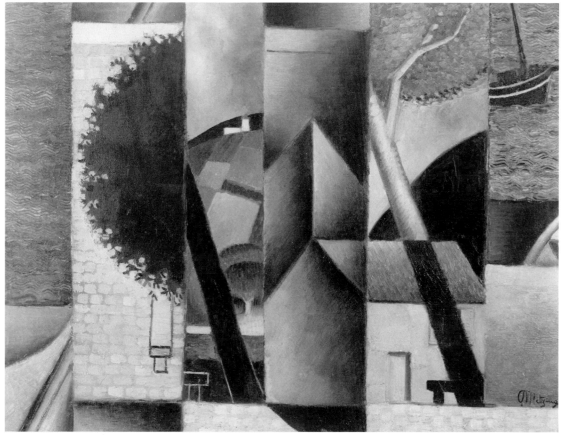

141

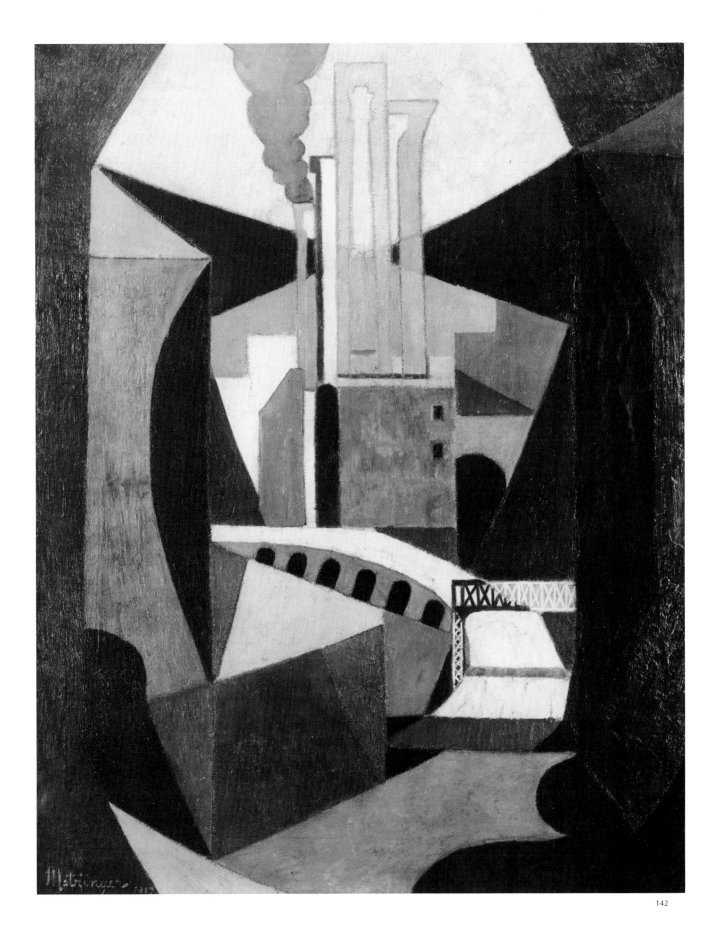

142. **L'Usine**, 1917
Oil on canvas
36¼ × 28¾ (92.0 × 73.0)
Lent by Mr. and Mrs. Robert G. Weiss

143. **Le Chemin de fer**, 1917
Gouache on paper
10⅝ × 8 (27.0 × 20.5)
Lent by Galerie Brockstedt, Hamburg

144. *Vue des toits et des maisons*,
c. 1916–17
(Oil sketch on reverse)
Oil on board
10⅝ × 8⅝ (27.0 × 22.0)
Private collection

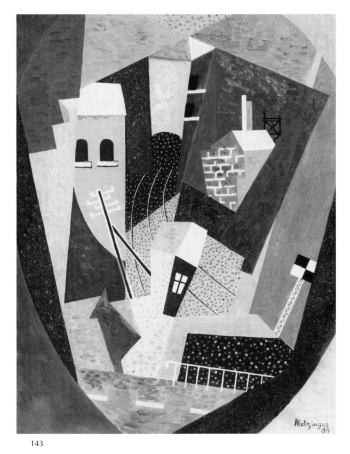

143

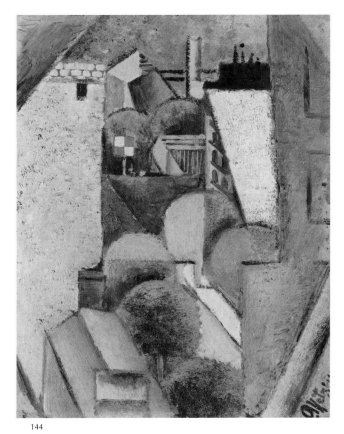

144

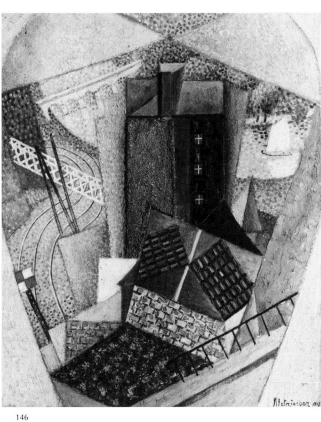

146

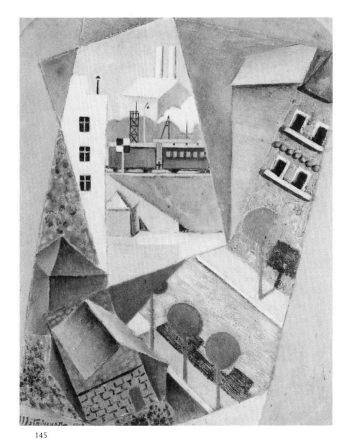

145

145. *The Factory*, 1917
Oil and collage on canvas
27¾ × 22¾ (70.5 × 58.0)
Collection of Sara and Moshe Mayer,
Geneva

146. *La Maison du garde-barrière*, 1917
Medium unknown
28¾ × 23½ (73.0 × 60.0)
Location unknown

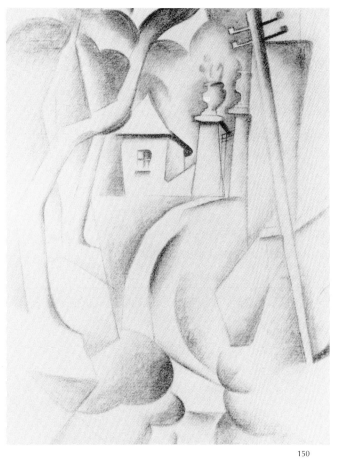

150

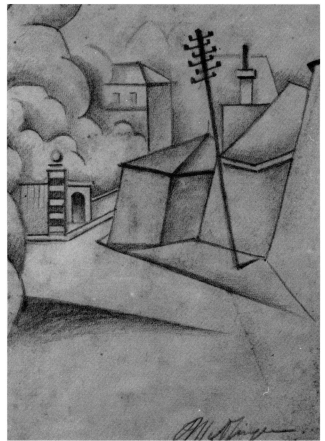

149

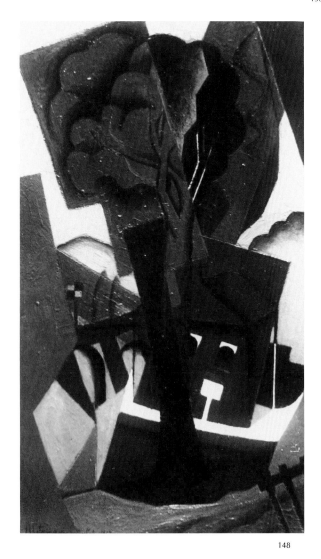

148

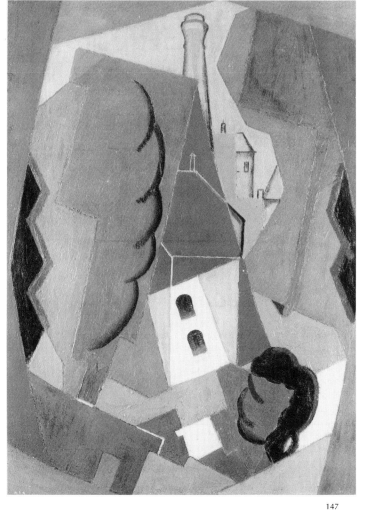

147

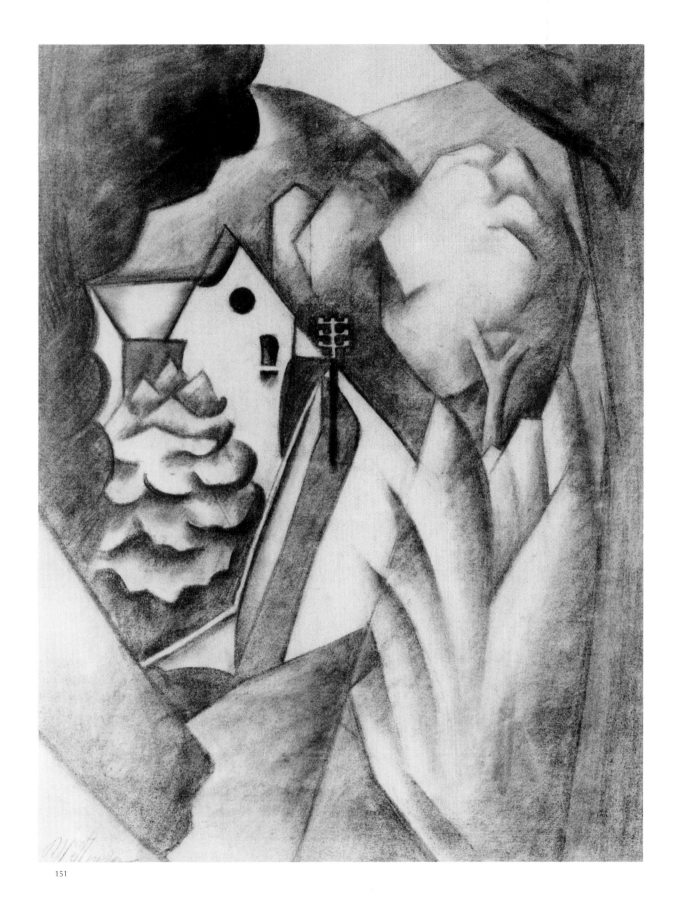

151

147. *Cubist Landscape*, 1917
Oil on canvas
36¼ × 25¾ (92.0 × 65.5)
Location unknown

148. *Landscape*, dated "Juillet 1917"
Location unknown

149. *Le Coin de rue*, c. 1917–18
Pencil on paper
9½ × 7 (24.0 × 18.0)
Location unknown

150. *Coin de rue*, c. 1917–18
Pencil on laid paper, laid down on board
24½ × 19 (61.5 × 48.3)
Location unknown

151. *Paysage cubiste*, c. 1917–18
Charcoal on paper
23½ × 17¾ (59.7 × 45.1)
Private collection, Chicago

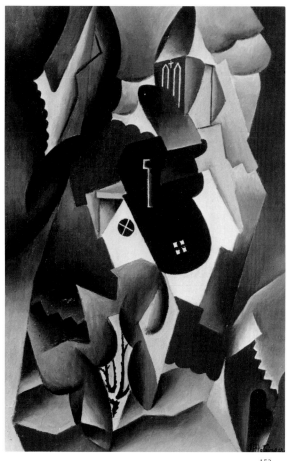

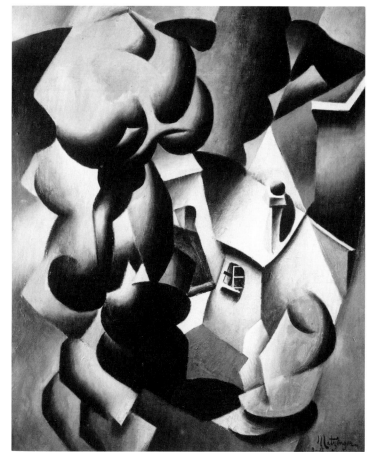

153

152

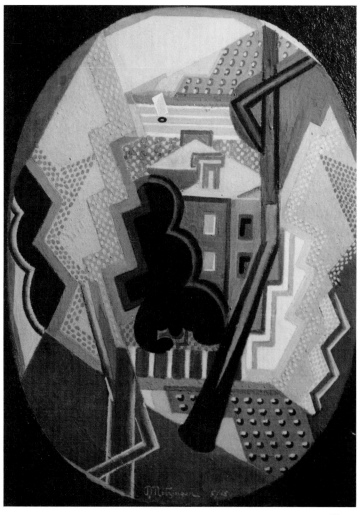

156

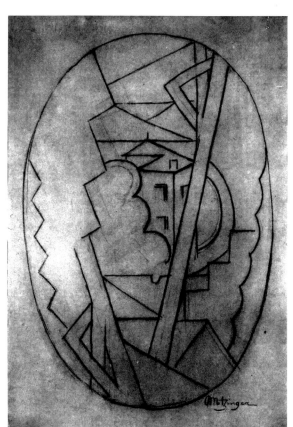

157

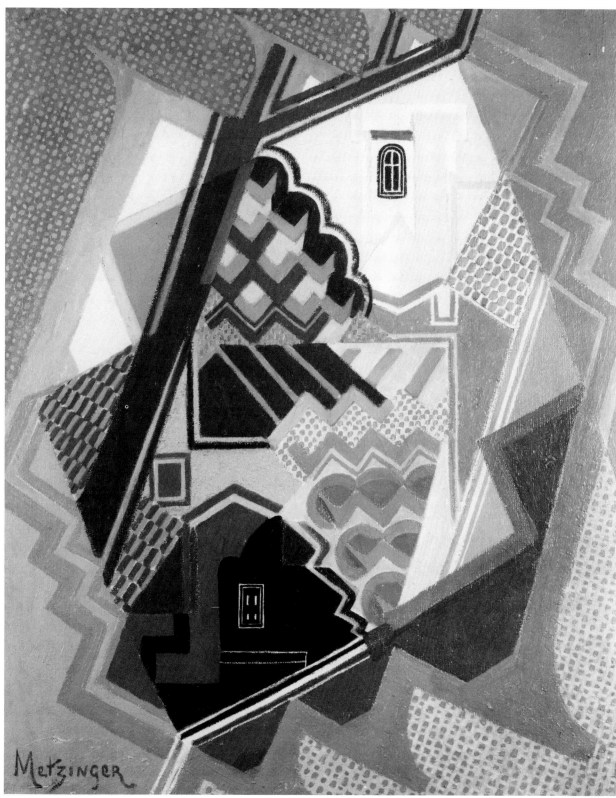

155

152. *Paysage*, dated "9–17"
Oil on canvas
31⅞ × 25⅝ (81.0 × 65.0)
Galerie Daniel Malingue, Paris

153. *Paysage village*, 1917
Oil on canvas
35¼ × 23½ (92.0 × 59.5)
Galerie Daniel Malingue, Paris

154. **Le Château**, c. 1918
Oil on canvas
28¾ × 19¾ (73.0 × 50.0)
Lent by Jacqueline and Max Kohler-Krotoschin
(illus. p. 31)

155. **Composition**, c. 1918
Oil on canvas
31⅞ × 25⅝ (81.0 × 65.1)
Lent by The Museum of Modern Art, New York, Gift of Mr. and Mrs. A. M. Adler, 1964

156. *Paysage oval*, dated "5/18"
Oil on canvas
28 × 21 (71.1 × 53.3)
Collection of Mrs. F. Rosenak

157. *Paysage oval*, c. 1918
Pencil on paper
17⅜ × 12¼ (44.0 × 31.0)
Collection of Herman Goldsmith, New York

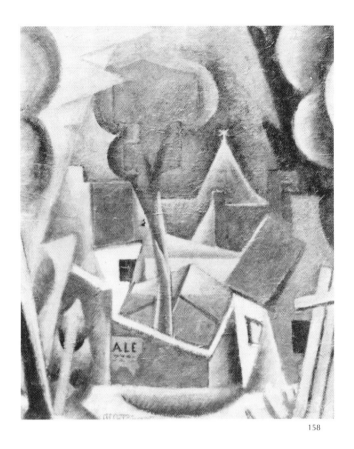
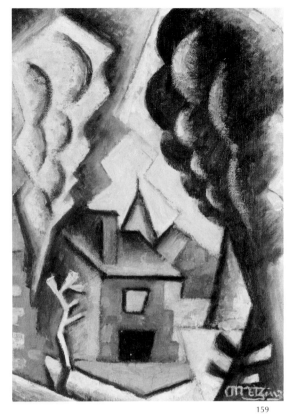

158

159

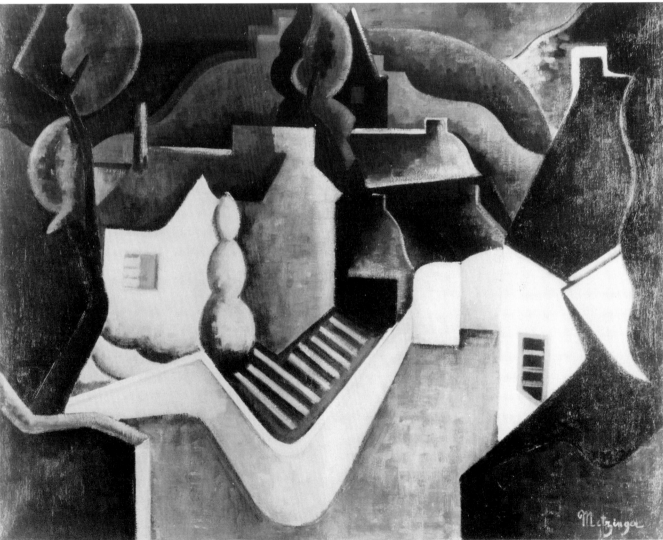

160

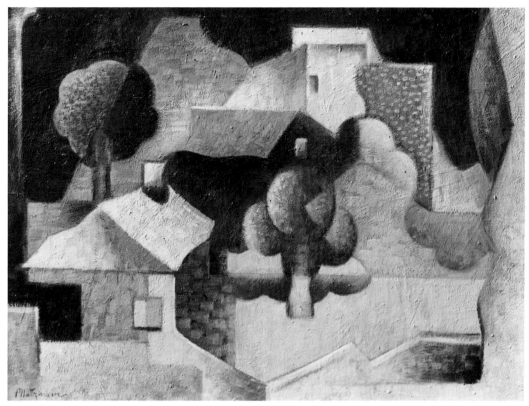

161

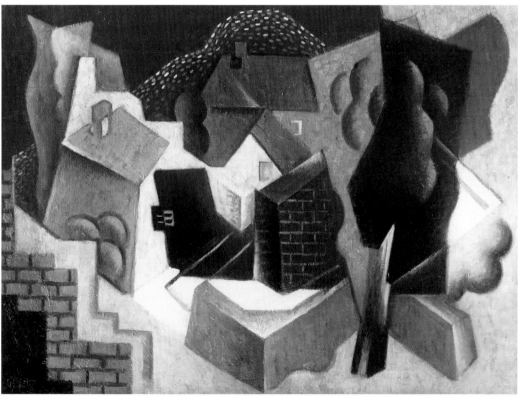

162

158. *Le Village*, dated 1919 (on verso)
Medium unknown
21⅝ × 18⅛ (55.0 × 46.0)
Location unknown

159. *Maison dans les arbres*, c. 1919
Oil on canvas
13¾ × 10⅝ (35.0 × 27.0)
Private collection, Paris

160. *Paysage*, c. 1918–19
Oil on canvas
28¾ × 35⅞ (73.0 × 91.0)
Collection of Dr. and Mrs. James E. Jones

161. *Paysage*, 1919 (WG)
Location unknown

162. *Paysage*, 1919
Location unknown

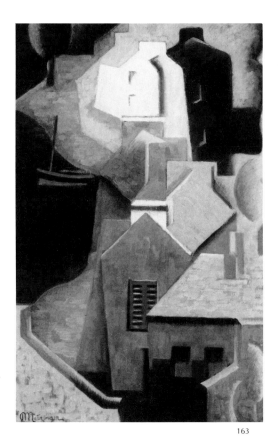

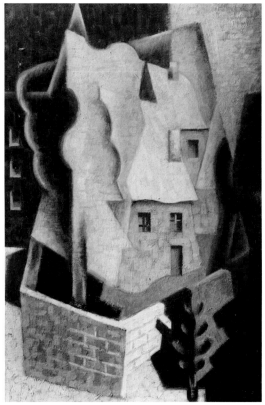

163 164

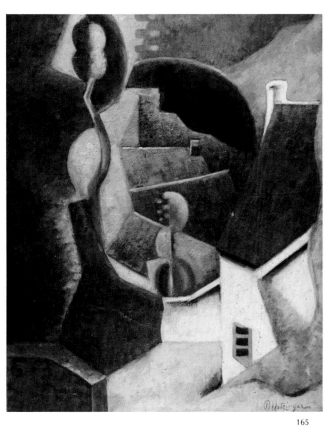

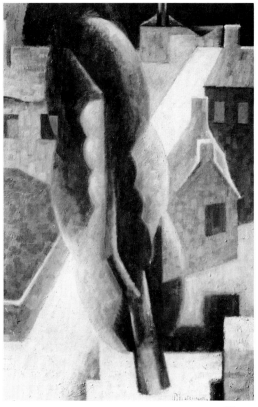

165 166

163. *The Port*, 1920 (WG)
Oil on canvas
31¾ × 21⅛ (80.6 × 53.7)
Yale University Art Gallery, Gift of Collection
Société Anonyme

164. *Paysage*, 1920 (BEM, November 1924)
Location unknown

165. *Paysage*, c. 1920
Oil on canvas
31⅞ × 25⅝ (81.0 × 65.0)
Musée National d'Art Moderne, Paris

166. Landscape, c. 1920
Location unknown

167. ***City Landscape***, c. 1919–20
Oil on canvas
21⅜ × 31⅞ (54.3 × 80.9)
The University of Iowa Museum of Art, Iowa
City. Owen and Leone Elliott Collection
(illus. p. 32)

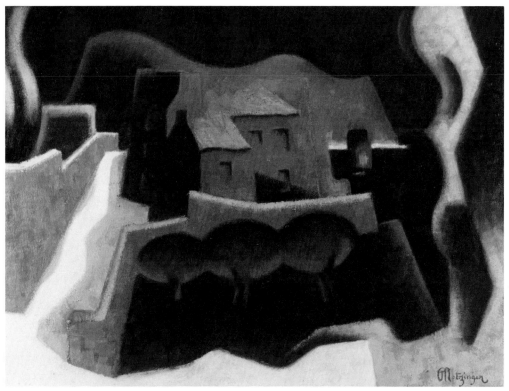

168

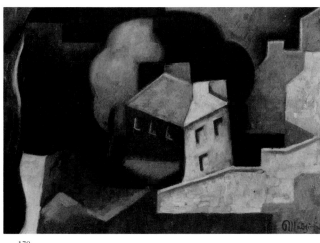

170

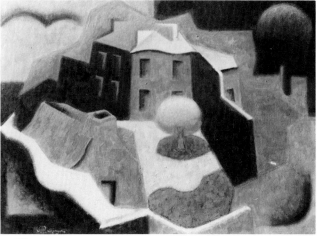

169

168. **Les Trois Arbres**, c. 1920–21
Oil on canvas
21 × 29 (53.5 × 72.5)
Lent by The University of Michigan Museum
of Art, Gift of the Estate of Maxine W.
Kunstadter in memory of Sigmund
Kunstadter, Class of 1922

169. *Paysage: Maisons vertes et noires*, 1921
Oil on canvas
25⅝ × 36 (65.0 × 91.5)
Private collection

170. *Paysage*, c. 1921
Oil on canvas
15 × 21⅝ (38.0 × 55.0)
Musée d'Art Moderne de Troyes, Gift of P.
and D. Levy

171. *Cubist Landscape*, c. 1921
Oil on canvas
23⅝ × 32 (60.0 × 81.3)
Scottish National Gallery of Modern Art,
Edinburgh

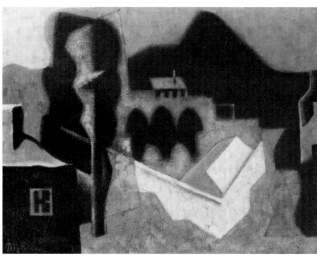

171

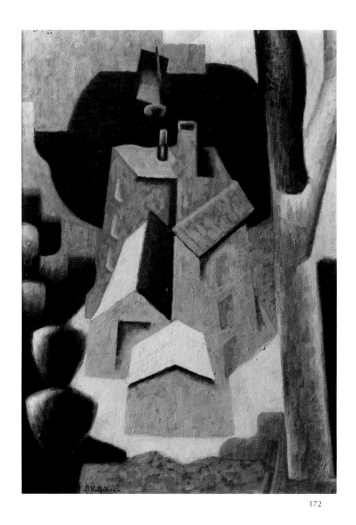

172

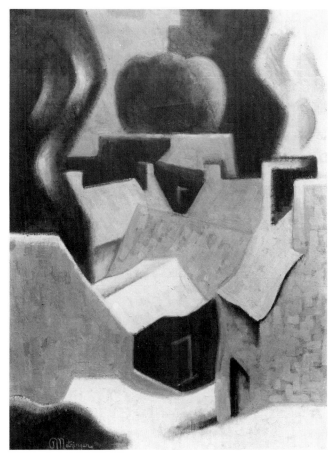

174

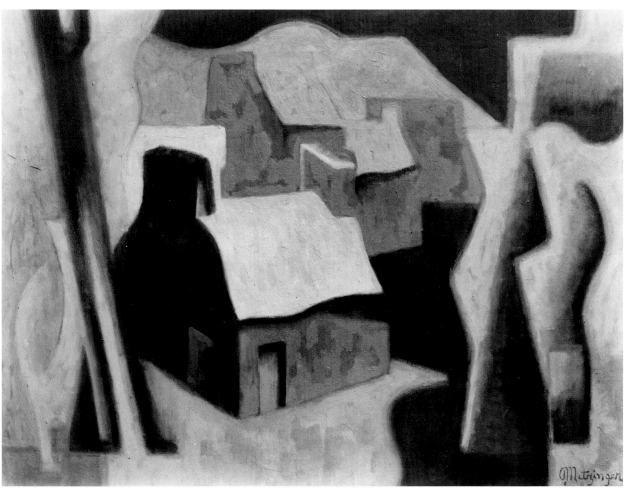

173

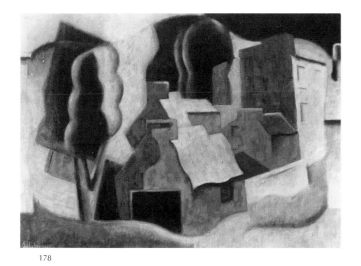

178

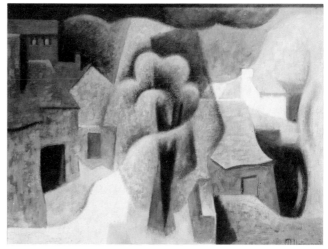

177

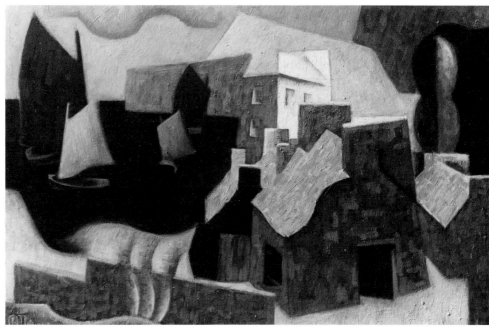

175

172. *Paysage*, 1921 (WG)
Location unknown

173. Landscape with house and tree,
c. 1921
Oil on canvas
23½ × 32 (60.0 × 81.0)
Location unknown

174. *Paysage*, 1921 (BEM, November 1924)
Location unknown

175. *Paysage*, c. 1921
Location unknown

176. Landscape with town and buildings,
c. 1921
Location unknown

177. *Paysage cubiste*, c. 1921
Oil on canvas
24 × 31⅞ (61.0 × 81.0)
Private collection

178. *Landscape*, c. 1921
Location unknown

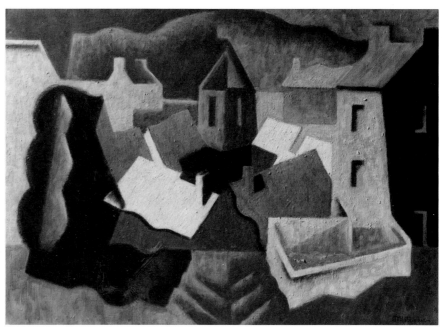

176

POST-CUBIST WORKS, 1922–1930

If Metzinger's paintings from 1922 through 1929 are more difficult to describe or to associate with a simple movement, they are for the most part easier to date, since many more are dated on the canvas and sales records for these works are somewhat more complete. For example, *Nature morte aux champignons* (187) was purchased from Léonce Rosenberg in September 1922, suggesting that the work was most likely completed earlier that year. The reverse perspective of the tabletop and the abstract handling of the background space are the only traces of Cubist devices that remain in an otherwise representational still life. This work seems to approach more closely than any other of Metzinger's paintings the Purist sensibility expressed by Amédée Ozenfant and Charles-Edouard Jeanneret in their 1918 book *Après le cubisme*. In fact Metzinger did contribute to Ozenfant's review *L'Elan* and certain aspects of Purist aesthetics did influence his work, but he never was an integral part of this movement. The solid modeling and illusion of space in Metzinger's work of 1922–25 were contrary to Purist aesthetics, as was as his continuing involvement with figures and landscape.

The classicizing tendency unchecked by Cubist discipline that characterizes Metzinger's paintings of these years led him to create some of his least successful works in 1923 and 1924. This is especially evident when one compares the works of these years to earlier treatments of the same themes. For example, *Le Goûter* (182) from 1923 is a rather mundane portrayal of a woman drinking tea in her garden as opposed to the more challenging version of this theme rendered in 1911 (31). Similarly *La Femme à l'éventail* (225) (woman with fan) and *Femme au miroir* (183) (woman with mirror) from the 1920s are dreamily sentimental and flaccid in comparison to the more exciting compositions of forms and patterns in earlier versions of these themes (37, 38, 64, 65, 66).

In some paintings of 1924 there seems to be a gradual hardening and abstraction of form that anticipates Metzinger's more interesting subsequent development. The new streamlining and geometric simplification of form evident in *Salomé* (200) continued through 1929, evolving toward a style that related strongly to the Art Deco aesthetic of the late 1920s and 1930s. Yet the unusual juxtaposition of objects in such paintings as *Still Life with Roulette Wheel* (217) and *Still Life with a Green Cup* (220) suggests an allegorical content that distinguishes these paintings from mere decoration.

Stylistically Metzinger's paintings of 1925 through 1929 are strongly reminiscent of Fernand Léger's paintings of that time, which Metzinger himself acknowledges in *Hommage à Fernand Léger* (240), but the unusual iconography of these works distinguishes them from the work of any other artist and engages the viewer's imagination to a degree that many of the earlier works do not. The introduction of spatial complexities in such works as *La Fenêtre dans le miroir* (227) and *Femme au perroquet* (229) counterbalances the strongly decorative appearance of these works. The subjective nature of the imagery in such works as *Le Portrait* (226), *Le Masque bleu* (235), and *Composition allégorique* (239) adds a very personal dimension to these paintings that is absent from many of Metzinger's earlier, more formalist works.

The promise of Metzinger's paintings of the late 1920s does not seem to have been fulfilled in his work from the 1930s to his death in 1956. In the early 1930s some awkward Surrealist elements appear in his paintings, and his later works look like clumsy pastiches of his earlier Cubist paintings. Always involved with writers and literary circles, as he had been since his earliest years in Paris, Metzinger evidently abandoned his writing on art in favor of writing poetry; a collection of his poems was published in 1947 under the title *Ecluses*. The absence of journals, letters, or dated reminiscences deprives us of greater insight into the artist and of a clear understanding of why his career developed as it did.

J. M.

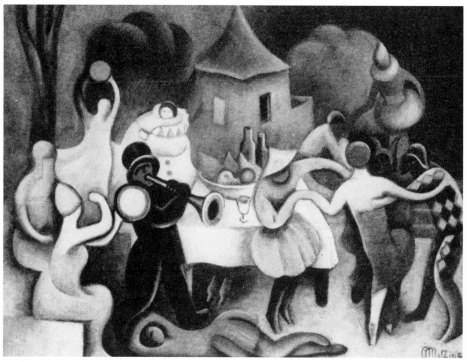

181

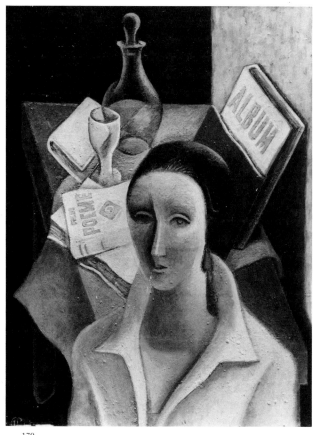

179

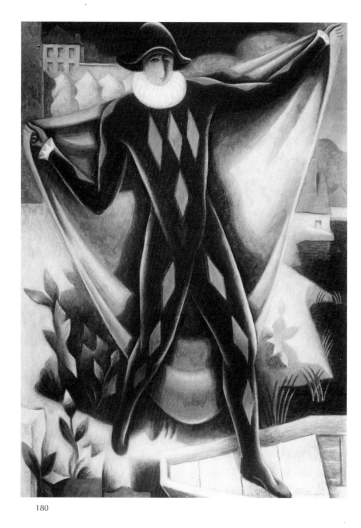

180

179. *Buste de femme et nature morte* (Portrait à la nature morte), c. 1922
Oil on canvas
31⅞ × 23⅝ (81.0 × 60.0)
Musée d'Art Moderne de Troyes. Gift of P. and D. Levy

180. *Arlequin*, 1922 (BEM, January 1924)
Medium unknown
63½ × 44¼ (162.0 × 112.0)
Location unknown

181. *Carnaval à Venise*, September 1922
Oil on canvas
23½ × 32 (60.0 × 81.0)
Location unknown

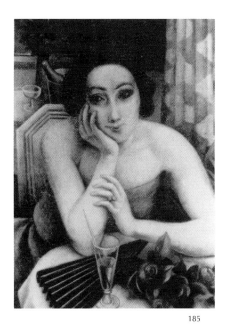

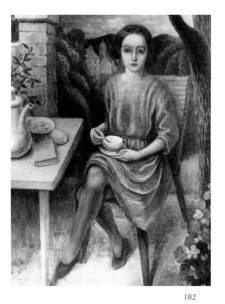

182

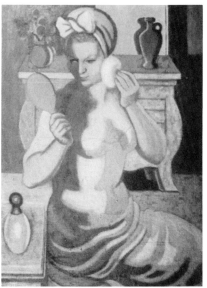

183

185

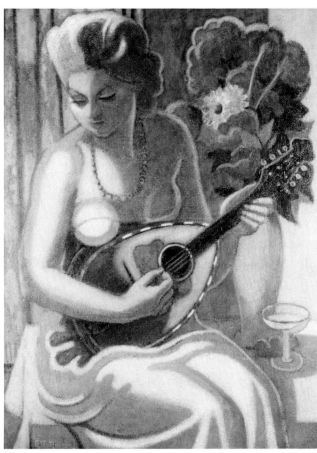

184

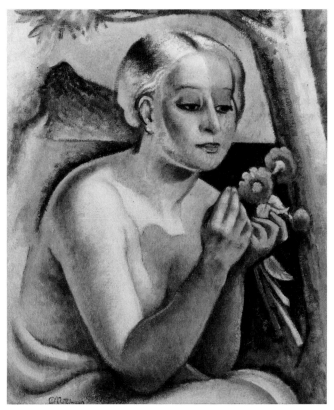

186

182. *Le Goûter*, dated "9–23"
Location unknown

183. *Femme au miroir*, c. 1923
Location unknown

184. *Jeune femme à la mandoline*, c. 1923
Oil on canvas
39⅜ × 28¾ (100.0 × 73.0)
Galerie Daniel Malingue, Paris

185. *La Jeune Femme pensive aux roses rouges* (Dame assise aux roses rouges), dated "10–23"
31⅜ × 23⅛ (79.7 × 58.7)
Location unknown

186. *Jeune Femme au bouquet de fleurs*, c. 1923
Oil on canvas
23⅝ × 28¾ (60.0 × 73.0)
Petit Palais, Geneva

187

189

188

187. **Nature morte aux champignons**,
c. 1922
Oil on canvas
19 × 24⅞ (48.2 × 63.2)
Lent by the Columbus Museum of Art, Ohio:
Gift of Ferdinand Howald

188. *Le Melon*, 1923 (BEM, February 1924)
Location unknown

189. *Le Pot de géraniums*, 1923 (BEM, February 1924)
Location unknown

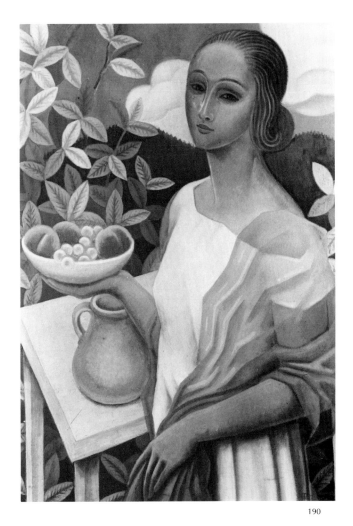

190

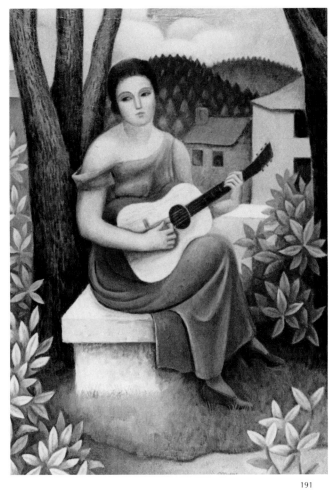

191

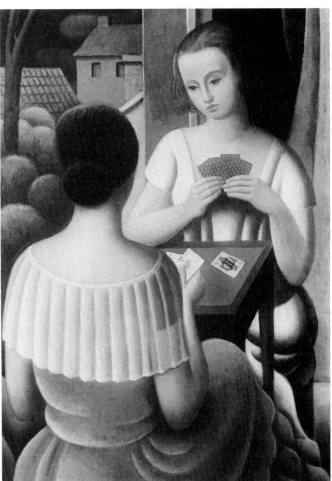

192

190. *Woman with Still Life*, dated "janv. 1924"
Location unknown

191. *Young Woman with a Guitar*, dated "2−24"
Oil on canvas
35½ × 25¼ (90.0 × 64.0)
Collection Rijksmuseum Kröller-Müller, Otterlo, The Netherlands

192. *Femmes jouant aux cartes*, c. 1924
Location unknown

193. *Le Port*, dated "2−24"
Location unknown

194. **Country Seat with Horsemen**, dated "août 1924"
Oil on canvas
23¾ × 32 (60.5 × 81.0)
Collection Rijksmuseum Kröller-Müller, Otterlo, The Netherlands

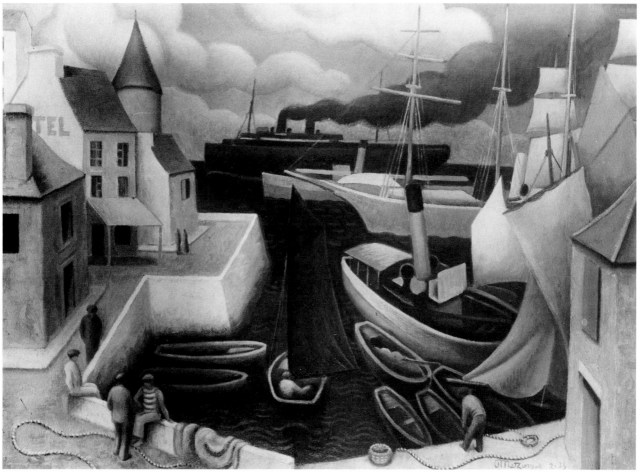

193

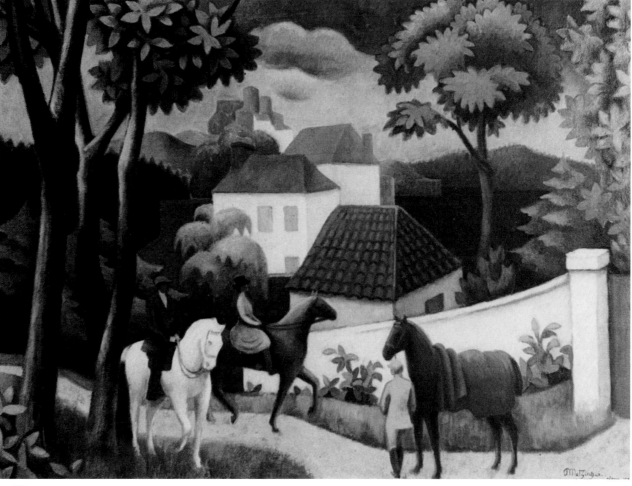

194

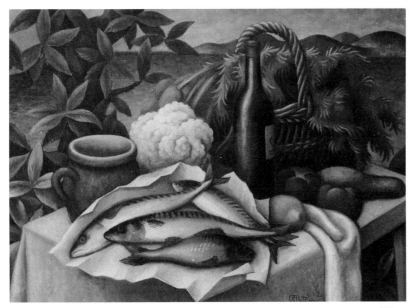

195

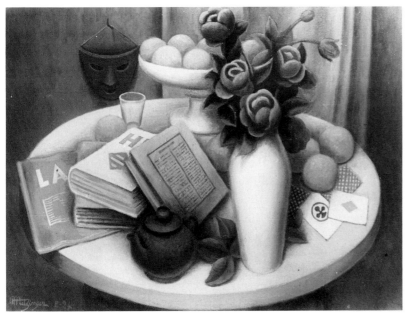

196

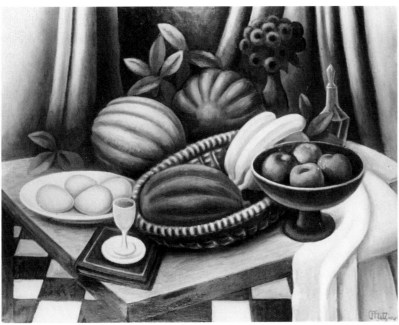

197

195. *Nature morte aux poissons*, 1924
Oil on canvas
25½ × 36¼ (65.0 × 92.0)
Petit Palais, Geneva

196. *Les Roses*, dated "2–24"
Location unknown

197. Still life with bananas, melons, and goblet, 1924
Location unknown

198. *Clown à la mandoline*, c. 1924
Oil on canvas
39⅜ × 28¾ (100.0 × 73.0)
Petit Palais, Geneva

199. *Le Clown*, 1924 (BEM, December 1924)
Location unknown

200. *Salomé*, 1924 (BEM, December 1924)
Location unknown

201. *Equestrienne*, 1924
Oil on canvas
32 × 23½ (81.0 × 60.0)
Collection Rijksmuseum Kröller-Müller, Otterlo, The Netherlands

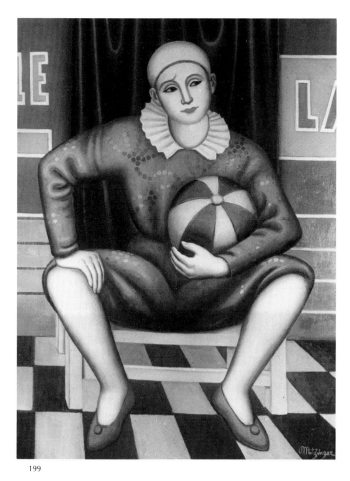

199

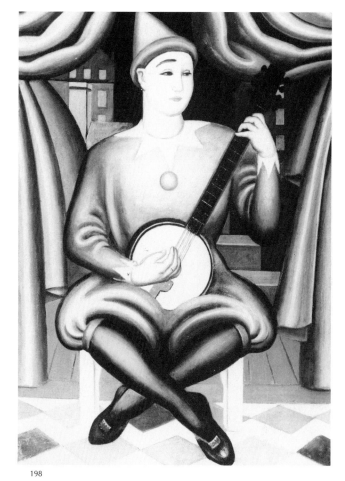

198

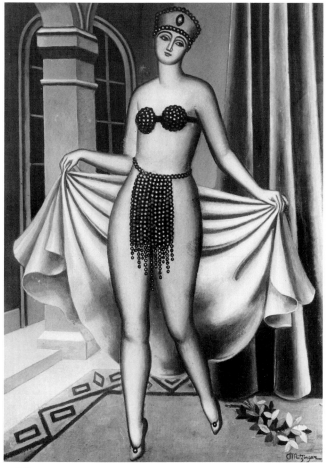

200

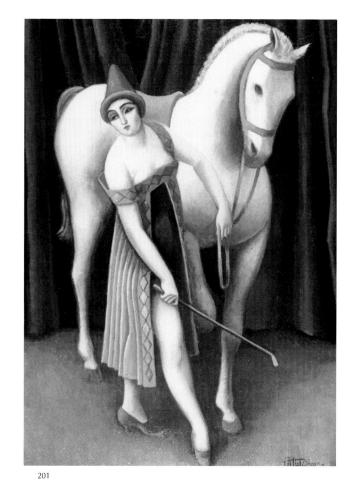

201

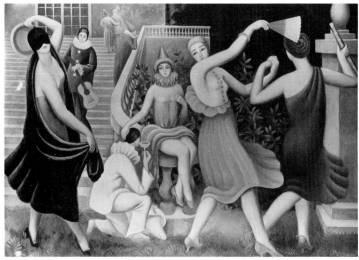

202

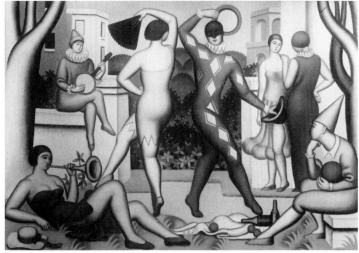

203

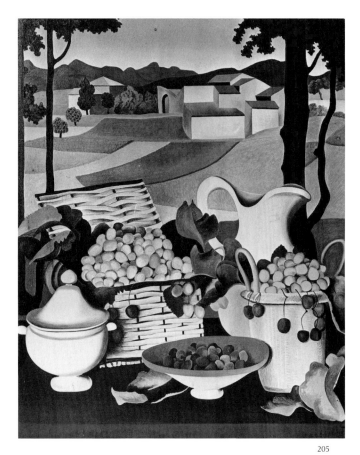

205

202. *La Comédie italienne*, 1924
Medium unknown
35 × 51¼ (88.9 × 130.2)
Location unknown

203. *The Harlequins*, 1925
Oil on canvas
35 × 51 (89.9 × 129.5)
Location unknown

204. ***Still Life*** (Nature morte), 1925
Oil on canvas
31⅞ × 23⅝ (80.7 × 60.0)
The Detroit Institute of Arts, Gift of Mr. and
Mrs. Isadore Levin

205. Still life, c. 1924–25
Location unknown

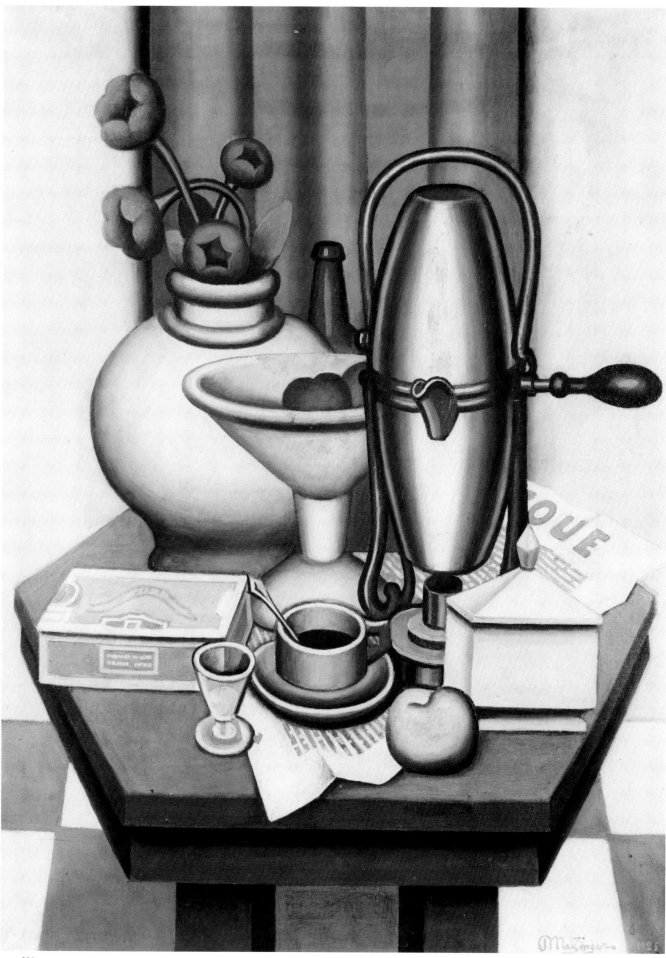

204

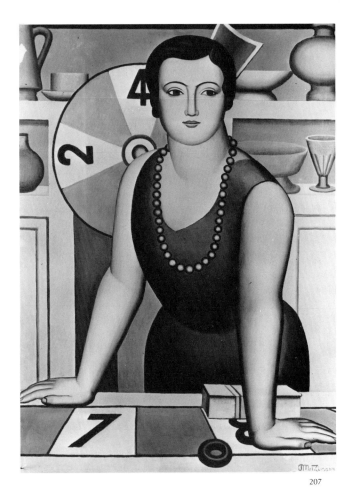

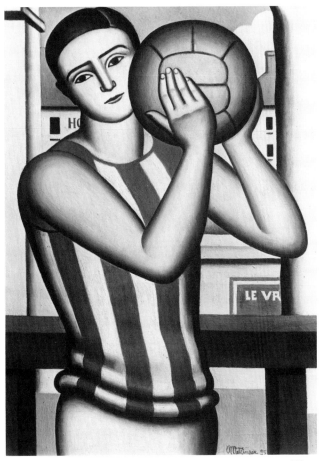

206

207

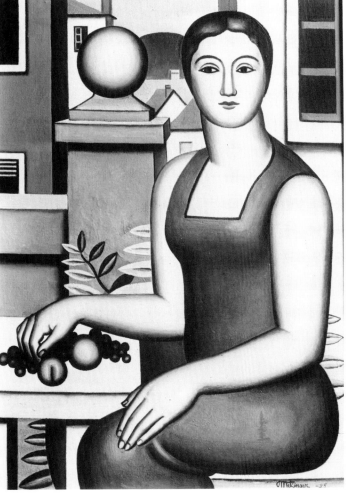

208

206. *Le Joueur de football*, 1925
Oil on canvas
39½ × 29 (100.3 × 73.7)
Location unknown

207. *La Loterie* (Loterie foraine), 1925
Location unknown

208. *Femme aux fruits*, 1925
Location unknown

209. *La Gare*, 1925
Medium unknown
25½ × 36 (65.0 × 91.5)
Location unknown

210. *Le Pont rouge*, 1925 (BEM, December 1925)
Location unknown

211. *Paysage*, 1925 (BEM, March 1925)
Location unknown

212. *L'Usine*, 1925 (BEM, May 1925)
Location unknown

213. *Paysage*, 1926 (BEM, October 1926)
Location unknown

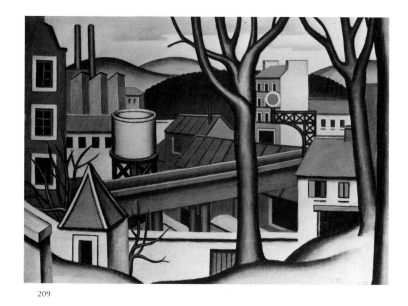

209

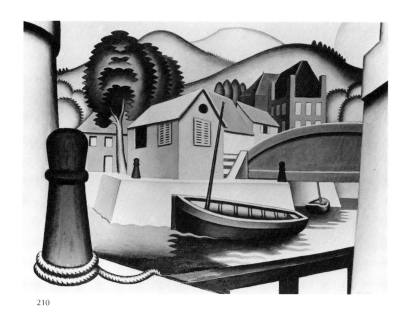

210

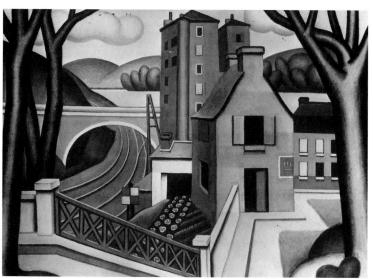

211

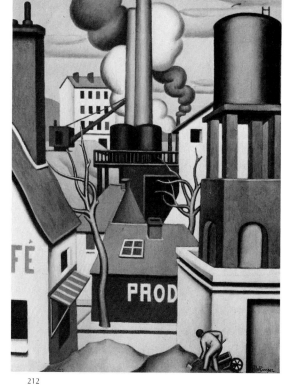

212

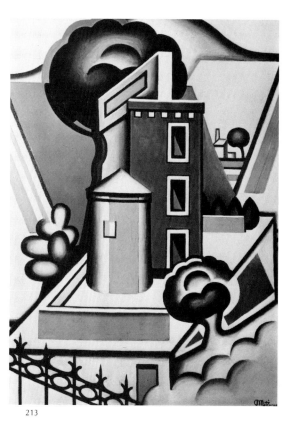

213

215

218

214

214. *Still Life with a Black Vase*, 1926 (BEM, March 1926)
Oil on canvas
23½ × 31½ (60.0 × 80.0)
Collection Rijksmuseum Kröller-Müller, Otterlo, The Netherlands

215. *Le Bocal aux poissons*, 1926 (BEM, October 1926)
Location unknown

216. *Nature morte aux poissons rouges*, 1926 (BEM, June 1926)
Location unknown

217. **Still Life with Roulette Wheel** (Abstraction with Roulette), 1926
Oil on canvas
15 × 22¹³⁄₁₆ (38.1 × 57.9)
The University of Iowa Museum of Art, Iowa City, Gift of Owen and Leone Elliott
(illus. p. 32)

218. *La Roulette*, c. 1926
Medium unknown
38¼ × 57½ (97.0 × 146.0)
Location unknown

219. Still life with birds, c. 1926
Oil on canvas
28½ × 39 (72.4 × 99.1)
Collection of Arnold Scaasi

220. **Still Life with a Green Cup**, 1927
Oil on canvas
25½ × 36¼ (65.0 × 92.0)
Collection Rijksmuseum Kröller-Müller, Otterlo, The Netherlands

216

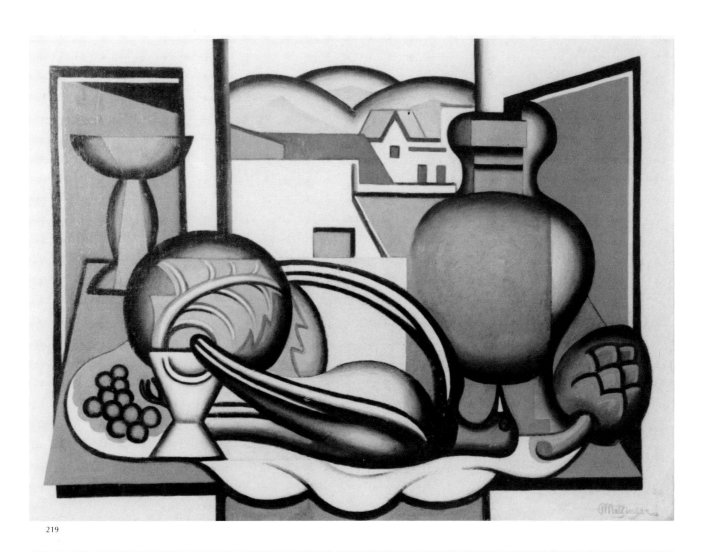

219

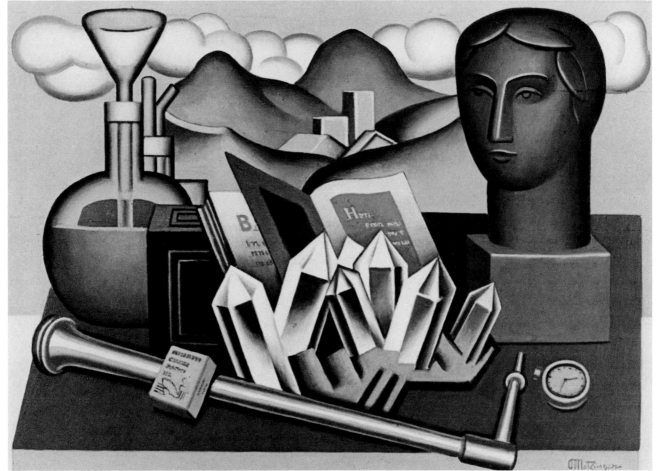

220

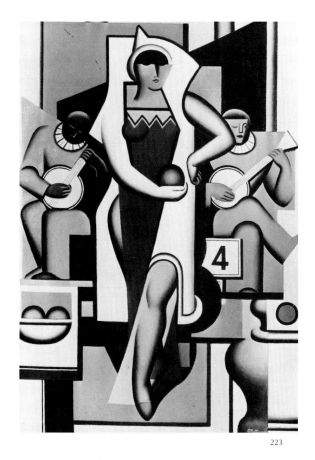

223

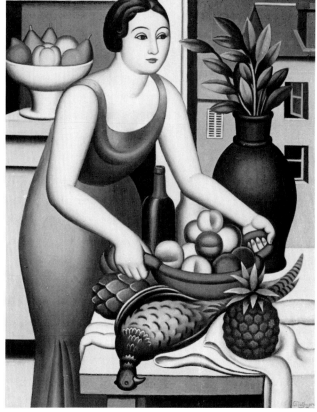

222

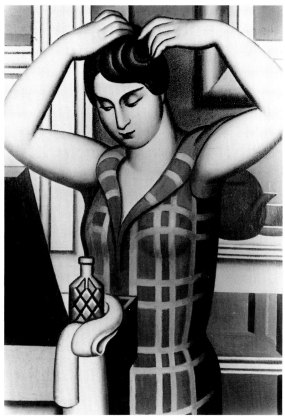

221

224

221. *Femme à sa toilette*, (Femme à sa coiffure, Woman Dressing), 1926 (BEM, July 1926)
Location unknown

222. **Woman with Pheasant** (Pêches et faisan), 1926 (BEM, March 1926)
Oil on canvas
45¾ × 36 (116.0 × 89.0)
Collection Rijksmuseum Kröller-Müller, Otterlo, The Netherlands

223. *La Jongleuse*, 1926 (BEM, December 1926)
Location unknown

224. *Le Clown*, c. 1926
Pencil and watercolor on paper
6¼ × 7½ (16.0 × 19.0)
Musée National d'Art Moderne, Paris

225

226

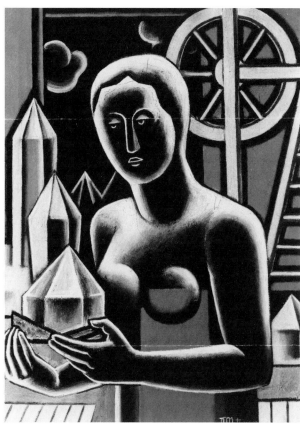

228

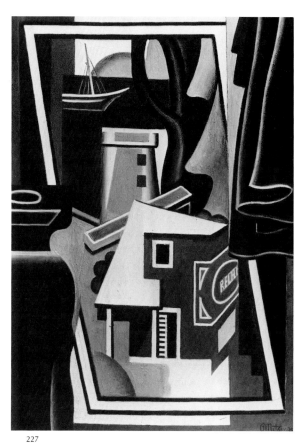

227

225. *La Femme à l'éventail* (Woman with Fan), c. 1927
Location unknown

226. *Le Portrait*, c. 1927
Oil on canvas
36¼ × 25½ (92.0 × 65.0)
Galerie Klewan, Munich

227. *La Fenêtre dans le miroir* (Paysage vu dans la glace), 1927 (BEM, May 1927)
Oil on canvas
21¾ × 15 (55.0 × 38.0)
Location unknown

228. Woman with prisms, c. 1927–28
Location unknown

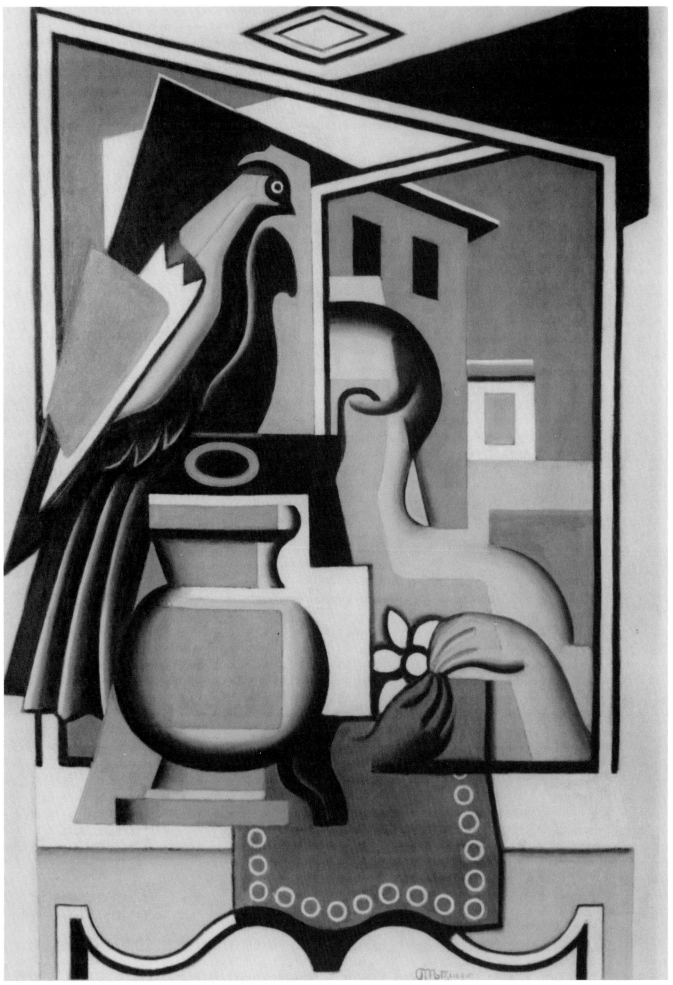

229. **Femme au perroquet** (La Fenêtre),
c. 1927
Oil on canvas
36¼ × 25½ (92.0 × 65.0)
Lent by Mr. and Mrs. F. L. Schoneman

230. *Le Sphinx*, c. 1928
Oil on canvas
45⅝ × 35 (116.0 × 89.0)
Petit Palais, Geneva

231. *The Masks*, 1928
Oil on canvas
54 × 40 (137.2 × 101.6)
Collection of Arnold Scaasi

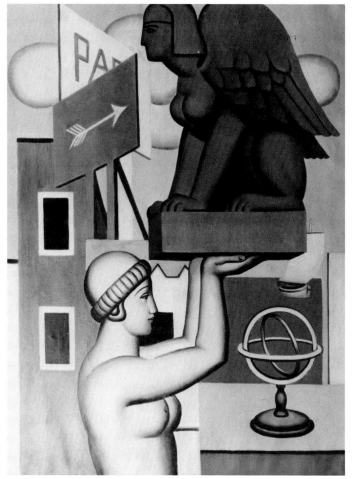

230

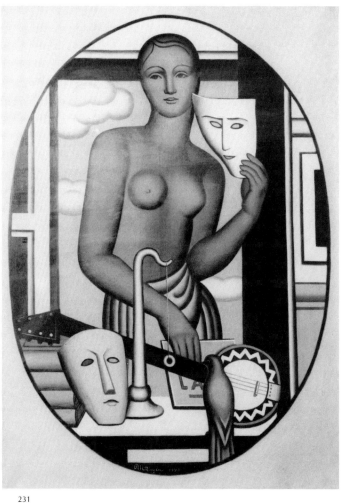

231

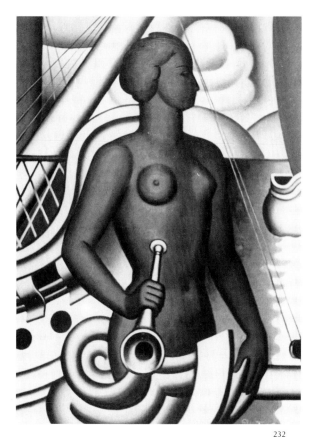

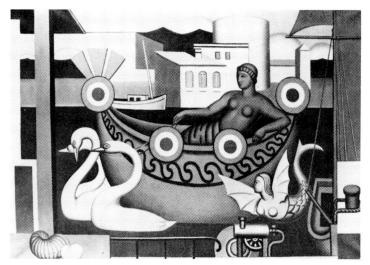

234

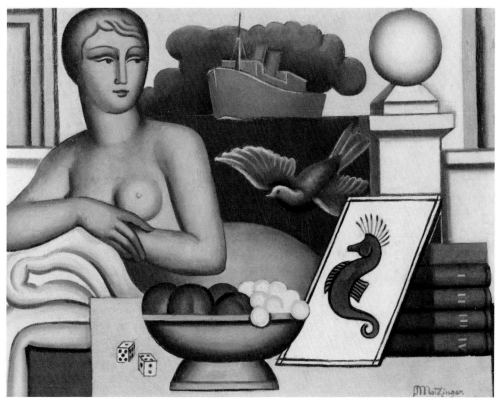

233

232. *Female Nude on Board Ship*, 1927
(BEM, November 1927)
Oil on canvas
39¼ × 28¾ (100.0 × 73.0)
Collection Rijksmuseum Kröller-Müller,
Otterlo, The Netherlands

233. *Femme nue allongée*, c. 1927–28
Oil on canvas
20¾ × 28 (52.5 × 71.0)
Collection of Sol Levitt

234. *Sirène dans un bateau*, c. 1928
Medium unknown
44½ × 63¼ (113.0 × 160.7)
Location unknown

235. *Le Masque bleu*, 1928 (BEM, December 1928)
Location unknown

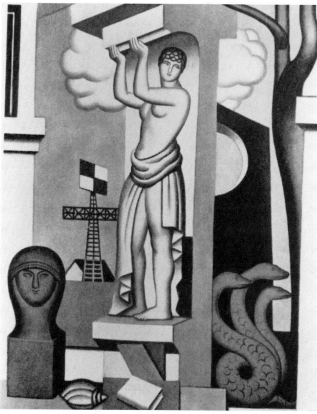

236

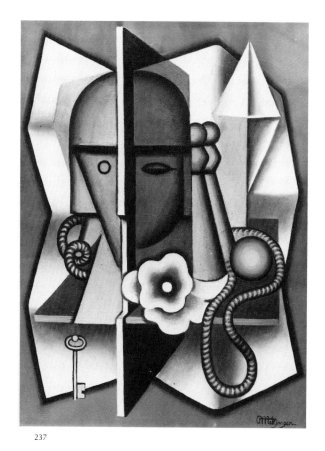

237

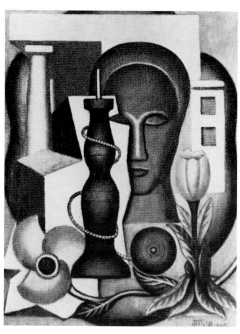

238

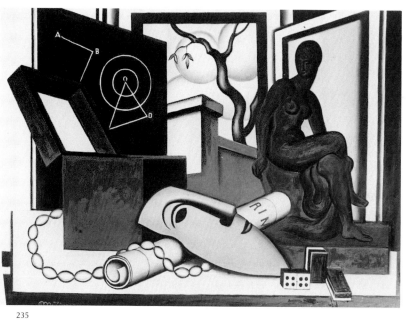

235

236. *Imaginary Landscape* (La Statue du sémaphore), c. 1928
Oil on canvas
45¾ × 35 (116.0 × 89.0)
Location unknown

237. *Tête et jeu de quilles*, 1929 (*Apollo* 11, 66 [June 1930]: 482)
Location unknown

238. *Le Bilboquet*, c. 1928−29
Medium unknown
25½ × 19¾ (64.8 × 50.2)
Location unknown

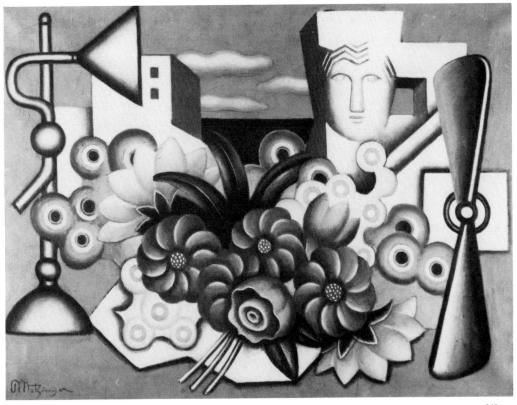

240

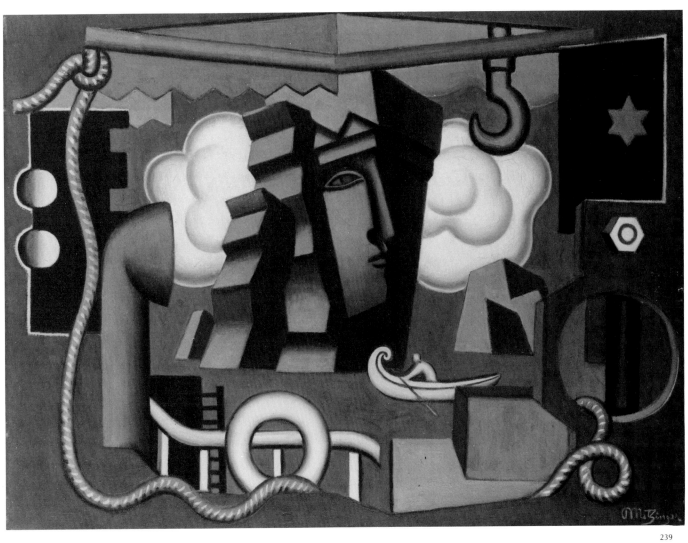

239

242

241

239. *Composition allégorique*,
c. 1928–29
Oil on canvas
21¼ × 28¾ (54.0 × 73.0)
Musée d'Art Moderne de la Ville de Paris

240. *Hommage à Fernand Léger*, c. 1929
Oil on canvas
21¼ × 28¾ (54.0 × 73.0)
Collection of Preferred Equities Corporation,
Las Vegas, Nevada

241. *La Sphère et le banjo*, c. 1930
Oil on canvas
25½ × 36¼ (65.0 × 92.0)
Private collection

242. *Nature morte à la mappemonde*,
c. 1930
Oil on canvas
25½ × 36¼ (65.0 × 92.0)
Location unknown

BIBLIOGRAPHY

PUBLICATIONS BY JEAN METZINGER

"Note sur la peinture." *Pan* (Paris), October-November 1910.

"Cubisme et tradition." *Paris Journal*, 16 August 1911.

"Alexandre Mercereau," *Vers et prose* 27 (October-December 1911): 122–29.

———, and Gleizes, Albert. *Du «Cubisme»*. Paris: Figuière, 1912. First English edition: *Cubism*. London: Unwin, 1913.

"Art et esthétique." *Lettres parisiennes*, suppl. 9 (April 1920): 6–7.

———, and Léger, F. "Réponse à notre enquête—où va la peinture moderne?" *Bulletin de l'Effort moderne*, February 1924, 5–6.

"L'Evolution du coloris." *Bulletin de l'Effort moderne*, Paris, 1925.

"Enquête du Bulletin." *Bulletin de l'Effort moderne*, October 1925, 14–15.

"Metzinger, Chabaud, Chagall, Gruber, et André Mouchard répondent à l'enquête de Beaux-Arts sur le métric." *Beaux-Arts*, 2 October 1936, 1.

"Un Souper chez G. Apollinaire." *Apollinaire*. Paris, 1946.

Ecluses. Preface by Henri Charpentier. Paris: G. L. Arlaud, 1947.

"1912–1946." Afterword to reprint of *Du «Cubisme»* by A. Gleizes and J. Metzinger, pp. 75–79. Paris: Compagnie française des arts graphiques, 1947.

"Le Cubisme apporta à Gleizes le moyen d'écrire l'espace." *Arts spectacles*, no. 418, 3–9 July 1953.

"Structures de peinture, Structures de l'esprit, Hommage à Albert Gleizes." With essays, statements and fragments of works by Gleizes, Metzinger, André Beaudin, Severini, et al. Lyons: Atelier de la Rose, 1954.

Suzanne Phocas. Paris: Galerie de l'Institut, February 1955.

Le Cubisme était né: Souvenirs. Chambéry: Editions Présence, 1972.

PUBLICATIONS ABOUT JEAN METZINGER

Gleizes, Albert. "Art et ses représentants: Jean Metzinger." *La Revue indépendante*, September 1911, 161–72.

Salmon, André. "Jean Metzinger." *Paris Journal*, 3 October 1911.

Olivier-Hourcade. "Silhouettes: Metzinger," *Paris Journal*, 29 July 1912.

Galerie Berthe Weill. *Gleizes, Metzinger, Léger*. Catalog introduction by J. Granié. Paris, 1913.

LeMaître, Yvonne. "An Interview with Jean Metzinger on the Cubists and What They are Doing in the World of Art." *Lowell* (Mass.) *Courier Citizen*, May 1913. (Clipping preserved in scrapbook in Mabel Dodge Luhan Archive, Yale University).

Galerie André Groult, *Exposition de sculptures de R. Duchamp-Villon; dessins, aquarelles d'Albert Gleizes; gravures de Jacques Villon; dessins de Jean Metzinger*. Catalog preface by André Salmon. Paris, 1914.

Apollinaire, Guillaume. "Jean Metzinger à la Galerie Weill." *Paris Journal*, 27 May 1914.

Dermée, P. "Jean Metzinger—une esthétique." *Sic* (Paris), March-April 1919, 336.

George, Waldemar. "Jean Metzinger." *L'Esprit nouveau* 2, no. 15 (February 1922): 1781–88.

Turpin, Georges. *Jean Metzinger, oeuvres récentes et anciennes*. Exhibition catalog, May-June 1943. Paris: Galerie Hessel.

Courthon, Pierre. "Un grand Cubiste: Metzinger." *Arts-Documents* (Geneva), 20 (1952).

"Herbin and Metzinger." Review of exhibition at Niveau Gallery. *Arts Digest* 29 (1 December 1954): 23.

Johnson, S. E. *Metzinger: Pre-Cubist and Cubist Works, 1900–1930*. Exhibition catalog. Chicago: International Galleries, 1964.

Hiscock, Karin. "Jean Metzinger: His Role as Painter/Theorist in the Cubist Circle, 1910–1915." M.A. thesis, Birmingham (U.K.) Polytechnic, 1985.

ACKNOWLEDGMENTS

Support from the National Endowment for the Arts made it possible to do research on Jean Metzinger and to organize this exhibition. It is especially fitting that the exhibition opens at the time when the Endowment is celebrating its twentieth anniversary; this exhibition was made a reality with the assistance of the Endowment and stands as a symbolic tribute to the National Endowment for the Arts' valuable support of many other exhibitions over the past two decades.

A generous grant from the J. Paul Getty Trust enabled me to illustrate in the catalog more than 180 works that were not shown in the exhibition and to reproduce some of the paintings in color. Deborah Marrow, Publications Coordinator of the J. Paul Getty Trust, was most helpful in guiding me through the application process so that the proposal would be favorably considered. I am grateful to Professor Linda Henderson of the University of Texas at Austin and Professor George Heard Hamilton of Williams College for their encouragement to pursue this project and their support of my proposal to the J. Paul Getty Trust.

A major portion of the research on Metzinger involved finding paintings and drawings by him in both private and public collections. I would like to thank the following people for their generous assistance in locating works by Metzinger: Arthur Altschul, New York; Patrice Bachelard, formerly of the Musée d'Art Moderne de la Ville de Paris; Sherry Ann Buckberrough, Hartford, Connecticut; Charles Chetham, Smith College Museum of Art, Northampton, Massachusetts; Verna Curtis, Milwaukee Art Museum; Mariana Draper, Sala Dalmau, Barcelona; Christian Dérouet, Musée National d'Art Moderne, Paris; Jean-Jacques Dutko, Paris; Joseph Faulker, Chicago; Suzanne Foley, University Art Museum, University of Wisconsin, Milwaukee; Oscar Ghez, Petit Palais, Geneva; B. C. Holland, B. C. Holland, Inc., Chicago; R. Stanley Johnson, R. S. Johnson International, Chicago; Samuel Josefowitz, Lausanne; Helmut Klewan, Galerie Klewan, Munich; Linda Kramer, Sotheby's, New York; M. Lorenceau, Brame et Lorenceau, Paris; Daniel Malingue, Paris; Jacques Melki, Paris; Larry Randall, Randall Gallery, New York; Mrs. F. Rosenak, Niveau Gallery, New York; Monique Schneider-Manoury, Paris; Helen Serger, La Boétie, Inc., New York; Kristin Sorenson, Christies, New York; Andrew Strauss, Sotheby's, New York; Rolf and Margit Weinberg, Zurich.

Additional works were located through a letter of inquiry to colleagues in American and European museums, whose responses and cooperation are sincerely appreciated. I would like to thank them for their assistance in furnishing information about the works and for their help in arranging loans.

I am grateful to the many private collectors who welcomed me into their homes and generously agreed to share their treasures for this exhibition. Their cooperation in sending photographs of their works or allowing Ed Peterson to photograph the works is greatly appreciated.

I would like to thank Mrs. Caral Lebworth for her contribution toward catalog production costs.

As I recall the various stages of organizing this exhibition, I realize what an invaluable collaborator Daniel Robbins has been. His enthusiasm and support as much as his expertise in the study of Cubism have been steadfast resources upon which I could rely. His willingness to share information, to discuss the dating of Metzinger's work, and to facilitate loans has helped immeasurably with the completion of this project. His essay on Metzinger's role in the Cubist movement is an important addition to the literature. Not only does it clarify Metzinger's contribution to the movement, but it also challenges the traditional interpretation of Cubism.

In every exhibition there is at least one person whose efforts in almost every aspect of the project were invaluable and should be recognized as a major contribution to its successful realization. Gail Parson Zlatnik has devoted considerable time and energy to a wide range of responsibilities with outstanding skill and perseverance; her assistance in requesting loans, working with lenders, ordering photographs, obtaining permissions, writing catalog entries, editing, and keeping track of numerous details has been exceptional.

Ann Walston designed the catalog with remarkable sensitivity and skill. Libra Wagoner showed exemplary patience and skill in typing and correcting the catalog manuscript.

I would like to thank the members of the staff at The University of Iowa Museum of Art for their individual contributions to this exhibition: Honee A. Hess, Curator of Education; Jo-Ann Conklin, Registrar; Jean Schroeder, Assistant Registrar; Judith McTammany, former Administrative Assistant; David Dennis, Installation Coordinator; James Lindell, Carpenter; Nancy DeDakis, Secretary to the Director; Sally Mohney, Membership Secretary; Carol Thompson, Curatorial Assistant; and Rita Lambros and Anne Sullivan, Print Study Room Assistants. The encouragement and support of Robert Hobbs, Director of The University of Iowa Museum of Art, were essential for the completion of this exhibition.

I am especially grateful to Owen and Leone Elliott of Cedar Rapids, Iowa. Their generous donation of four paintings to The University of Iowa Museum of Art was the impetus for this exhibition.

J. M.

LENDERS TO THE EXHIBITION

The University of Michigan Museum of Art, Ann Arbor

Lawrence University, Appleton, Wisconsin

Museum of Fine Arts, Boston

Albright-Knox Art Gallery, Buffalo, New York

Fogg Art Museum, Harvard University, Cambridge, Massachusetts

The Art Institute of Chicago

The David and Alfred Smart Gallery, The University of Chicago

Columbus Museum of Art, Ohio

The Detroit Institute of Arts

The University of Iowa Museum of Art, Iowa City

Herbert F. Johnson Museum of Art, Cornell University, Ithaca, New York

Bass Museum of Art, Miami Beach

Yale University Art Gallery, New Haven, Connecticut

New Orleans Museum of Art

The Solomon R. Guggenheim Museum, New York

The Museum of Modern Art, New York

The Chrysler Museum, Norfolk, Virginia

Rijksmuseum Kröller-Müller, Otterlo, The Netherlands

Musée d'Art Moderne de la Ville de Paris

Musée National d'Art Moderne, Paris

Philadelphia Museum of Art

Museum of Art, Carnegie Institute, Pittsburgh, Pennsylvania

Museum of Art, Rhode Island School of Design, Providence

The Saint Louis Art Museum

Rupertinum, Salzburg

San Francisco Museum of Modern Art

Mr. and Mrs. Arthur G. Altschul

Dr. David S. Bradford

Mr. and Mrs. Thomas H. Dittmer

Mrs. Monroe Geller

Murray A. and Ruth Gribin

Mr. and Mrs. R. Stanley Johnson

Jacqueline and Max Kohler-Krotoschin

Mr. and Mrs. M. Thomas Lardner

Mr. and Mrs. Herbert M. Lyman

David Markin

Hope and Abraham Melamed

Mr. and Mrs. Marshall Padorr

Mr. and Mrs. F. L. Schoneman

Mr. and Mrs. Joseph Randall Shapiro

Victor Skrebneski

Margit and Rolf Weinberg

Mr. and Mrs. Robert G. Weiss

Private collections

Galerie Brockstedt, Hamburg

Sidney Janis Gallery, New York, New York

JEAN METZINGER IN RETROSPECT

Photography

The photographs in this volume have been provided, in the majority of cases, by the owners or custodians of the works and are reproduced with their permission.

Copyright of the works herein reproduced is controlled by A.D.A.G.P., Paris/V.A.G.A., New York, and to these works the following notice is applicable: © 1985 A.D.A.G.P., Paris/V.A.G.A., New York.

Photography for The University of Iowa Museum of Art by Mark Tade and Steve Tatum.

In addition, the following photographic credits are noted:

Rolf Achilles: 49

© 1985 The Art Institute of Chicago. All Rights Reserved: 38, 97, 140

Art Resource: 18

Photographie Bulloz: 45, 55, 58, 62, 239

Service Photographique, Caisse Nationale des Monuments Historiques et des Sites, Paris © 1985 ARCH PHOT., Paris/S.P.A.D.E.M./ V.A.G.A., New York: 70, 73, 86, 87, 88, 94, 108, 114, 118, 119, 120, 146, 148, 153, 161, 162, 164, 166, 172, 173, 174, 175, 176, 178, 179, 180, 182, 188, 189, 190, 192, 193, 196, 197, 199, 200, 202, 203, 205, 206, 207, 208, 209, 210, 211, 212, 213, 215, 216, 218, 221, 223, 227, 235, 237.

Sala Dalmau, Barcelona: 90

© 1985, Founders Society, Detroit Institute of Arts, Modern Art, negative 11015: 204

R. Richard Eells: 130

Fine Arts Photography, Nathan Rabin: 77

Allan Finkelman: 79

André Godin: 3, 170

Helga Photo Studio: 139

R. Stanley Johnson: 8a, 8b, 142

Joseph Klima, Jr.: 96

Lauros-Giraudon: frontispiece

Robert E. Mates: 37, 52

Photographie Musée National d'Art Moderne, Centre Pompidou, Paris: 30, 42, 46, 51, 54, 57, 75, 76, 100, 102, 104, 129, 165, 224.

Ed Peterson: 61, 109, 112, 132, 156, 219, 229, 231

Maurice Poplin: 157

Jon Reis: 121

Joseph Szaszfai: 83, 163

Randall Tosh: 15, 67

Ray Trahan: 91

A. J. Wyatt, Staff Photographer, Philadelphia Museum of Art: 24, 135

Design

Ann Walston

Joyce Kachergis Book Design and Production
Bynum, North Carolina

Typesetting

G & S Typesetters, Austin, Texas

Printing

Stamats Communications
Cedar Rapids, Iowa